CALIFORNIA
COUNTRY

INTERIOR DESIGN, ARCHITECTURE, AND STYLE

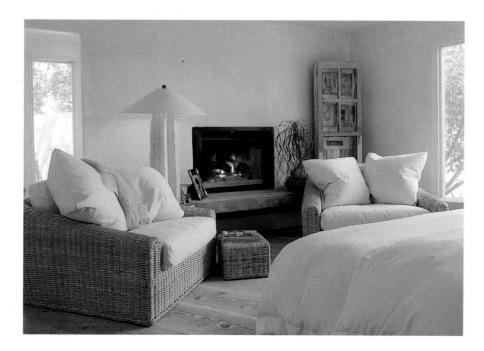

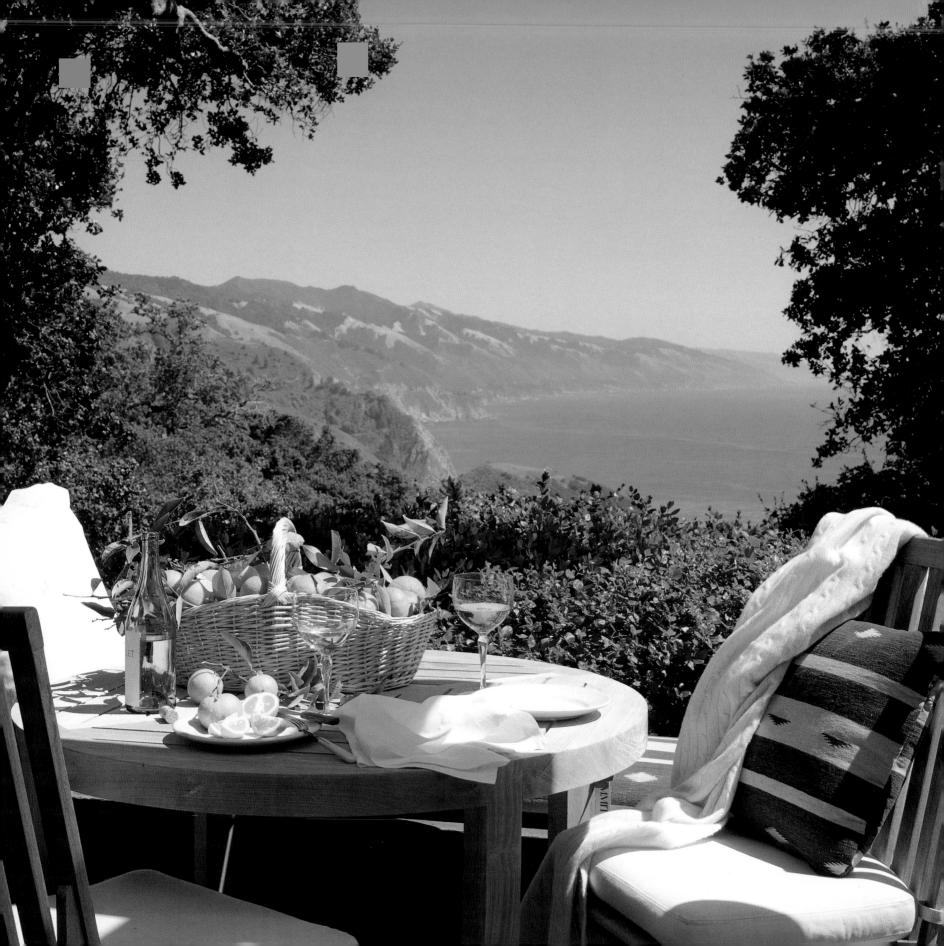

CALIFORNIA COUNTRY

INTERIOR DESIGN, ARCHITECTURE, AND STYLE

BY DIANE DORRANS SAEKS
PHOTOGRAPHY BY JOHN VAUGHAN

FOREWORD BY HERB CAEN

Chronicle Books • San Francisco

Library of Congress Cataloging-in-Publication Data:
 Saeks, Diane Dorrans.
 California Country / by Diane Dorrans Saeks;
 photographs by John Vaughan.
 p. cm.
 Includes index.
 ISBN 0-8118-0016-4 (hc)
 1. Country homes—California. 2. Interior decoration—California—History—
20th century.
 I. Vaughan, John, 1952- . II. Title
NA7561.S24 1991 91-42734
728' .37'09794—dc20 CIP

Book and cover design by Laura Lamar, MAX, San Francisco, with assistance by Lisa Motzkin and Katherine Inglis. Produced on the Macintosh using DesignStudio page design software from Letraset, and Futura, Bernhard and Liberty type font families from Adobe, Inc. and Bitstream. Type output by Copy It. Film processing by Faulkner Color Lab.

Photography for the following residences appears courtesy of *House Beautiful.*
All rights reserved:
Flax, copyright © 1990, Hearst Corporation.
Durenberger, copyright © 1990, Hearst Corporation.
Power, copyright © 1990, Hearst Corporation.
Moore (design), copyright © 1989, Hearst Corporation.

Photography for the following residences appears courtesy of *Architectural Digest.*
All rights reserved:
Benaroya, copyright © 1991, Architectural Digest Publishing Corp.
Mondavi, copyright © 1989, Architectural Digest Publishing Corp.
Alaton (S. Barbara), copyright © 1988, Architectural Digest Publishing Corp.

Photography for the following residences appears courtesy of *Metropolitan Home.*
All rights reserved:
Hoopes, copyright © 1986, Meredith Corp.
Anderson, copyright © 1989, Meredith Corp.
Hammond, copyright © 1989, Meredith Corp.
Brady, copyright © 1990, Meredith Corp.
Sakata, copyright © 1990, Meredith Corp.

Distributed in Canada by:
Raincoast Books
112 East Third Avenue
Vancouver, B.C.
V5T 1C8

10 9 8 7 6 5 4 3 2 1

Chronicle Books
275 Fifth Street
San Francisco, California
94103

Previous pages: For Carolyn and Wally Wolf in Santa Ynez, San Francisco designer Ron Mann created a white–on–white bedroom scheme. A glorious view of Big Sur from Kipp and Sherna Stewart's terrace. Special thanks to Stephen Brady.
Above: Horticulturist Sarah Hammond picked David Austin's pale apricot shrub rose, Tamora, *Echinops* 'Veitch's Blue', phlox, a noisette rose ('Mme. Alfred Carrière'), and jasmine.

Acknowledgments

We have spent a joyful and fulfilling year traveling throughout California to put this book together. Our heartfelt thanks to very talented designers and architects for their visions and the remarkable residences shown on these pages. We would especially like to thank the owners, who opened their doors and their homes, and enthusiastically shared their lives and ideas with us. ¶ Both of us, in our work with publications across the country, meet exceptional editors, photo editors, and art directors. We owe them special gratitude for inspiration and encouragement over the years. ¶ Thanks to Dorothy Kalins and Donna Warner, Carol Helms, Jane Clark, Steven Wagner, and Barbara Graustark at *Metropolitan Home*. Paige Rense, editor of *Architectural Digest*, continues to be the very best editor, and special thanks also to her photographer liaison, James Huntington. At *House Beautiful*, Peggy Kennedy, Betty Boote, and Jody Thompson–Kennedy have been wonderful to work with. ¶ Thanks to Robert Harvey Q.S.O., Geraldine Paton and Erica Donaldson, Jeanne Allen, Marc Grant, Patty Rouas, Scott Lamb, and especially Gwyneth Dorrans for years of warm friendship and encouragement. ¶ Fred Hill, our literary agent, once more steered us wisely and safely. Laura Lamar, designing our second book together, has been a superbly organized and inspiring art director. She has been a steady, witty, and wonderful presence throughout the project. Terry Ryan, armed with a great eye and dozens of Blackwings, is a thoughtful, lively editor. ¶ Thanks, also, to Charlotte Stone at Chronicle Books. Maria Miranda Gresham and David Thibeault continue to be the finest hardworking assistants. Big thanks. Warmest thanks, once again, to Nion McEvoy, Editor–in–Chief of Chronicle Books, who has been enthusiastic about this book from the moment we proposed it to him at the party to launch *San Francisco A Certain Style*, our first book, at the San Francisco Museum of Modern Art.

—D.D.S., J.V.

For my son,
Justin, with love,
always

D.D.S.

For Marilyn Schafer,
Lois Wagner Green,
and Winnie Firpo, for
all their support,
inspiration, and love.

J.V.

Table of Contents

The many aspects of California Country style are shown in these vignettes. Pictured from left: Meyer lemons from Kipp and Sherna Stewart's Big Sur garden; a Mexican mercury glass vase and easygoing sofas designed by Michael Moore for a beach house in Montara; creamy roses and an ivorine collection at Laura Lamar and Max Seabaugh's Anderson Springs cottage; great old oaks shade the terrace of Robert and Margrit Mondavi's Napa Valley house.

 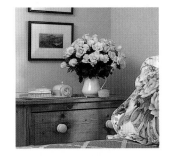 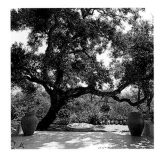

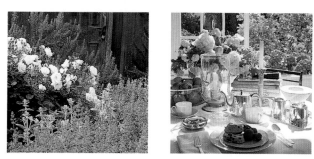

Chuck Winslow's amethyst painted table adds punch to a Sonoma County living room; Michael Taylor's timeless design for a family near Malibu Beach; Sarah Hammond's garden grows beautifully, thanks to her great eye for composition, color, and enchantment; Stephen Brady sets a glamourous table on his San Francisco terrace. Brady, a great entertainer, sets out linen napkins, fresh flowers, antique silver, and fat pillows on Paris park chairs. Life in California is indeed wonderful.

Foreword

Summer and smoke. Midsummer and the smoke of a thousand barbecues. California perfume of dust, underbrush, and pine merging on a hot afternoon punctuated by the champagne pop of well–stroked tennis balls. Stately eucalyptuses like filigree against pink dusk. Murmured conversations, glow of cigarettes, an old hi–fi playing even older Sinatra. ¶ Wonderful world of midsummer forcing you to count the days, count your blessings, count the ways in which I love thee, California, tousle–haired beauty dancing through poppies. ¶ Home-made peach ice cream. ¶ Driving back toward the City on 101 in a sea of boats being towed. The midsummer half–moon disappears in a gentle fog that lops the heads off the Golden Gate Bridge towers. ¶ "Thank you," said the tolltaker. ¶ No. Thank YOU.

...HERB CAEN

Opposite: The view from a terrace high above Sonoma: gnarled old olive trees and distant, dappled hills. In the spring, daffodils and paperwhites bob among spiky blue amaryllis.

Introduction
LIVING IN THE LANDSCAPE

I came to live in California from Washington, DC, twelve years ago. San Francisco's cool bright light, five-minute winters, chic city life, and fast escapes to the country made the West Coast seem another world. Like a frost-bitten northerner migrating to the balmy antipodes, I anticipated endless summer days at the beach, and sun-filled rooms with natural canvas sofas, sand-dusted bare floors, and a certain Californian élan. I imagined white flowers in crystal vases, witty antiques, ocean vistas, and brave little houses perched above rock-strewn coves. ¶ California is even richer and more fulfilling than my original oxygenated dreams. It's possible to drive down the Silverado Trail in the Napa Valley at sunset with Dietrich Fischer-Dieskau on CD performing "Pecheurs de Perles" or Carlos Santana playing full-tilt "I Love You Much Too Much" and cross the majestic Golden Gate Bridge just in time for a fast bite at Stars Cafe before *Aida* at the Opera House. Another weekend, the scenario sketches lunch with friends at a Malibu beach house, a visit to the grand Getty Museum, then a swift dash to Sunset Boulevard in time for dinner and paparazzi at Spago or City or Campanile. ¶ Interior design's beloved "California Look," first popularized by designers like Michael Taylor and Ron Mann, is just one scheme that works. Country

houses here just as often mix French and English country antiques, new crafts, hand–blown Mexican glass,

this–minute stone tables, and museum–quality art. A *mas* in the south of France or a house in Granada or

Umbria or even Austria may be the inspiration for architecture in the Napa Valley or Woodside or Carmel

Valley, but literal translation is never intended. It's a mood, a way of building, a not–too–done look the

owners are after. ❡ California is young. Sir Francis Drake dubbed the coast New Albion when he claimed it

for England in 1579. Spaniards soon followed, but it wasn't until 1841 that the first organized group of

American settlers came by land. The state is still inventing itself. Mission meets Modern, rustic roughs up

glamour, and spontaneity rules. Ideas, styles, and traditions never have time to calcify. ❡ A country house

can be anything the owner dreams. In Big Sur or St. Helena, in Mendocino, Laurel Canyon, Berkeley,

Lake Tahoe, or Russian Hill—fresh ideas breeze in through open windows. The best interior designers leave

their egos at the door and create cross–cultural rooms that are friendly and pull–up–a–chair easy. They

find their inspiration in beautiful old furniture that breathes life and character into apartments and houses.

Past and present converge and life blooms. That's California Country. Come and explore with us.

...DIANE DORRANS SAEKS

Previous page: Hollywood costume designer Theadora Van Runkle's Laurel Canyon retreat. Van Runkle loves to bring in old–fashioned cottage flowers from her cutting garden. *Opposite:* Barbara Colvin Hoopes' inspired metal mix. Casa Blanca lilies, grapes, and daisies say Napa Valley. Decorative flowerpots on the mantle by Eric Cogswell.

Wine Country

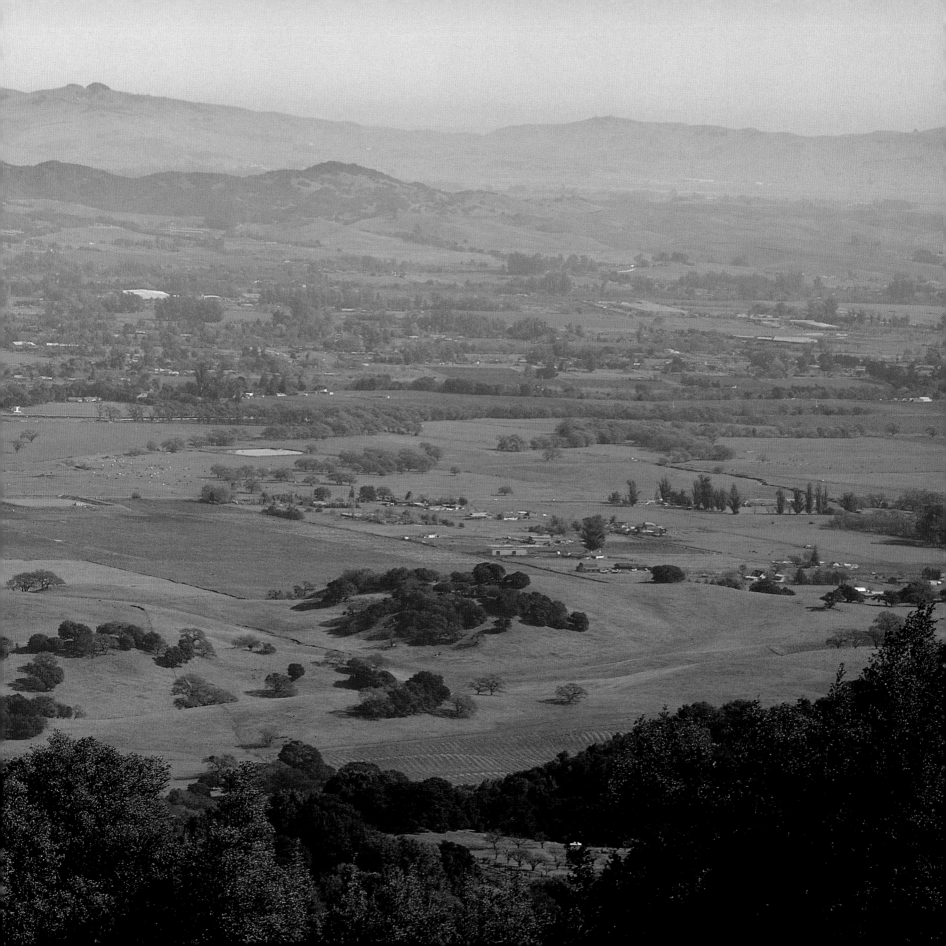

L ate in Napa Valley summer evenings, warm air shimmers as the sun slides from a pale western sky. Dark green ridges and rocky outcrops sheltering the vine–striped flatlands turn pink, then gray and inky blue, and begin to lose their definition. As the last bright light pirouettes across the hilltops, the golden valley falls silent. A fragrance of rich earth and ripening grapes and ancient trees fills the air. ¶ Drive up Highway 29 through the Napa Valley, or north from Sonoma to Glen Ellen or Healdsburg in spring, and the bare vines sprout vivid green leaves. Chrome–yellow mustard flowers carpet the fields. As the weather warms, the graceful vines flourish green leaves that later flush to rich, rusty red. Winter can be a rather moody place of leaden skies, black sculptural vines, and glowering clouds. To everything there is a reason, and this is a time of rest and revival. The slow progression of the seasons brings a sense of well–being. ¶ Wine–growing districts are scattered throughout California. Fields of vines curve around the prime Carneros region to the north of San Pablo Bay, encircle small–town St. Helena, climb the highlands above Lake Hennessey, and robe the Alexander Valley. Every day, it seems, acres of young vines are planted on the flat land near Sonoma and Sebastapol. Vineyards flourish in the rich soil north of

Santa Barbara, the Central Valley, Monterey County, Riverside, and the Russian River, and struggle on chalky and volcanic soil near Calistoga and in the mountains behind Santa Cruz. ❡ Sparkling–wine maker John Scharffenberger lives in a plain–Jane Victorian in the Anderson Valley not far from his Philo winery. The legendary Robert Mondavi and his wife, Margrit Biever Mondavi, are king and queen of Wappo Hill. Now, too, they can see the temple–like architecture of the new Opus One winery, built in partnership with the Rothschilds. The Schreyers of San Francisco built their Modernist house as the perfect escape from the City. Barbara Colvin Hoopes and her family have a flower–filled house beside a quiet road north of Yountville. It's just an hour's drive from San Francisco, and the family arrives all year to take in the riches of the countryside. Barbara cooks vegetables from the garden. If they occasionally feel like dining out, they can drive to Auberge du Soleil, Table 29, Mustard's, Tra Vigne, or Terra, or stop in at the legendary Oakville Grocery for Acme Bread, Joseph Phelps wines, and a world of cheeses. And painter Carlo Marchiori repairs to Calistoga for his own version of a busman's holiday—he comes to paint everything in sight. ❡ For those who live surrounded by the ancient ritual of growing grapes, the wine country nourishes the heart and stirs the soul.

Previous pages: Chappellet Winery co–owner Molly Chappellet insists that the glamorous image of living in a vineyard is only partly true. "Wine making is an art," she said, "but it's also agriculture. Vineyard owners are at the mercy of the weather, just like every other farmer." Still, the wine countries of California offer forth a bountiful, blessed life.

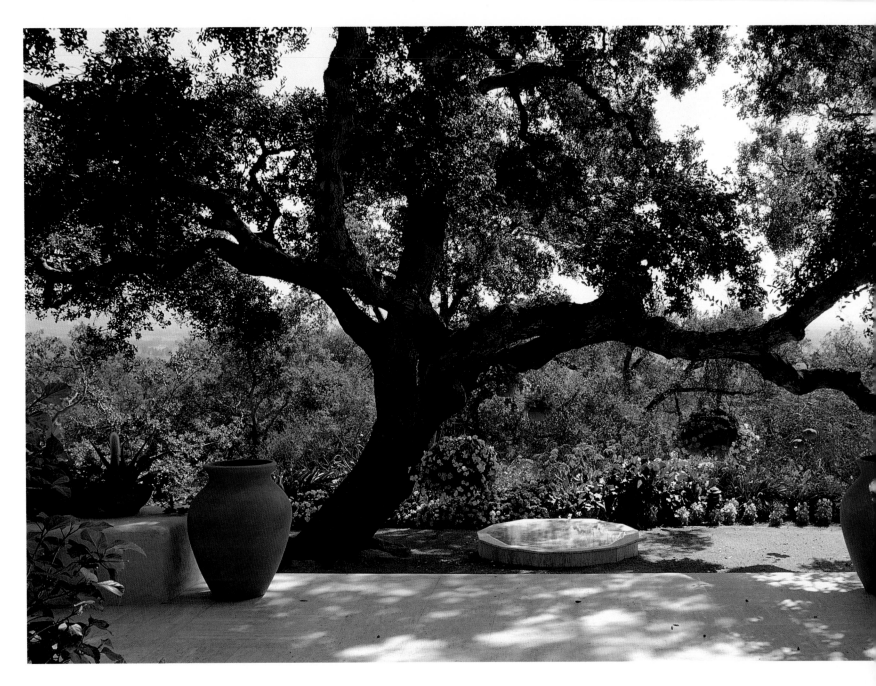

All through summer and some-
times as late as December,
the Mondavis roll their bed out
onto the terrace in the evening
and sleep under the old oaks.

An international welcome:
The bell was found in England,
the massive doors were built originally for an Umbrian monastery.

Los Angeles architect Cliff May designed the Robert Mondavi Winery in Oakville in 1966. The building is perhaps one of the best–known examples of the California Mission style. A drawing of the winery, with its noble bell tower and tile roof, has appeared on the label of every bottle of Mondavi wine produced there. In 1979, Robert Mondavi and his wife, Margrit, head of cultural affairs for the winery, asked Cliff May to design a house for them on the crest of a 650–foot hill overlooking the Napa Valley and the Mondavi vineyards. ¶ "We loved his style. He was also a great friend, so we asked him to design our house," recalled Margrit. May eventually said it was the best house he had built. ¶ Nine years later, the house and its considerable estate were completed. The Mondavis named their domain Wappo Hill after a tribe that inhabited the valley until the middle of the nineteenth century. One day, out picking wildflowers, Margrit found a Wappo stone bowl, and there is evidence to suggest that their hilltop was used for tribal ceremonies and as a lookout. ¶ Guests driving up the winding road to the house now see tennis courts, a barbecue arbor, and a flourishing fruit orchard. Unseen on the other side of the hill are solar panels that provide energy for the

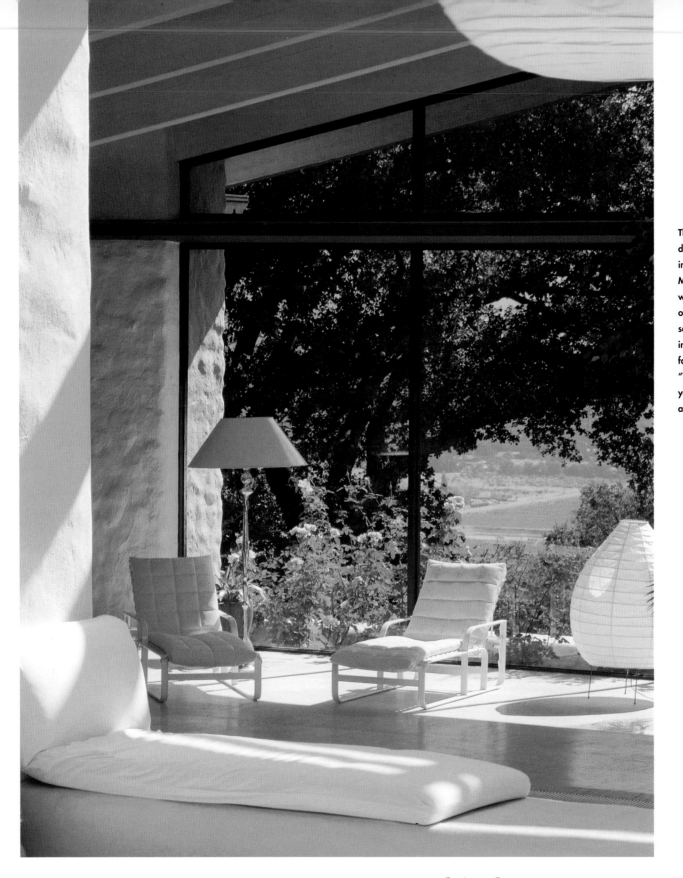

The house coolly blurs the distinction between outdoors and indoors. From the terrace, the Mondavis and their guests can watch over more than 400 acres of pinot noir, chardonnay, and sauvignon blanc grapes basking in the sun. "Early spring is my favorite season," said Margrit. "The mustard flowers are vivid yellow, and the hills and valley are brilliant green."

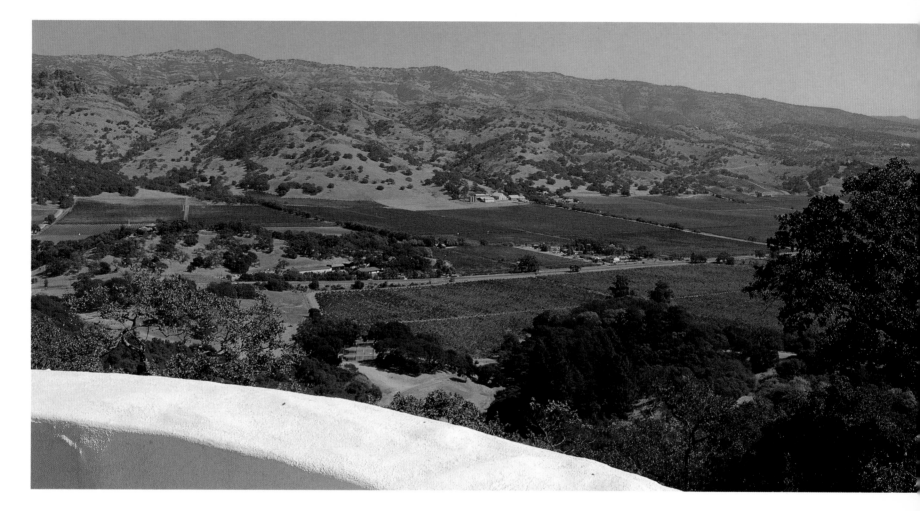

From the tower, the view takes
in the historic Silverado Trail and
the valley's bountiful vineyards.

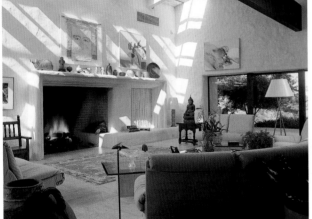

Every day, the Mondavis do forty laps in the solar–heated 20' x 45' pool. (Yes, two guests have had the misfortune to fall in.) The sky–lit house is full of light, art, and flowers. A second–century Roman bust stands on a plinth in the living room. Friends gather around the fireplace on cool Napa evenings and crisp winter days.

house most of the year and help to heat the indoor pool and spa. ❡ "The house exudes warmth and serenity, even though it is on such a grand scale," said Margrit Biever, who admitted that at first she found the cool stucco–walled rooms rather intimidating. The vast, sky–lit center of the house is the multi–level beamed living room with a large travertine–edged swimming pool as a focus. Overhead, panels in the roof can be electronically controlled to open the roof to the sky. To give a sense of welcome, informal groups of wicker armchairs and canvas–upholstered sofas are set around the living room for family and guests. ❡ "From the beginning, we decided that the house should be minimally furnished," said Margrit. "We used natural fabrics like linen, cotton duck, silk, and pale pigskin with no pattern." ❡ The dining table seats just eight. More often, the Mondavis entertain outdoors on terraces shaded by ancient oaks, or in their landscaped gardens. Margrit is an accomplished cook. She loves to prepare picnics and dinners for friends. And before dinner, guests can count on Robert Mondavi to pay a visit to his private wine cellar, with its French wine racks, antique Spanish doors, and great Mondavi and Opus 1 vintages.

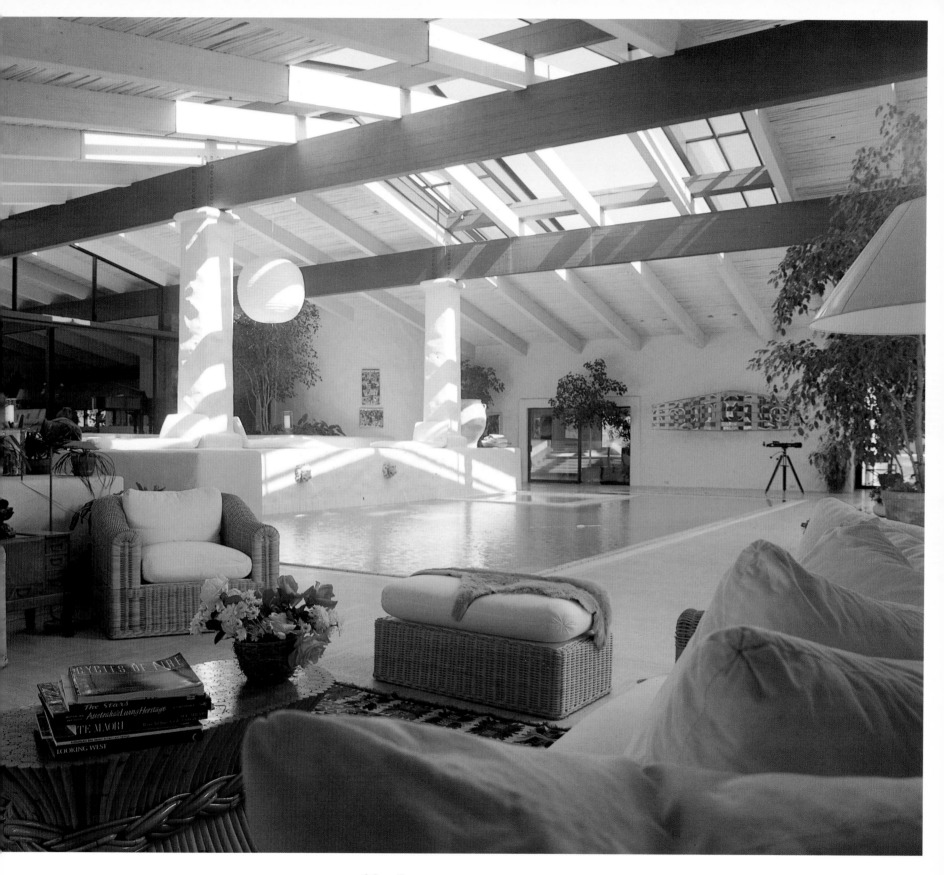

Yountville
BARBARA COLVIN HOOPES AND SPENCER HOOPES HOUSE

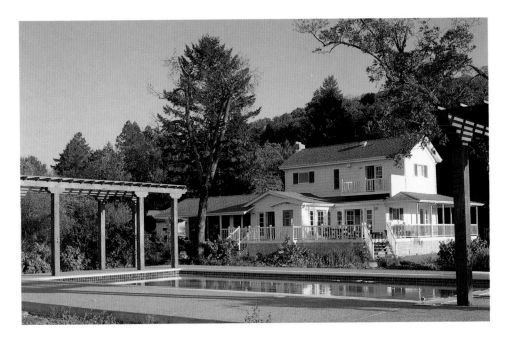

The Hoopes' Yountville house,
above and *opposite*, was
an 1880 farmhouse gone to seed
when they found it. The couple
gave their house the Cinderella
treatment with a handsome veran-
dah, new decks, new windows,
a new kitchen, and a completely
renovated interior.

On Saturdays year–round, San Francisco fashion designer Barbara Colvin Hoopes and her husband, Spencer, an executive, telephone their friends, dash to the market, then head north for their Yountville house to start cooking. ❡ "I get so much pleasure out of enter-taining that it's worth the extra effort," said Barbara, who bases her menus on whatever is best at the market (and in their garden and orchard) that morning. Traditional, hearty dishes that don't require split–second timing are her forte and her friends' favorites. Getting her daughter, Lindsay, and her girlfriends involved in dinner preparation is one way Barbara Hoopes makes the day fun, not drudgery. Lindsay and her chums go out into the garden with Barbara to discover what has ripened since they last harvested. It may be Granny Smith apples, persimmons, orange and white pumpkins, fennel, intensely flavored Sweet 100 tomatoes, arti-chokes, kale, pomegranates, or late sunflowers still standing among the overgrown zucchini. Some of their finds are used for table and mantel decora-tions; others go into the cooking pot. ❡ Like many city dwellers who've purchased land in the Napa Valley, Barbara and Spencer enjoy their weekend house summer and winter, rain or no rain.

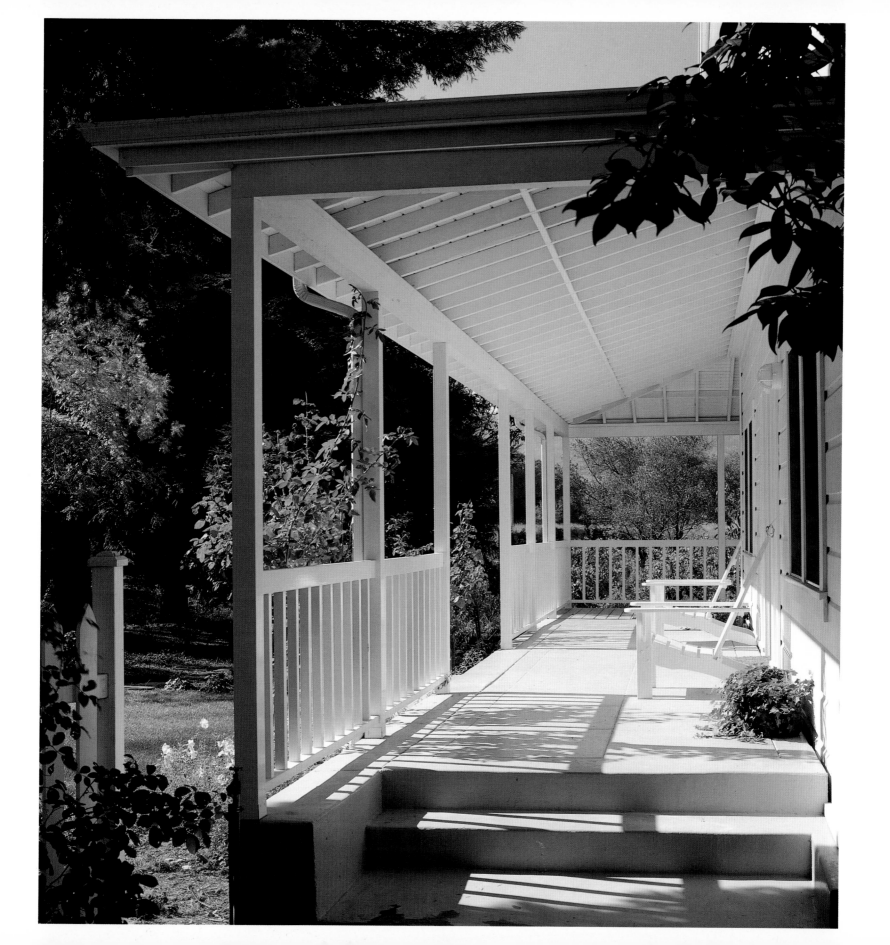

Above: Barbara arranges flowers throughout the house—even in the kitchen. A newly crafted stairway leads to bedrooms upstairs.

Summers, the family spends long days tending the vegetable and flower gardens. The orchard and grape vines get their share of attention and produce bumper crops of grapes and apples. Chores done, the family explores nearby antique shops. ¶ Friends arrive in the late morning, and summer lunch is always alfresco under the wisteria arbors that shelter the new pool. Lazy conversation, occasional splashes, and the rustle of book pages turning are the only sounds. ¶ Life at the house wasn't always so idyllic. Three years ago, the two–career couple decided to forgo travel to distant resorts and find a spot nearby where they could relax and entertain on weekends. Barbara decided to search the Napa and Sonoma valleys for the perfect weekend house. When they first saw this house, they loved the quiet location, but the building was frankly a dog. No one seemed to want it, re-called Barbara. Little wonder. Rooms were dark and poky, the verandah was shady and faced the road, and kitchens and bathrooms were dated and dingy. The 110–year–old house was showing its age. ¶ "With the impatience of a new homeowner, I was very anxious to move in. I knew exactly how I wanted all the rooms to look, so I ordered all the dishes, hardware, linens, and furniture in two days the minute we closed."

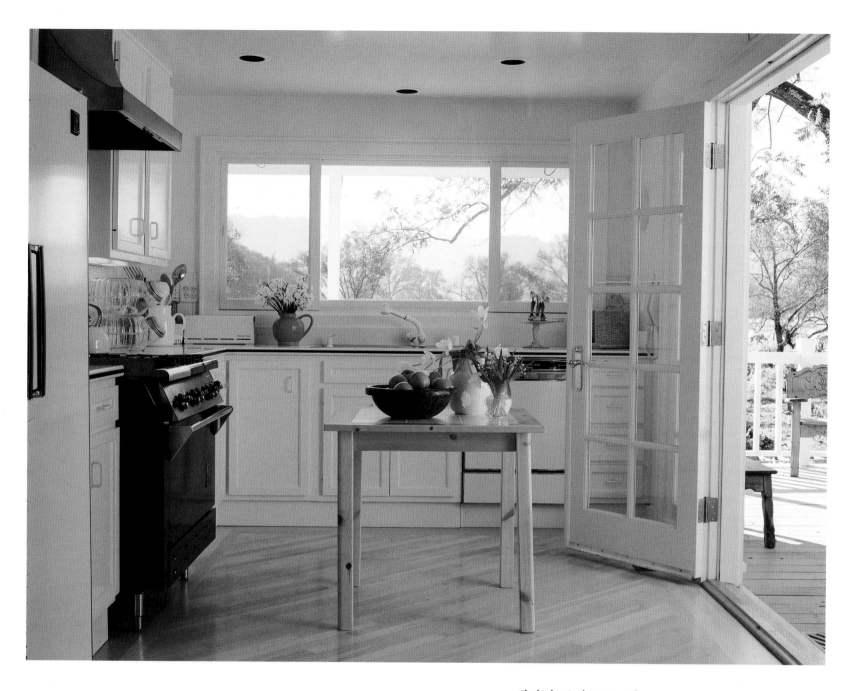

The kitchen is almost an outdoor room. In summer the doors stay open so that the family can dash in, find cold drinks and treats, then wander, refreshed, back to the garden or pool. Surfaces are all very easy maintenance—the idea is not to spend the weekend cleaning up.

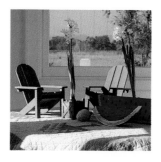

A happy new homeowner, Barbara didn't anticipate that they would run into major foundation problems. They also had to dig a new well and repair the chimney. Construction delays stopped the project in its tracks for nearly a year. Still, after long months on hold Barbara and Spencer kept up their enthusiasm. ¶ "The things we bought in that first frenzy looked right from the beginning. Rooms look exactly as I had envisioned them, with sunshine streaming in the windows all day, and the relaxed mood that makes you stop and enjoy the beauty of the Napa Valley,"said Barbara. The new kitchen—with a restaurant stove, well-stocked cupboards, Italian faucets, generous counters—is the true heart of the house. Summer days, the French doors stay open and the deck and garden become an extension of the room. Around lunchtime, a table is set up front and center, with all the makings for splendid sandwiches and salads, along with cold drinks and sweet treats. ¶ Friends who visit for the first time think that the house is brand new. "I suppose in a way it is new," marveled Barbara. "It certainly doesn't look anything like it did when we first saw it.... Now I think we'll just relax and enjoy the fruits of our labors."

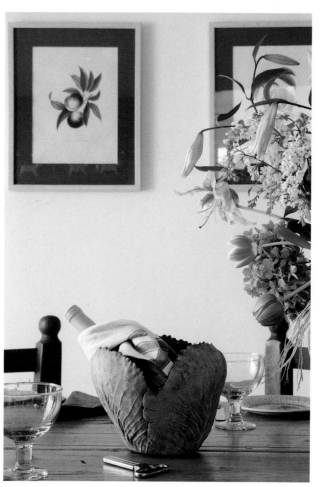

A massive old pine dining table, *opposite*, here topped with spring blooms, was one of the first treasures Barbara Colvin Hoopes found for her renovated country house. For winter dinners, Barbara creates centerpieces using late-season bounty from the garden: pumpkins, apples, pomegranates, Osage oranges, sunflowers.

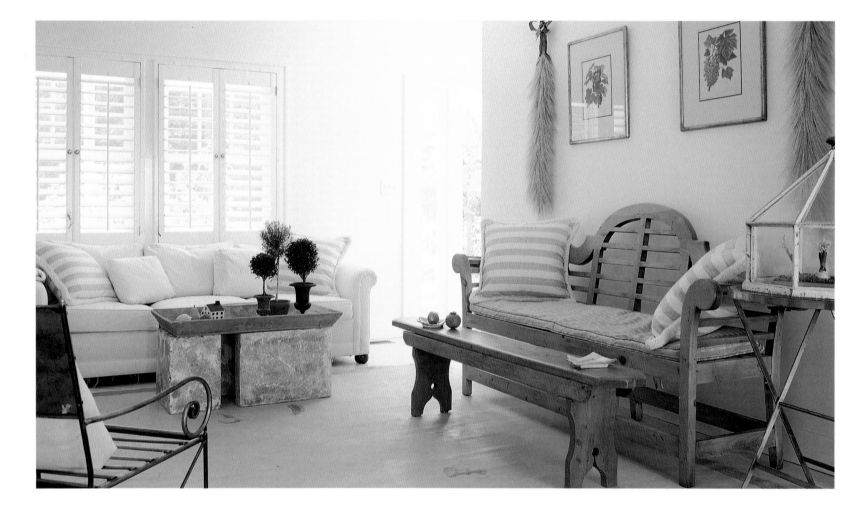

Her color scheme throughout is
pale, inviting, and fresh,
with clotted–cream–colored walls,
diagonally laid bleached
floors, and accents of cool white,
spruce green, and verdigris.

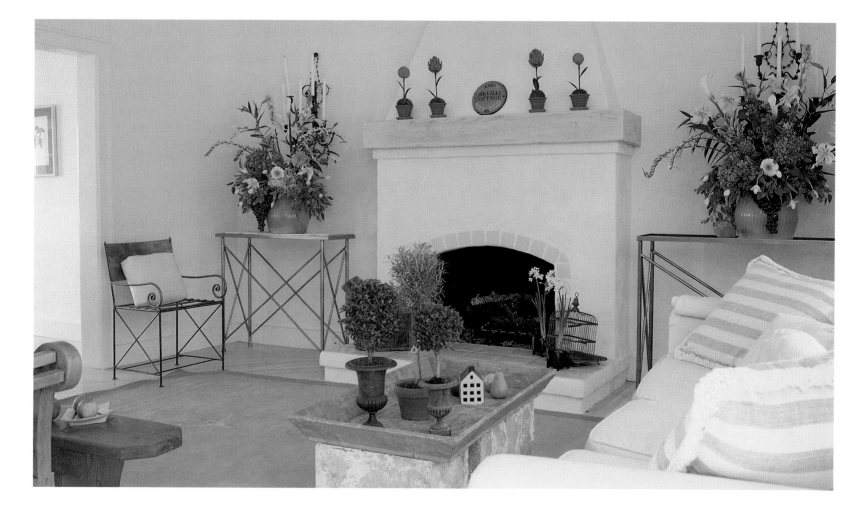

No country–cute cliches here,
just pressed white linens, bountiful
flowers, oversized chairs and
sofas covered in unbleached
canvas, and decorative painted
canvas "rugs." Children in wet
swimsuits can run around.

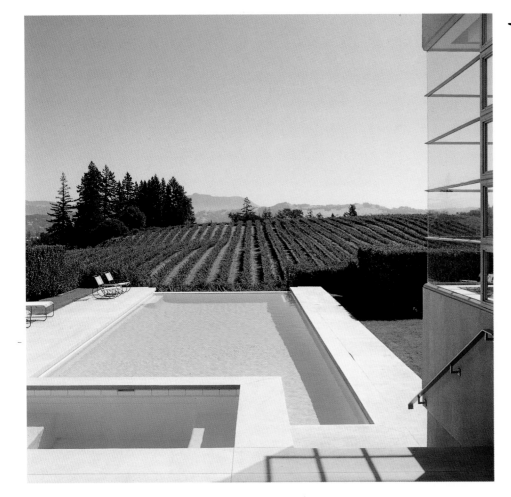

The crisp lines of the Schreyers' pool, *above,* are as pared–down and elegant as the house. Mitered glass corners make the windows almost invisible. *Opposite:* Rows of poplars and olives and lichen–encrusted old oaks surround the house and enliven the setting.

Victorian houses, shady verandahs, hearty redwood barns, and simple adobe or timber farm structures were the true architectural originals of California's wine–growing regions. Today, however, new property owners look further afield than the vernacular for their inspiration. Rolling hills shaded with madrones and oaks, long golden summers, and flourishing vineyards in Napa and Sonoma counties stir memories of Provence and Tuscany. And many a St. Helena, Carneros, Monterey County, or Alexander Valley house stands witness to its Umbrian or Florentine fore-bear. ❡ Bond portfolio manager Gary Schreyer and his wife, Chara, happen to be passionate and knowledgeable about Modernist architecture and the Bauhaus aesthetic. It was natural for them to see a clean–lined Modernist house on their expansive Healdsburg land. The couple asked San Francisco architects Jim Jennings and Bill Stout to design a house that was unapologetically modern yet in harmony with the land. ❡ "Modernist archi-tecture and its paradigm have a logical relationship to the geometry of the hilltop site and the vine-yards. The alignment of the house is perpendicular to the rows of vines," said Jennings.

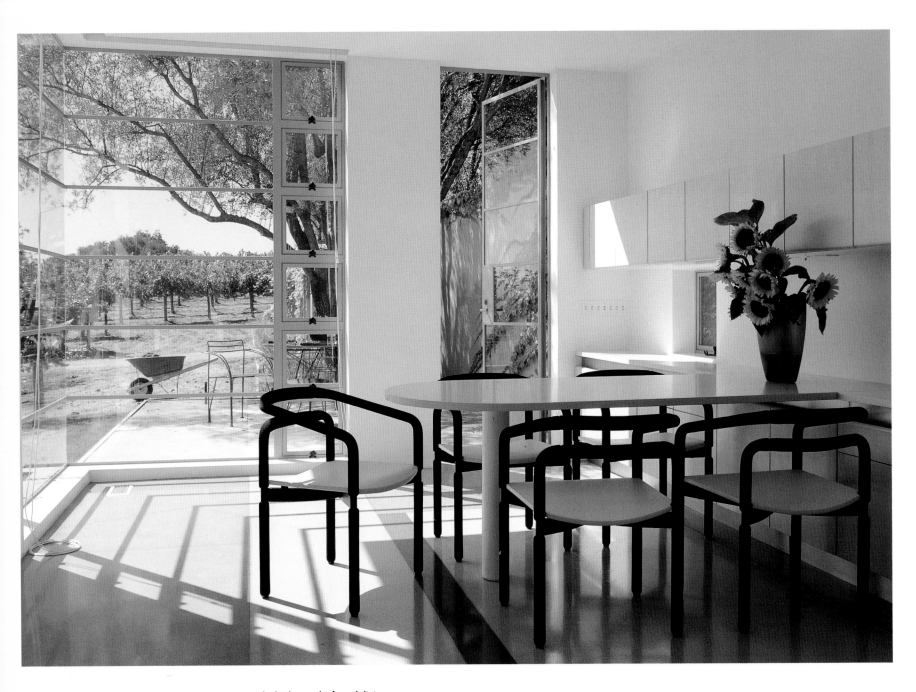

The kitchen and informal dining room, with classic "Rubber" chairs by San Francisco designer Brian Kane, focus on the hills and life outdoors. The climate at Dry Creek is hot and parched in the summer, sunny and fresh in the winter.

In composition, the house takes its ideas from the Bauhaus and from the works of Russian constructivist Kasimir Malevich. In the use of interior and exterior walls as defining planar elements, Jennings was also inspired by the architecture of Mies van der Rohe. San Francisco designer Gary Hutton worked on the interiors with the architects even before ground was broken. Their goal was to provide beautifully detailed rooms, pleasing surfaces. ❧ "The house is about architecture, not decorating," said Hutton. Still, all choices had to be correct because there would be no ruffle or flourish to cover up a mistake. Colors for the interior and exterior were developed by colorist James Goodman to integrate the building with the site. Working in an almost mystical way, Goodman collected rocks, stones, twigs, minerals, and soil from the land to conjure up the textures, tones, and composition of the wall finish. The finished color is a silvery green–gray, which seems to glow golden in the late afternoon sun and changes subtly with the light and the season. ❧ "Today, the house is at once very dynamic and transparent. The owners appreciate it and use it well. When I visit, I sense that this house is life–filled," Jennings said.

The attenuated house is basically one room deep, aligned along a central axis. Windows overlook 40 acres of chardonnay grapevines.

A "Mondrian," as seen through the eyes of a young art student, hangs over the fireplace. Andirons were designed by Gary Hutton. Chairs are slipcovered in violet leather. To emphasize the horizon, to expand the views and give a visual reference, the architects designed the window mullions in fine horizontal edge–to–edge steel. Glass is mitred in the corners. Working window mullions are in heavier steel.

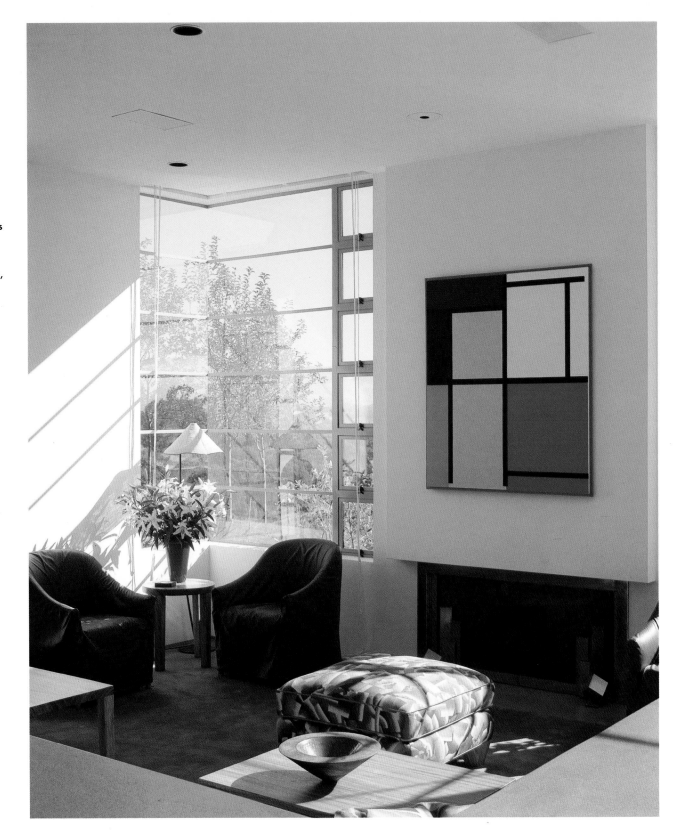

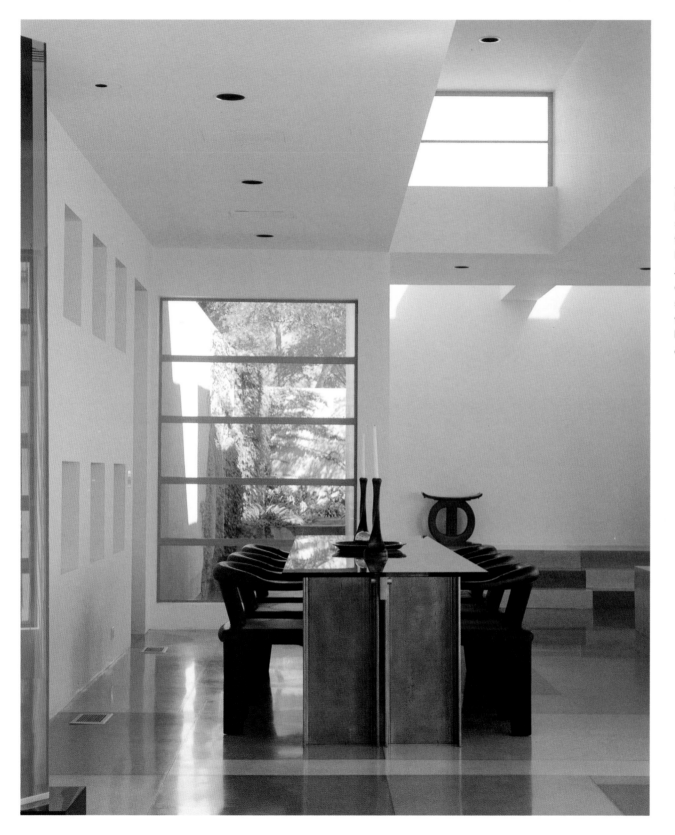

The entry foyer and dining room have floors of poured-in-place silica terrazzo. Hutton designed the floor after paintings of Wassily Kandinsky. San Francisco colorist James Goodman developed its colors from the site's mineral samples. The steel and glass table was designed by Jim Jennings. Fat black leather Scarpa "Veronica" chairs are like pieces of sculpture.

Calistoga
CARLO MARCHIORI VILLA

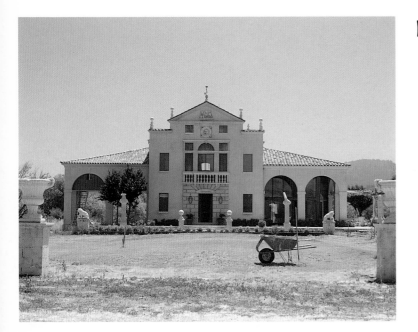

It's hard to tell what's real and what's fake at Ca' Toga, set in five acres just north of Calistoga. Marchiori's admiration for Palladio's Villa Barbaro (1557–1558) is clear. Even on this scale, he's managed a similar pediment and facade, the echo of a colonnade. Extraordinarily detailed double-height frescoes, *opposite*, were all painted first on canvas.

The tiny spa town of Calistoga is an unlikely setting for a Palladian–style villa, complete with superb homage–to–Veronese frescoes, not to mention barn swallow nests in the rafters. Modest ranch houses and sweet Victorian cottages are *de rigueur* here. But then, master muralist Carlo Marchiori, the creator of Ca' Toga, has never been intrigued by the expected. ¶ "I decided to build my villa here because I like the setting in the middle of the valley. I have 360–degree views with the Palisades to the east and Mt. St. Helena to the north," said Marchiori, who lives in San Francisco and makes his living as an artist–for–hire painting fine murals for hotels in Singapore, casinos in Atlantic City and Las Vegas, and restaurants in San Francisco. The artist grew up in the town of Bassano del Grappa, north of Venice, and along the Brenta River. There he was surrounded by Palladian villas. He rode his bicycle across a Palladian bridge. And he studied traditional decorative painting à la Veronese for three years at a Padova art school. ¶ In 1986, Marchiori hired then–fledgling architects Lucy Schlaffer and Paul Bonacci to design a simple barn onto and into which he could graft the exterior and interior of his dreams. ¶ "I wanted to do the essential, basic

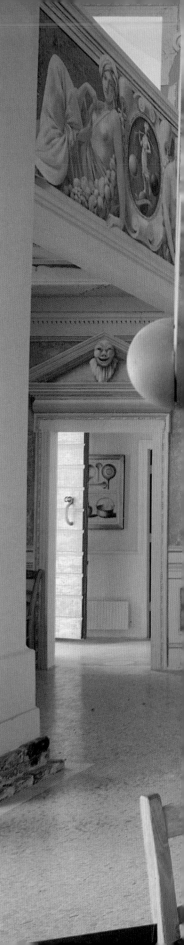

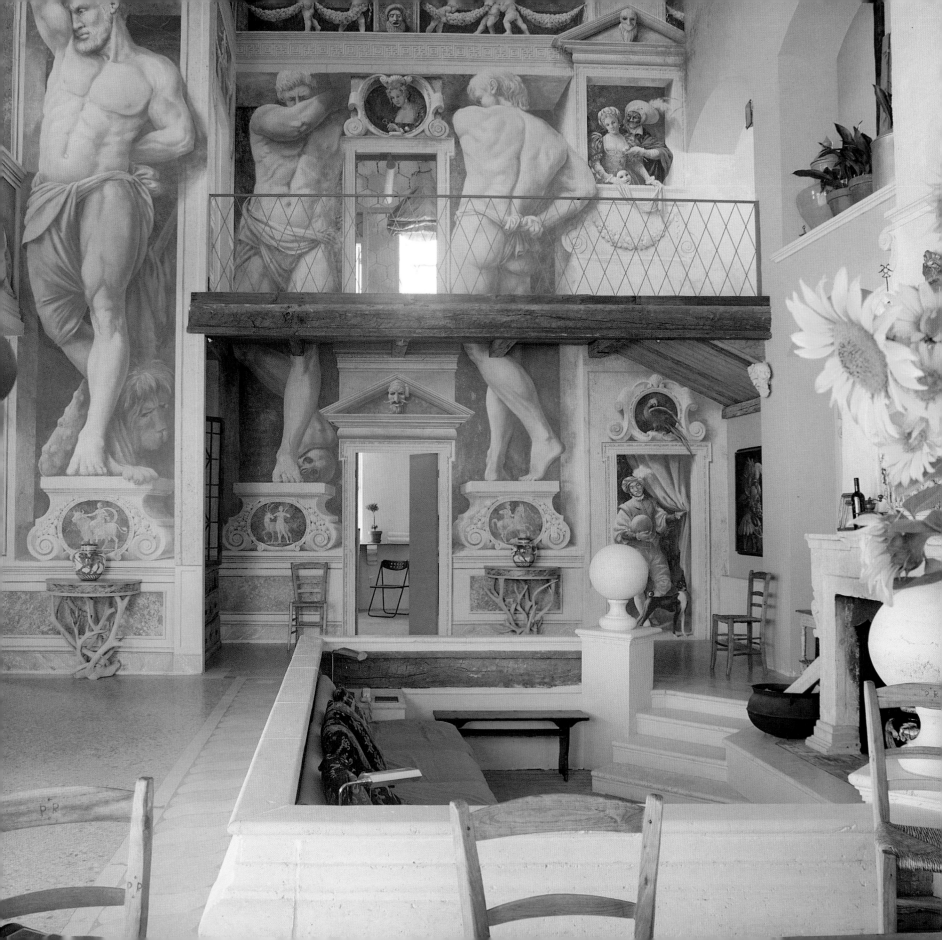

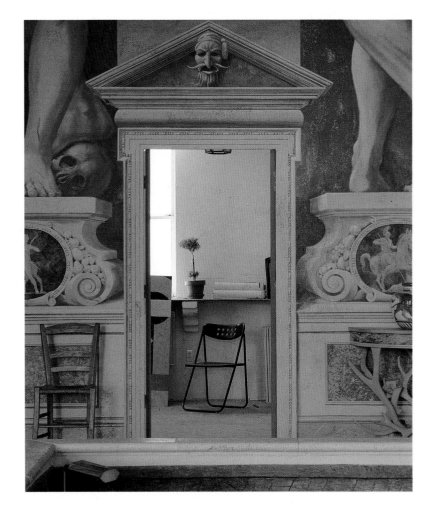

Marchiori amuses himself
by trying out different painting
techniques on his doors. Some
have *faux* rustication, another
is painted in Pompeian style,
yet another has the look of
pietra dura. (That door hides
the washing machine.)

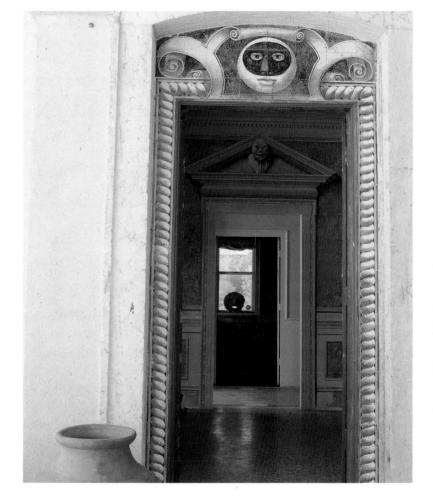

One door seems surrounded by *faux* tiles—or are they? Exterior or interior, Marchiori leaves no surface untouched.

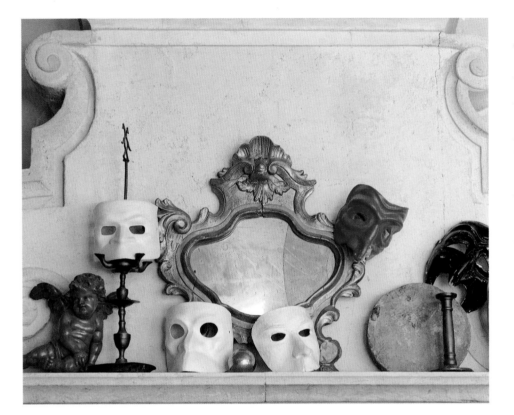

On the cast–stone mantel, a Venetian mirror, *putti*, and masks. Like supernumeraries in this long–playing opera, figures inspired by *commedia dell'arte* make walk–on appearances all over the house. Several of Marchiori's friends appear in frescoes—just as Marcantonio Barbaro's wife and friends were captured on the Villa Barbaro's walls by Veronese.

Palladian villa but I couldn't afford masonry. The house is all built of steel, concrete blocks, and wood, including scavenged barn wood," said Marchiori. "I wanted the house to look like a grand Treviso villa from Palladio's time that had become deserted. After centuries of decay, some farmers have taken it over. Animals lived there... then a decorator comes along," Marchiori joked. "I didn't want the house to be formal. That wouldn't be any fun," he said. ¶ His pastiche is particularly captivating in the living room. There, terrazzo floors (some real, some painted) are set on what he describes as "a wooden horror." Deer antlers support *demi–lune* tables; rough–hewn redwood beams hold up a balcony. ¶ "I paint on canvas using house paint. It will last longer than the dinosaurs," Marchiori said. His secret, however, is that he chooses only traditional natural pigment colors like ochre, red oxide, raw sienna, and indigo, and never stark black or pure white. Marchiori spatter–paints "Verona marble" wall insets and "marble" baseboards. Every door frame, column, pediment, wall, and balcony has felt the brush of his inspiration. "If you had a real villa, you would have a retainer to dust and clean the silver. I prefer things to look ruined and chipped," he said.

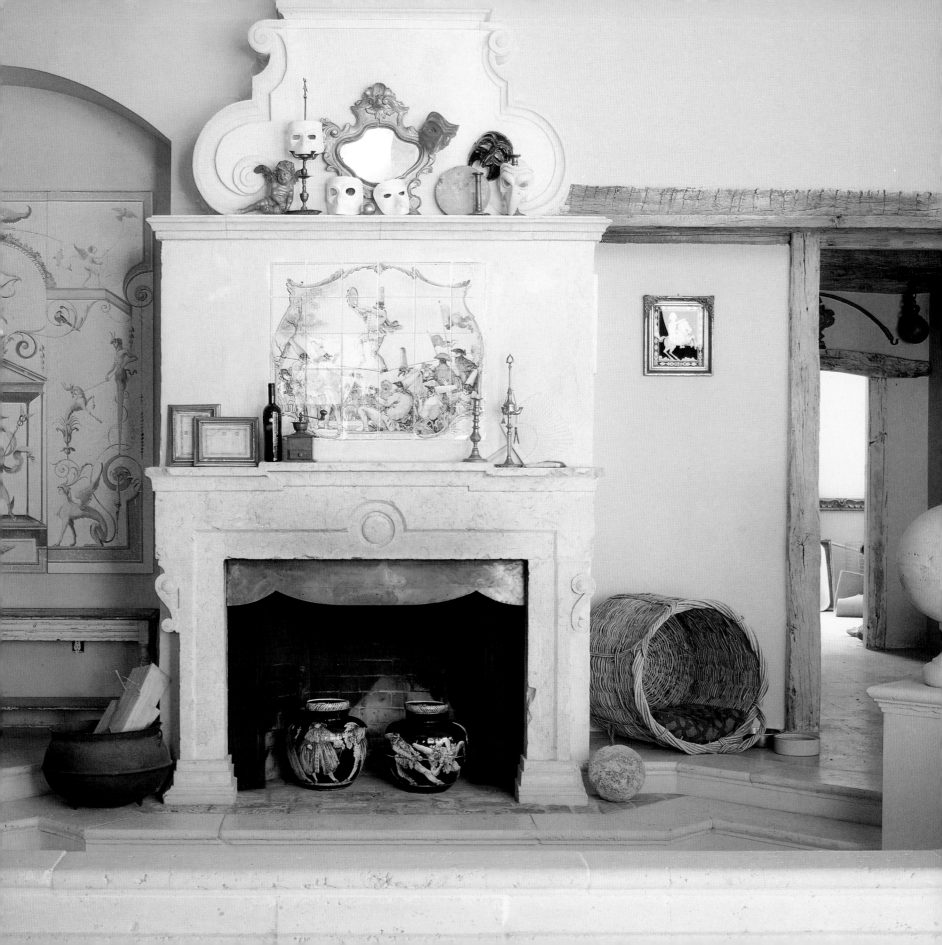

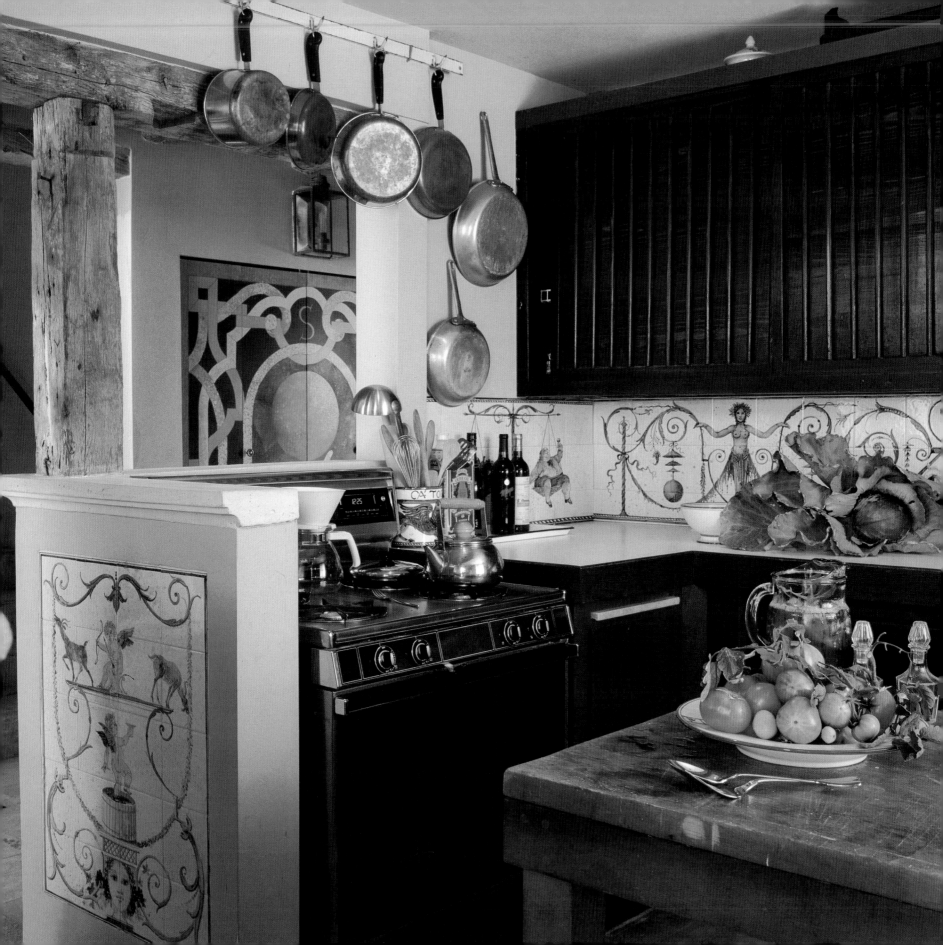

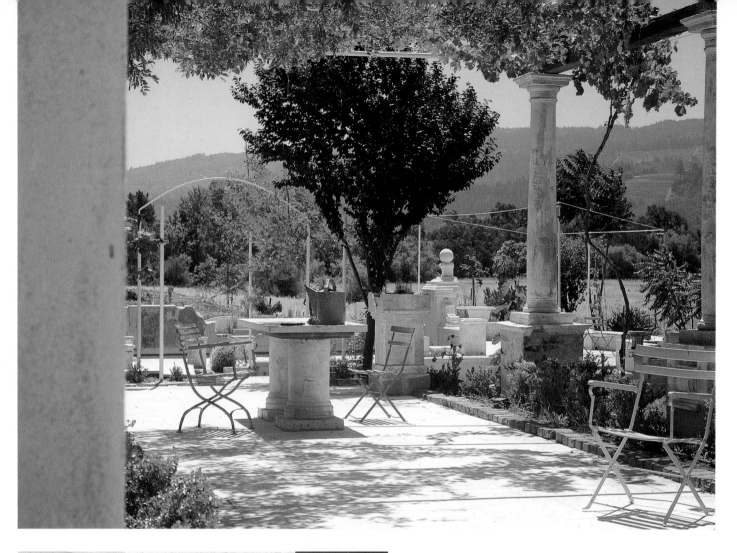

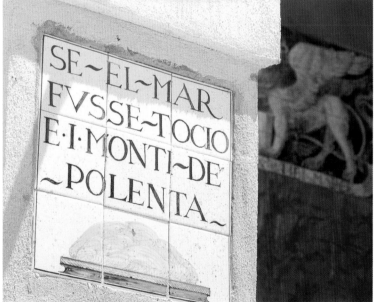

Even the kitchen has paint for days, and Marchiori has years' more techniques and tricks up his sleeve. The artist paints on winter weekends and in the summer cultivates tomatoes and squash and grapes. Marchiori's motto, *left*, from a Venetian folksong: "Se el mar fusse tocio e i monti de polenta." (If only the ocean were gravy and the mountains polenta.)

Napa Valley
A HILLTOP HOUSE BY ARCHITECT ROSS ANDERSON

The hills that rise from the Napa Valley would seem to be among the most desirable sites on which to build a retreat. Like box seats at the opera, they afford the very best sight-lines for the valley below, far from the hoi polloi. Manzanitas and old native oaks offer shade. The dry sound of lizards slithering through gray oak leaves can be heard. Hawks hover, buoyed by thermals. ¶ New York architect Ross Anderson spent several years getting to know his parents' new property, hacking through the underbrush, cutting trees, and finally seeing it as a rough, rocky elemental place. The weekend retreat Anderson designed is "a Brownie camera aimed at the view," with oversized windows to take in the light and the valley below. It's a seemingly simple formula that's at once compact and grand. The center section, with walls of bleached plywood, is anchored by two concrete block cubes. The roof—its shape inspired by valley farm sheds—sits on top of the house like a giant sun hat to protect the house from the intense heat. ¶ The interior of the house was kept utterly simple so that family and friends can come and go without fuss. Stone–colored concrete block and plywood walls are exposed, the better to let the materials speak for themselves.

Ross Anderson took his color cues from the earth, so his parents' house seems to rise naturally from the rocky hillside. The swimming pool, built at an angle, seems to charge out into oblivion.

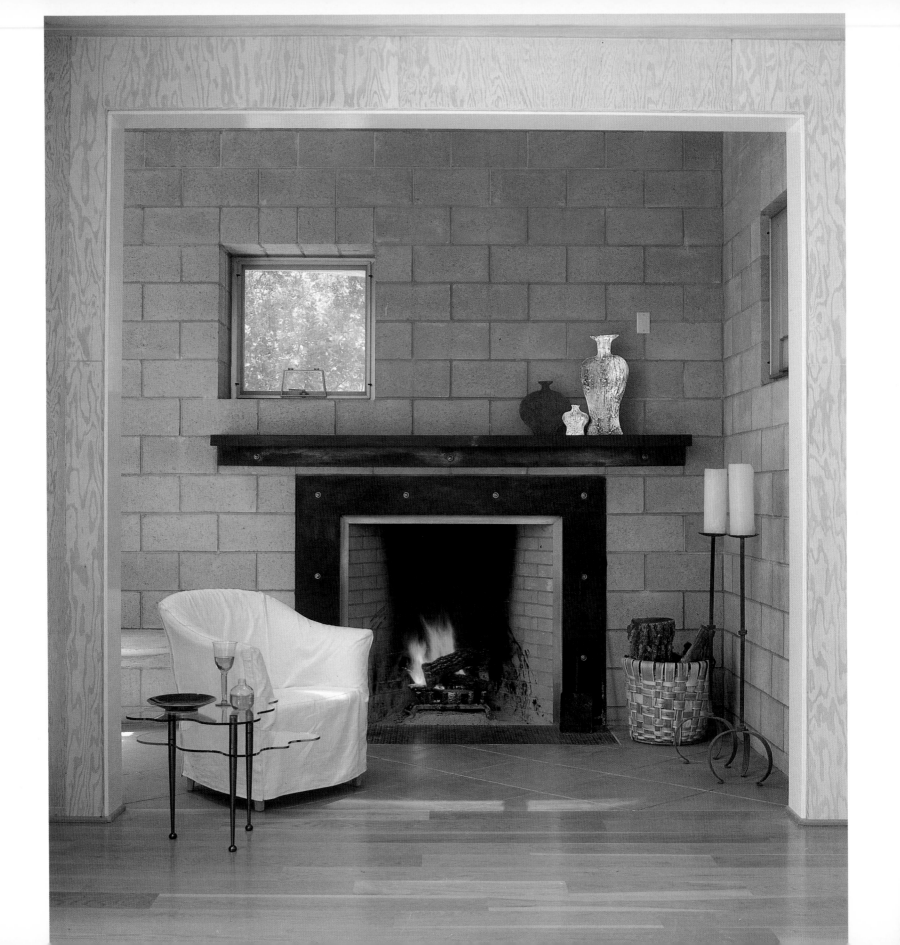

In a small "side chapel" off the living room, the Rumford fireplace is a functional square surrounded by bolted steel and crowned with a steel mantel. The three "Shadow" vases are by San Francisco designer Ron Mann. The Flexform Italian chairs covered in linen slipcovers and the glass "Cloud" table are from Postmark, San Francisco. Walls are bleached plywood. A simple bleached pine table by The Cottage Table Workshop, San Francisco, is surrounded by Italian chairs from Postmark.

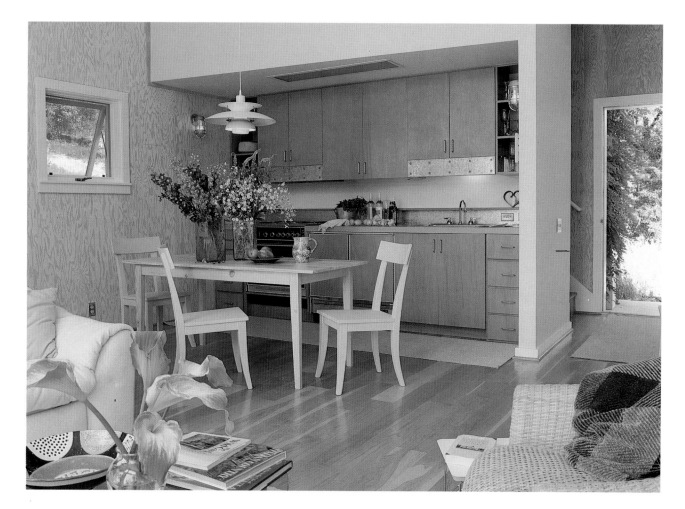

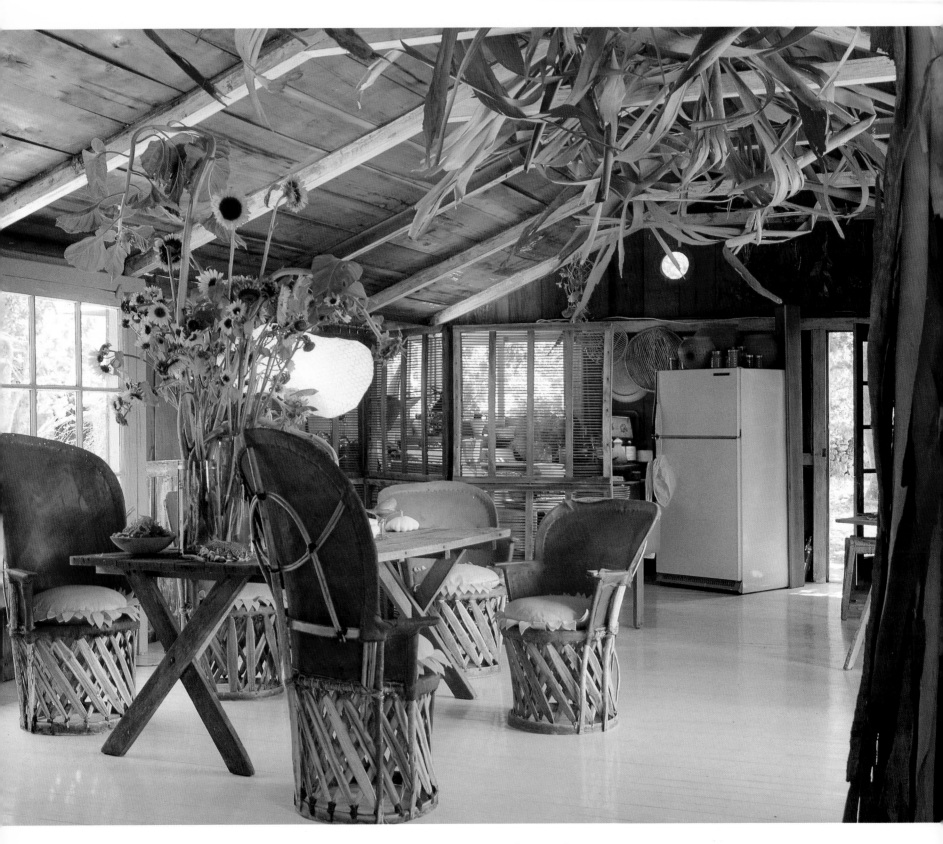

In quiet Lovall Valley, at the end of a winding road northeast of Sonoma, Ron Mann and Louise La Palme bring pizzazz to rustic weekends. Their cabin was designed simply to amuse themselves—not to be considered a serious showcase of design. Still, the rooms are filled with inspiration and great humor. ¶ Ron Mann has been highly regarded for more than 20 years as an original, energetic, and influential designer of interiors, furniture, and accessories. For Hollywood stars, Hong Kong entrepreneurs, Park Avenue sophisticates, and San Francisco families, he fashions innovative interiors that are published and emulated all over the world. This quintessential Californian designs rooms that are at once simple and very sophisticated. With materials like massive fir slabs, cast stone, steel, and natural canvas, he "sculpts" rooms of great beauty that never rely on color or pattern for their effect. On weekends, Mann and his wife, fabric designer Louise La Palme, retreat to their Sonoma property in the gentle curves of an extinct volcano crater. Among sculptural mounds of rock overgrown with statuesque old live oaks and bay laurels, the couple has devised the wittiest, most personal cabin. ¶ "We're at the end of a rural road here. The valley is completely private and still. There's

Equipales chairs, with golden sunflower seats made of felt by Louise La Palme, surround the 50–year–old trestle table, *opposite*. Impromptu room arrangements are made to please the eye and comfort the soul. Tabletops are crowded with flowers, favorite folk art, and fresh–picked vegetables. Hand–blown glass cylinder vases and pale–blue glass compotes were made to Mann's design in Tlaquepaque, Mexico. Mann has collected Mexican folk art for more than 30 years and has some remarkable examples, including these vivid painted clay creatures. *Below*: Sunflowers color a bucolic scene beside the old barn.

Mann discovered the ten–foot
high Mexican brass bed, *below*,
more than 30 years ago. Designed
around the turn of the century
for an army officer, it breaks down
and can be transported in a canvas
kit. Covering the duvet La Palme's
hand printed cotton. Her appliquéd
cloths dress the tables.

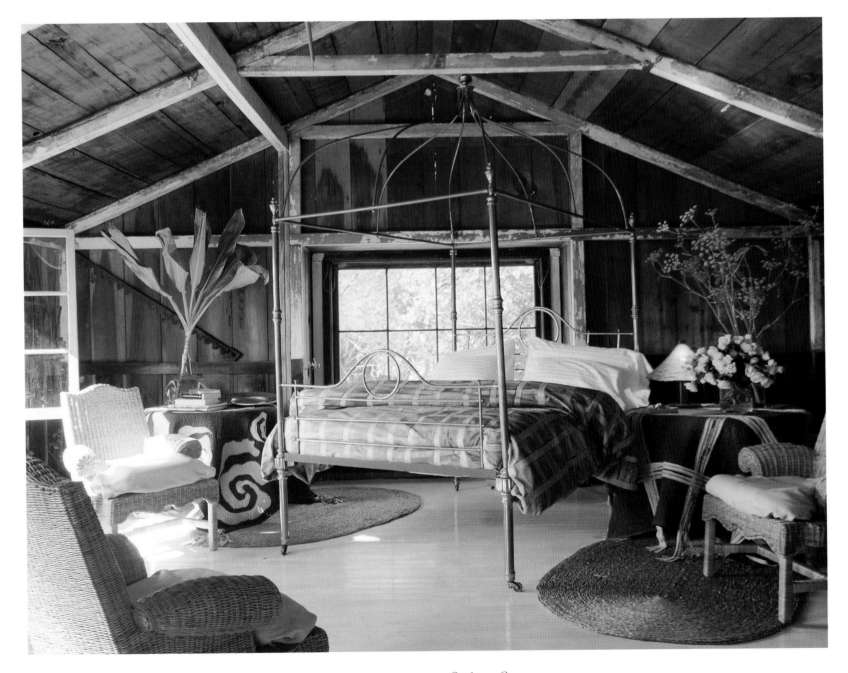

only the sound of trees. At night, you hear coyotes and croaking frogs out in the darkness," said Mann. ❡ The Lovall Valley cabin was originally built on its ten acres in 1907. For successive owners, the primitive structure had been renovated and "modernized" with little regard for its original integrity. When Mann and La Palme took possession on Thanksgiving Day, 1988, the house and barn, a vineyard, and an orchard had been abandoned for years. It felt like a ghost farm. They immediately began the long task of stripping the building back down to the redwood walls. They took pleasure in exposing the beams, restoring the gardens, and rescuing their trees. ❡ "We wanted the house to be lighthearted and a complete escape from city style," said Mann, who grew up on a farm in Missouri. "I go there now with no purpose but to be my own caretaker. I love the simple, basic chores like planting, sweeping, carrying water. We haul rocks, build terraces, chop wood. It's very Zen." Sophistication is far from their minds. They rise with the sun, eat salads and vegetables from the garden, welcome occasional guests, and take postprandial hikes over the hills. ❡ "On Monday mornings, we head back across the Golden Gate Bridge," Mann said. "We're nourished and recharged, ready to go back to designing."

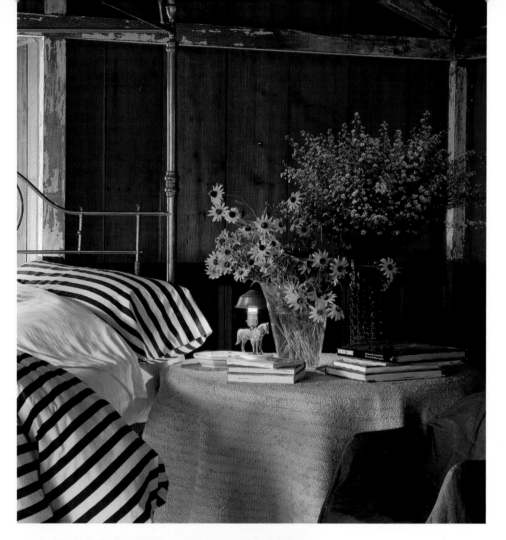

Window frames painted raw sienna stay open from sunup to sundown. Bed linens are vividly striped. It's a spontaneous, colorful setting for barefoot days. *Above:* Armloads of farm flowers fill forties Blenko vases on the raffia-topped table. The "Trigger" brass lamp was found among debris on the property. "Ribbons" of eucalyptus bark festoon the rafters.

Anderson Valley
JOHN SCHARFFENBERGER HOUSE

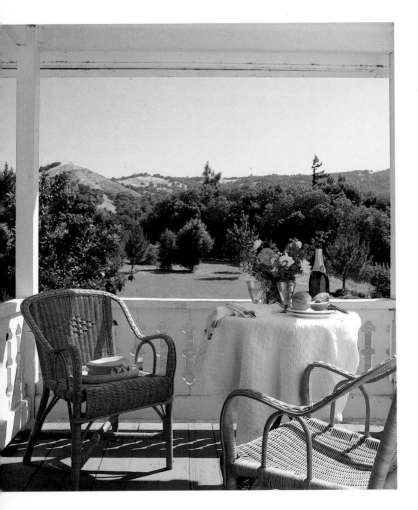

The great white house now holds pride of place in Scharffenberger's new garden. Suave beds of sun–loving Mediterranean and Irish flowers in lavender, white, pink, and blue surround the croquet–perfect lawn. Tina, the Great Dane, has the run of the property. From the upstairs balcony, guests see the sweep of Anderson Valley. Table accessories from Chez Mac.

Scharffenberger Cellars, founded in Philo, is recognized internationally as one of the leading producers of ultra–premium sparkling wine in North America. Just over a decade ago, at the age of 31, John Scharffenberger opened his namesake vineyard and winery with capital from the sale of a Ukiah property he had bought for a song. ¶ It was 1981, a great real estate market. Scharffenberger unexpectedly had the funds to pursue his dream to produce sparkling wine in the Anderson Valley in northern Mendocino County. He had studied biogeography and land use management at UC Berkeley, worked with master winemakers in the Napa Valley, and was now ready to follow his heart. ¶ Scharffenberger's long search for a house in the valley ended as soon as he saw the white–painted beauty perfectly sited at the confluence of Cemetery Creek and Anderson Creek. It had been solidly built in 1880 and carefully renovated over the years. ¶ "I was looking for a house that had some roots and character. I think of this as a plain–Jane Victorian with no gingerbread," said Scharffenberger. The original builder/owner was a craftsman who had joined the 1879 land rush to Northern California. Clear–heart redwood boards were used for the clean–lined exterior. Quirky

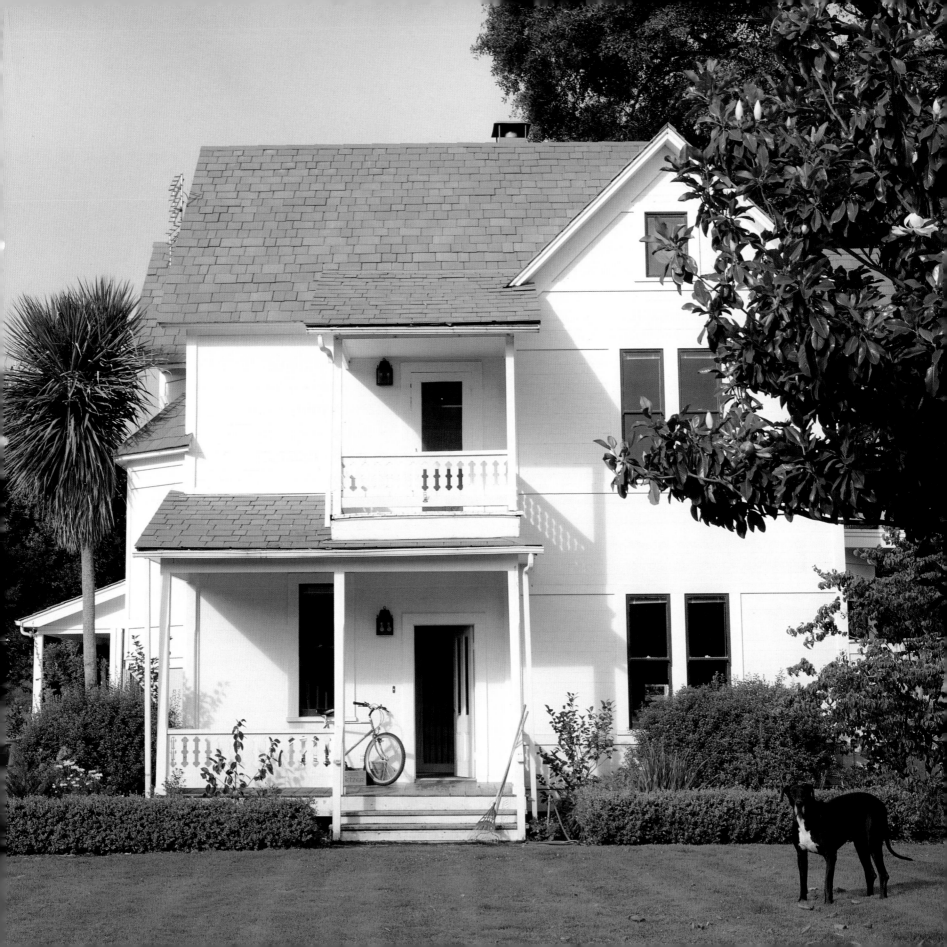

second–floor balconies for valley–viewing were his only flourish. ¶ In the six years since he first bought the house, John Scharffenberger has carefully made improvements. He carved an expansive living room/dining room from two dreary rooms, renovated the large farm–style kitchen, and painted walls a soothing creamy white. He has also been working on the garden and tending old fruit trees sheltered by live oaks, black oaks, bay trees, and madrones. ¶ "It's a very practical house for hot valley summers. All the heat goes up into the attic. On the coldest winter days, I have to huddle around the fireplace," admitted the down–to–earth Scharffenberger. ¶ The house and 22–acre property welcome friends from far and wide every weekend. There's even a quiet studio where poet and painter friends can escape from the madding crowd and work at their art for long solitary weeks. Weekends and evenings, Scharffenberger spends most of his time in the garden. And his business continues to expand. He's just planted 60 splendid acres of estate vineyard in Philo. Scharffenberger Cellars has opened a new winery designed by Sausalito architect Jacques Ullman, with interiors by Vicki Doubleday and Peter Gutkin. Scharffenberger is proving to be a fine steward of his land—and his house.

Scharffenberger and San Francisco designer Michael Moore worked with something–old–something–new to create character and comfort in the living room, *opposite*. Upholstered "Ruhlmann" sofa and striped chairs by Mike Furniture. Gilded candlesticks and gold finial lamp from Fillamento. Forged iron curtain rods were made by Boonville craftsman Steve Derwinsky. The oak dining table was created from two antique library tables. Scharffenberger found his century–old chairs in Colorado. Jewel candlesticks and Putto & Gargoyle teapot from Chez Mac, and candelabra from RH.

Healdsburg
A HOUSE IN THE RUSSIAN RIVER VALLEY

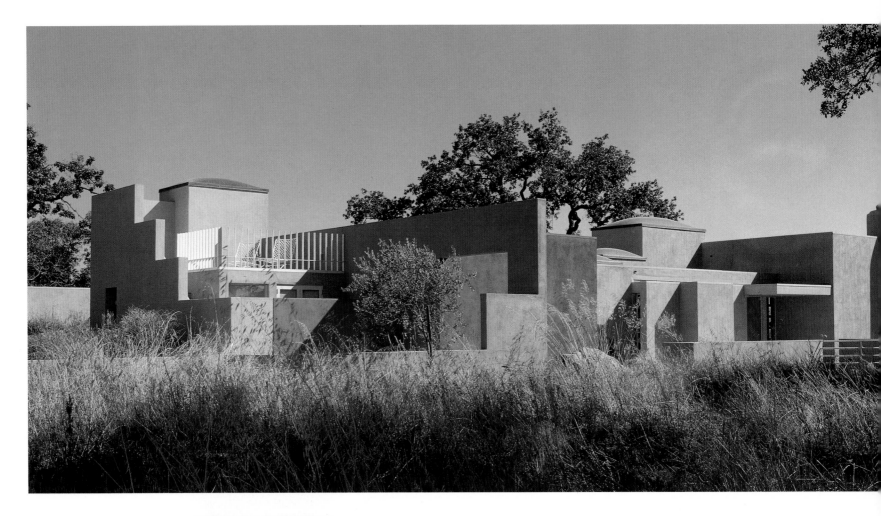

San Francisco colorist James Goodman designed the subtle play of custom colors for the exterior stucco. He collected stone shards, clay, and minerals from the site for inspiration.

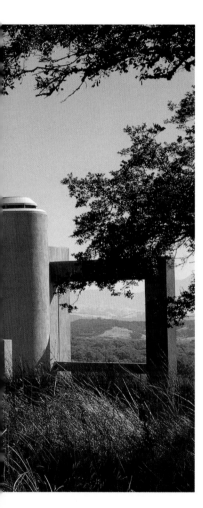

The California–Spanish hacienda tradition and powerful color–block geometries of Luis Barragan's architecture were the original inspiration for a house overlooking a 22–acre vineyard. As fine architecture should, the design picked up on the best of its role models, evolved, clarified, and finally became a two–level custom fit for the two fortunate owners. ❡ San Francisco architect Don Sandy, of Sandy & Babcock, devised a scheme that focuses with maximum impact on the extraordinary views in the front of the house. The living room and dining room face the valley, with its ever-changing rows of vines and the oak–patched hills beyond. As a complete change of pace, bedrooms are oriented toward a sheltered interior courtyard. The master bedroom and gallery open to a private court-yard with a Barragan–inspired poured–concrete fountain and reflecting pool. The rather crisp sculp-tural shapes of the exterior belie the easygoing mood of the rooms and day–to–day life within. In fact, said Sandy, the house has a very introspective spirit. The cellar, tucked into the hillside, is the perfect, cool place to store a growing wine collection—and, of course, the owners' own chardonnay. ❡ "Our Sonoma County house is a wonderful escape from the City, but we don't go there to do nothing.

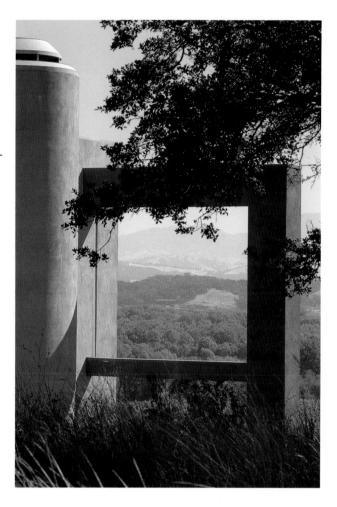

The wooden rectangle frames the view; it also holds a large barn door operated electronically to open or close the front windows, sheltering them from heat and cold. The cylindrical "tower" houses the living room fireplace.

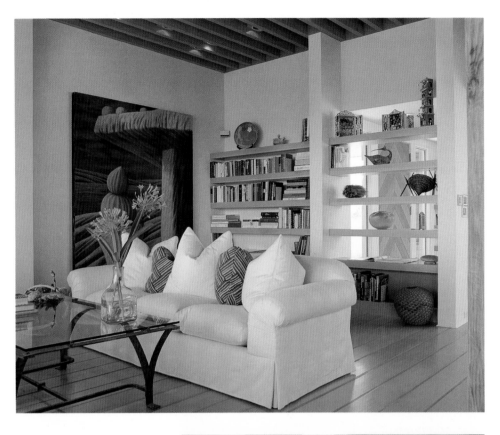

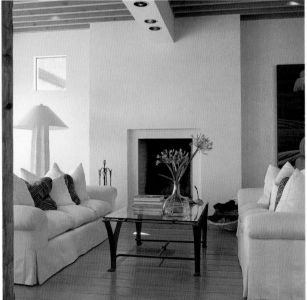

A painting by Healdsburg artist Wade Hoefer hangs behind the sofa. On open shelves are a collection of Indian baskets, pottery, Peruvian wood carvings, and art books. The iron–and–glass coffee table is from the Ginsberg Collection. Textured walls are painted pale ecru. The floor in the living room and dining room is a practical waxed Douglas fir with concrete grouting for texture.

We both enjoy gardening, playing tennis, painting, weaving, entertaining," said the vibrant owners of the very personal pueblo–style house on a knoll above the Russian River. Their mid–week residence is in Marin County, one hour to the south. ¶ They can also gaze out over their vineyards and watch the grapes ripen. In August or September, they're harvested, custom–crushed, and made into a fine, buttery chardonnay. One reason the couple—she's an interior designer, he runs a very successful art supply company—feel so relaxed is that they had the house designed as a home, not a weekend house. Eventually, they'll spend most of their time in the country. ¶ Perhaps best of all, the house works wonderfully year–round, report the owners. During the hot summer months, the house is open to the breezes. Friends come and go, to the pool or to the tennis court, or perhaps for a jaunt to the coast or to Healdsburg. Sometimes the owners will pack a picnic and walk down to their sandy beach on the banks of the Russian River. The daring may even take a dip. When the days turn cool or misty in December, the massive barn door rolls across the great expanse of glass overlooking the vineyard and the living room becomes a quiet refuge.

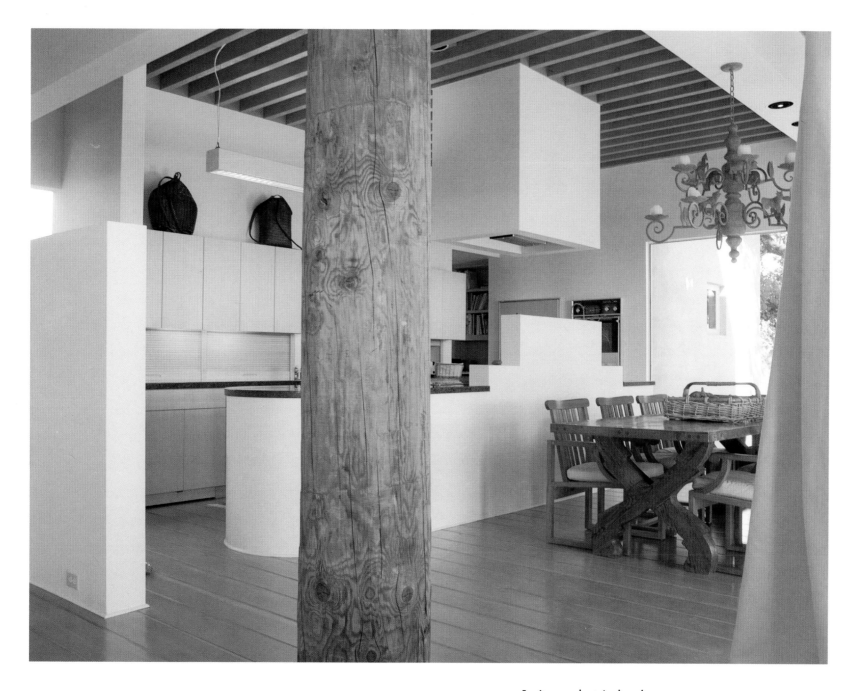

Furniture was kept simple and versatile for easy Friday afternoon arrivals and Monday morning departures. Plantation teak dining chairs were designed by Big Sur designer Kipp Stewart for Summit Furniture.

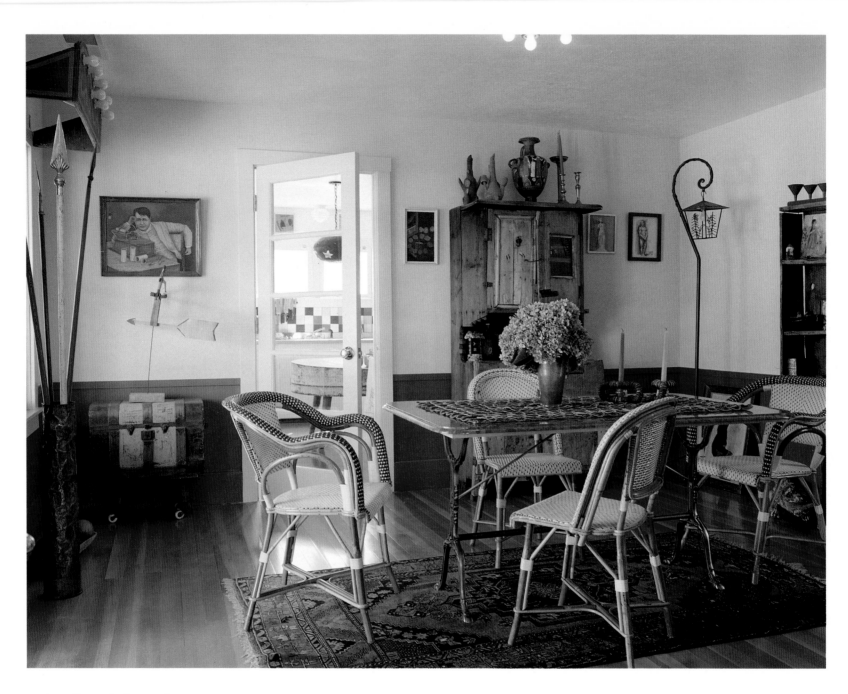

Passionate flea–market foragers, the
couple displays in their dining room fine
examples of paintings and crafts by
untutored artists. It's a feel–good collec-
tion, with found–wood cabinets made
by the Tarahumara Indians of Northern
Mexico, rare rural American crafts, and
prize–winning high–school art projects.

A fateful drive in the country in 1990 changed the lives of painter J. Carrie Brown and her husband of five years, caterer John Werner. "Driving along Highway 128, we suddenly saw the Jimtown Store and its For Sale sign and came to a screeching halt," recalled the couple. "It was an authentic country store—God's Little Acre with old rustic barns all set in the glorious valley. We immediately made inquiries about buying the property." ❡ The Jimtown Store was first opened by James Patrick in 1893 in a farming community east of Healdsburg that came to be known as Jimtown. The Goodyear family, which subsequently owned the store for several decades, had tried unsuccessfully to sell it and reluctantly decided to close its doors at the end of 1984. The small wooden farm cottage standing in one corner of the property really made the whole thing work for Brown and Werner. They would live there, run the store, and open their own Mercantile and Exchange to sell antiques and curiosities and local jams. They immediately called Berkeley architects Richard Fernau and Laura Hartman. ❡ "The house and store were staggeringly funky. I think a lot of architects would have suggested pulling them down, but we love that kind of *bricoleur* design gesture," said Fernau.

Brown and Werner's colorful cottage, *above.* With great sensitivity to the vernacular architecture, architects Richard Fernau and Laura Hartman opened up rooms, added windows salvaged from old houses, and created a cottage and store with character and style to spare.

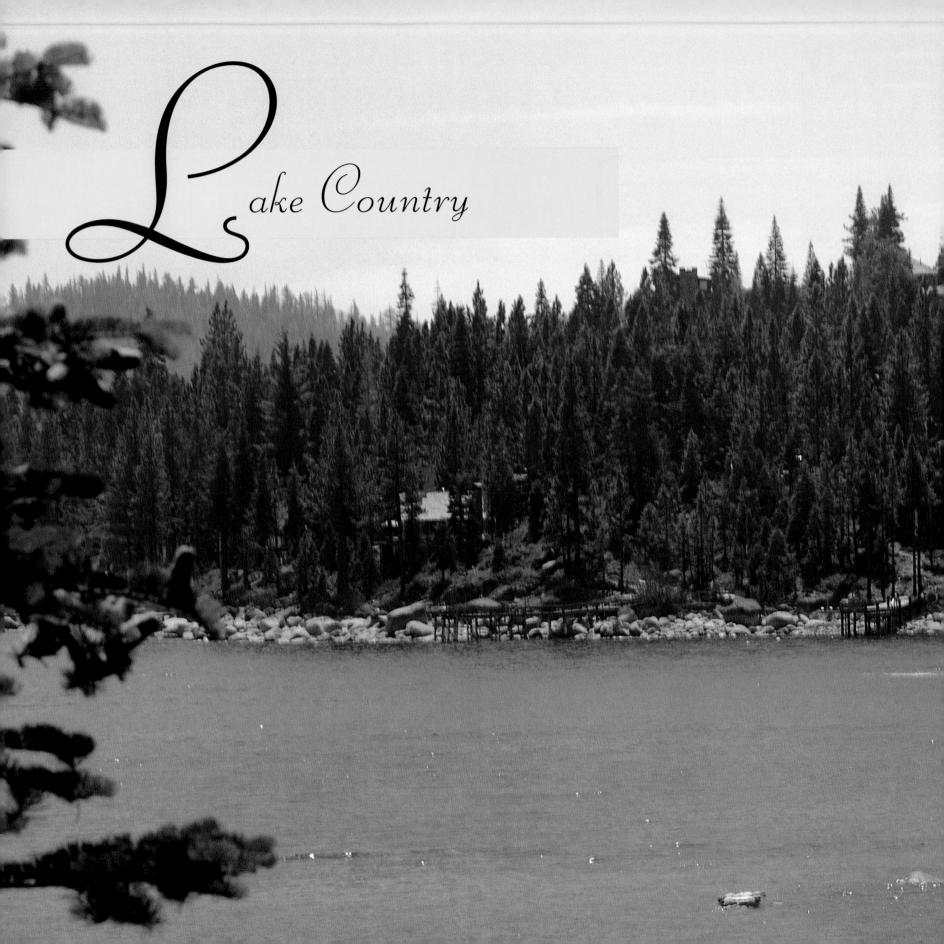

Lake Country

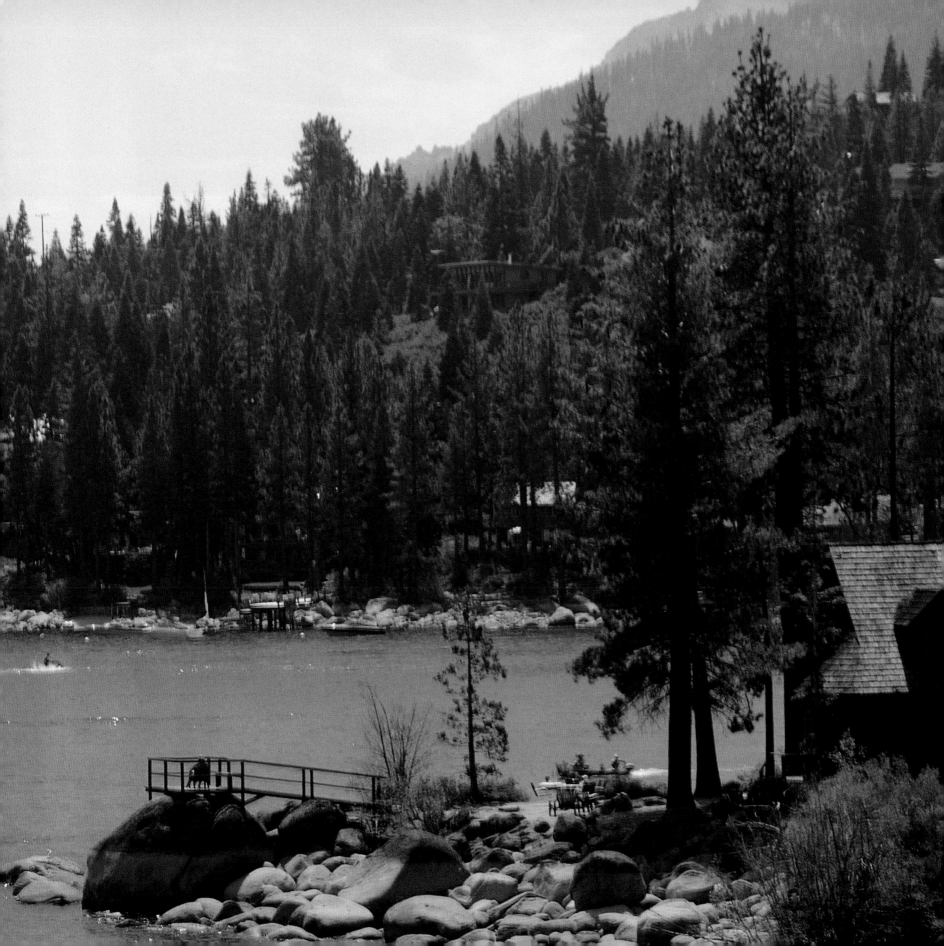

Lake Country
THE WIDE BLUE YONDER

I t was the Washoe Indians, a minor California tribe, who first lived on the shores of Lake Tahoe high in the Sierra Nevada. They considered the lake a sacred place. Surrounded by the highest peaks of the mountain range, the blue waters do, indeed, seem blessed. ¶ From a vantage point in the hills above Lake Tahoe, it is still possible to imagine how the wide lake looked centuries ago. Despite inevitable and justified concerns about the encroachment of daytrippers and pollution, the lake is still celestial, untouched by time. This is a barefoot kind of place where friends gather for a barbecue or a late lunch, and everyone watches yachts slowly sailing by or young children frolicking in the water. Visitors lie on the lawn at a summer music festival, sip a cold drink on a stone terrace, or slip through the water in an old wooden canoe and soon discover that a muted and pensive mood takes over. There's no reason to rush about. Redwoods and pines cast long, dark shadows across the boulder–strewn shore. In summer, the high elevation and smooth mountain air encourage a light–headed relaxation, a kind of pleasant torpor. The rigors of a three–hour drive from San Francisco quickly slip away, and a wonderful sense of place takes over. ¶ Winter comes early, whistling down the historic passes. Snow

usually starts falling before Thanksgiving, and the mountains around the lake gleam white across the water.

Logs trimmed and stacked outside the door at the end of summer are thrown into fireplaces to warm

hearth and hands. ❧ The Indians and later gold diggers had little company until the coming of the railroad.

At the turn of the century and into the twenties, San Francisco and Nevada families built houses on the

western shores. Most of those originals were rather woodsy, often inspired by the rustic and noble timbered

dwellings of Adirondack summer camps. In Meeks Bay, Homewood, Tahoma, Emerald Bay, Rubicon,

Brockway, and Tahoe Pines, old hand–hewn houses and weekend cabins still stand on the shores. It's chic

to be anti–style, and very non–U to be glitzy, glossy, or nouveau anything. Michael Taylor got it right for

Gorham and Diana Knowles' house when he designed big, comfortable chairs, stone–and–granite tables,

and deluxe fabrics in stylish variations of nature's colors. Jan Dutton's family comes to Lake Tahoe for

winter fun. Skis and boots are left in the warm mudroom, and children dash to warm themselves by the fire.

For the lake's summer people, tattered polo shirts, battered station wagons, wonky barbecues, and

antique Indian crafts collections have their own snob appeal. ❧ From precisely Easter weekend to Labor

Day, families gather. Around Thanksgiving, the winter people arrive. And the lake will always be there.

Previous pages: The lakescape from Diana and Gorham Knowles' terrace. Many old–time residents express concern that times at Tahoe are not what they were. From the Knowles' vantage point, the lake's beauty shines, clear and eternal.

Lake Tahoe
DIANA AND GORHAM KNOWLES HOUSE

The view from the Knowles' terrace is of a Tahoe that seems to have changed little since the Washoe Indians camped along its shores. Wicker furniture is by Ivy Rosequist for Wicker Wicker Wicker. Plantation teak terrace furniture is by Summit Furniture. The Knowleses often set out in the canoe, *far right*, to visit friends, the music festival, or an outdoor cafe around the rocky shore. Diana's 1930 wood–hull speedboat, *Tamarack*, is under wraps until the drought–stricken lake's level rises.

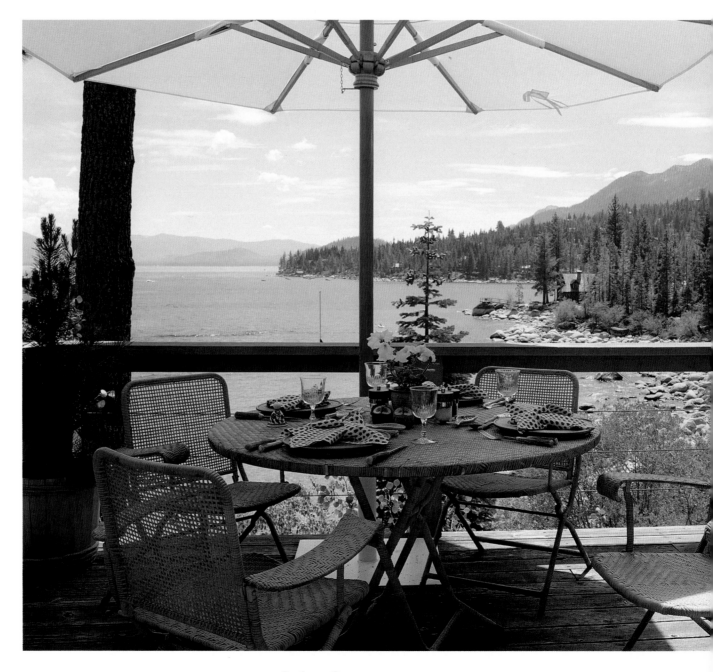

San Franciscans Diana and Gorham Knowles have mapped out a splendid year for themselves. The principal residence of these native Californians is a rather grand (and very private) house in Presidio Heights, with an interior designed by Michael Taylor. In winter and spring, they escape on weekends to their house in Pebble Beach. Summer is for Lake Tahoe. From the end of June until Labor Day weekend each year, they're in residence among the firs and pines at Meeks Bay. ¶ Michael Taylor, who designed three other houses for the couple, worked closely with Diana on the interior design. The scheme was completed in 1986. ¶ "I told Michael I wanted to match the furniture colors to the outdoors. He took the warm gold from fall leaves, the orange/red from manzanita bark, and the soft gray/beige from sand on the shore," said Diana. Over–scale benches and chairs have rush seats. "When the furniture finally arrived, Michael told us he had a present for us. He took us up to the road, and there was a huge piece of polished granite on a flatbed truck. Michael said he had a crane coming the following day. It was to be the table for our living room. They lifted it over the house and then maneuvered it through the French doors and across the room. It turned out we

Full-height windows in the
living room and library afford
towering views of the pristine
lake and bring a wonderful
quality of light into the rooms.
Michael Taylor designed all
of the furniture, including pine
benches, for the rooms.

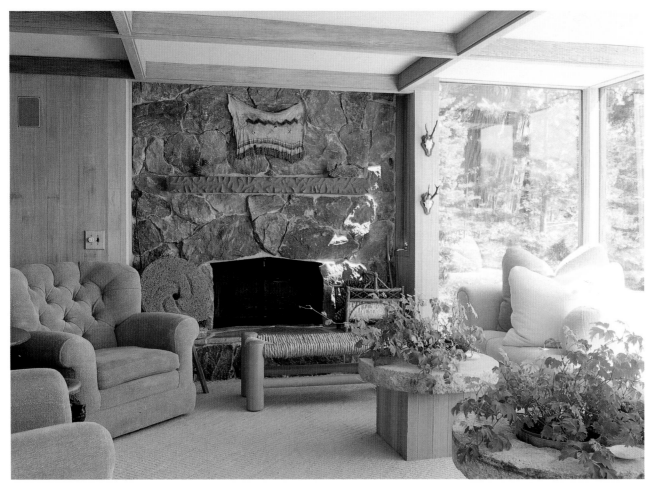

Over-scale banquettes and
fat chairs are upholstered in hand-
woven chenille, *right*, which feels
wonderful on tanned bare legs.
Twig sculpture on the cedar siding
wall by Charles Arnoldi.

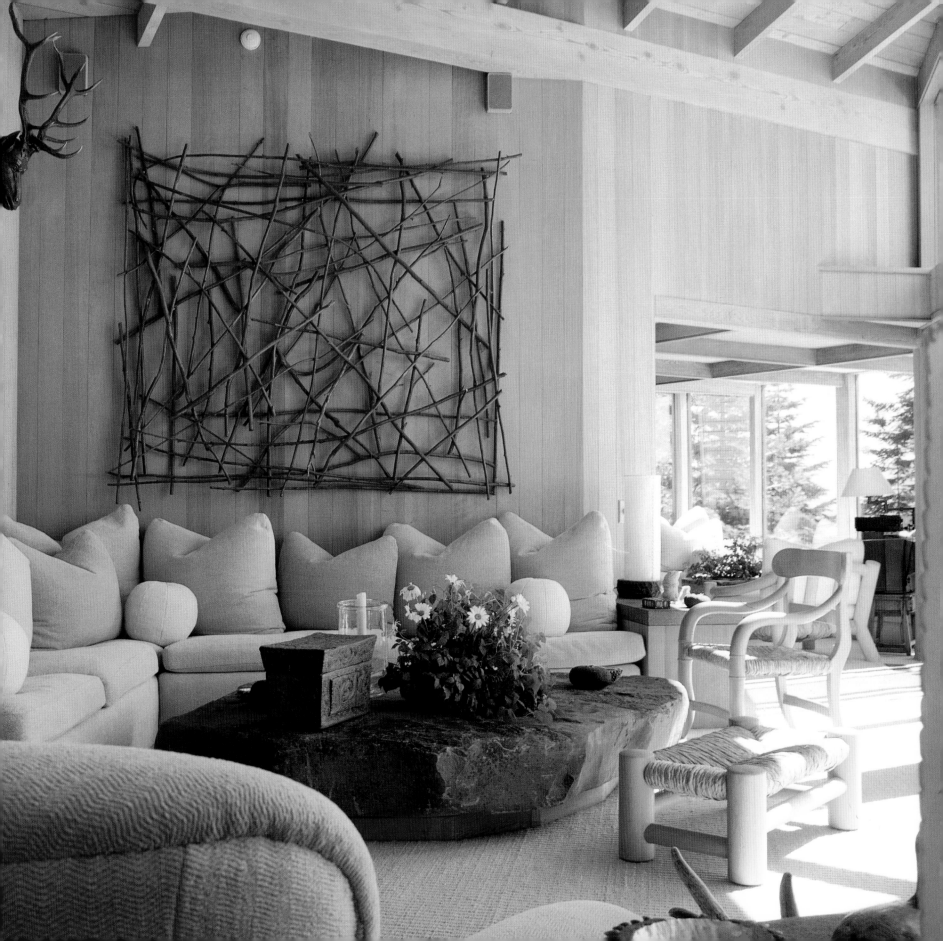

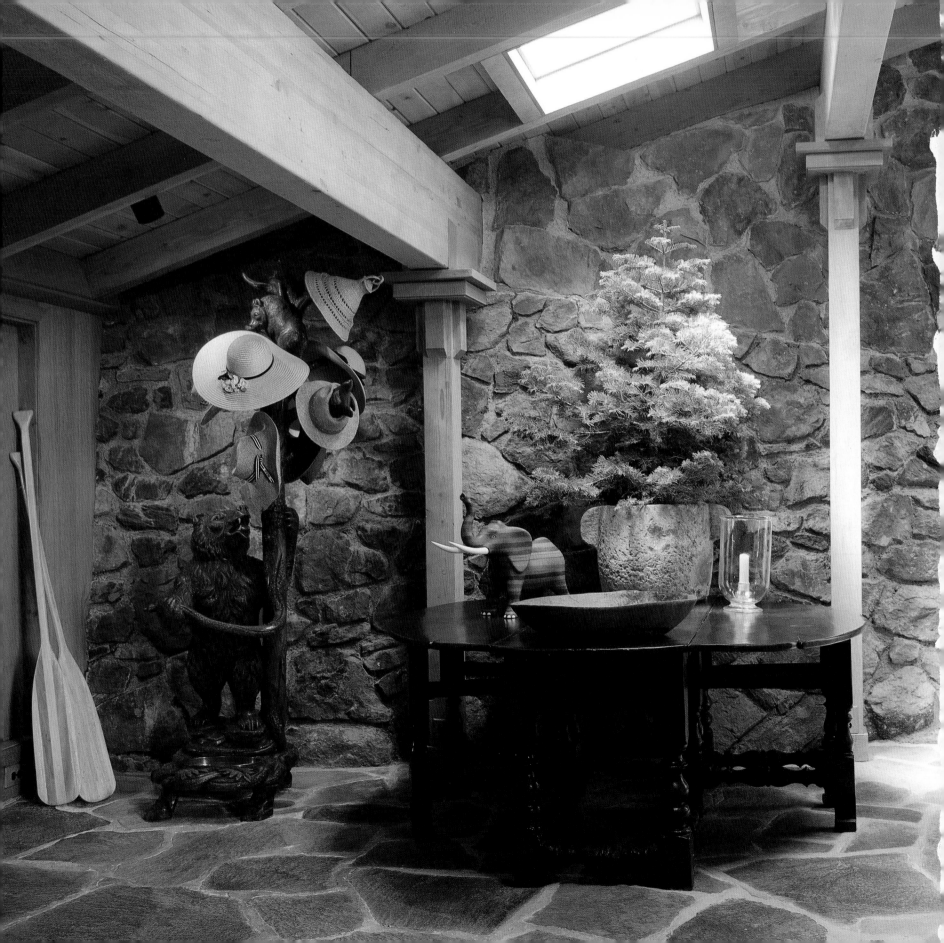

had to reinforce the floor to hold it," recalled Diana. "The house works perfectly for our days there. We have friends on weekends, but it's also very comfortable for two people." It is a tribute to Michael Taylor—and to the highly receptive Knowleses—that almost six years later the design is as striking, fresh, and appropriate as when it was first completed. ❡ "Michael was wonderful at seating, and arranging furniture for conversation. He knew just where to have tables for books and drinks, and where to place chairs," Diana said. "After the house was complete, I called him and told him that the wonderful thing about the furniture was that it was too big to move. It doesn't end up in the wrong place," she recalled. A porcupine quill box and an antique carved wood box from the Philippines still top stone tables, just as Taylor had chosen. The couple keeps the house filled with orchids and fresh flowers. ❡ "We may have a chair or banquette reupholstered, but we'll never change the house. We have a feeling of continuity here. And of course, enormous appreciation for how much Michael has enhanced our lives," said Diana Knowles.

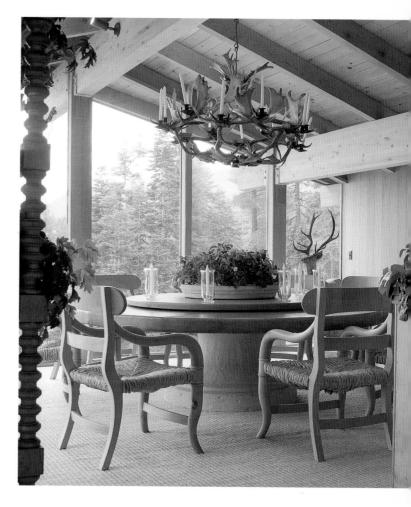

The slate-floored foyer, *left*, serves many purposes throughout the summer. The nineteenth-century English drop-leaf table is often used for a buffet, and tables may be set up for dinner guests. The hand-carved wooden bear hat rack was discovered in Austria.

Lake Tahoe
JAN DUTTON FAMILY COTTAGE

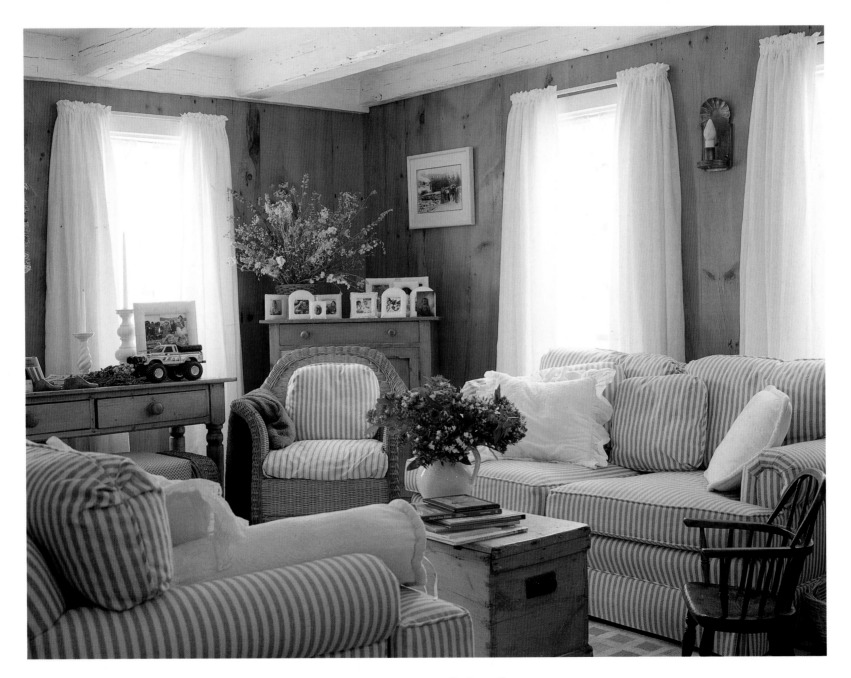

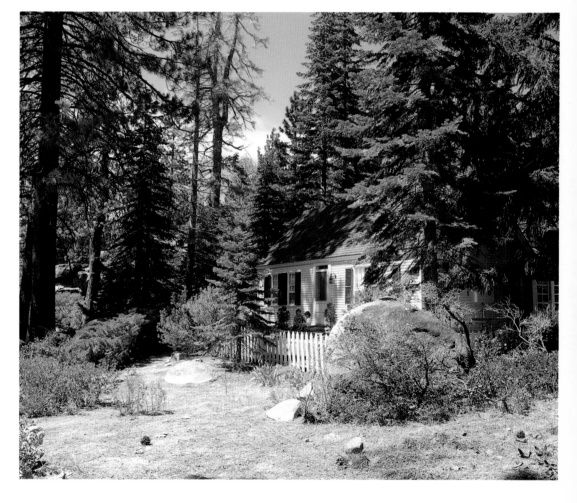

For years, Jan Dutton, owner of Paper White Ltd., an embroidered linens company in Marin County, took her family holidays at Lake Tahoe. And for years, summer and winter, she would hear stories of a transplanted Maine cottage standing among the redwoods and firs near the lake. Legend had it that the white clapboard house had been the Atlantic Coast summer refuge of a single family for 212 years, passed down from one generation to the next. Finally, in the mid–thirties, a Californian (a piano maker by trade) inherited the cottage. He returned to New England to find the house in disrepair, so he had it dismantled and shipped west to San Francisco via the Panama Canal. The piano maker had the little shuttered cottage rebuilt on a rocky piece of land on the shores of Lake Tahoe. ¶ Five years ago, in search of a holiday house for her family, Dutton learned that the cottage was for sale. Ever the idealist, she made an offer, sight unseen, and soon found herself the owner of a romantic wreck. ¶ "I loved the setting, but the house needed major work. The interior was dismal and dark, and the roof leaked," said Dutton, mother of Dylan, Tyler, and baby Francesca. Keeping faith with the original spirit, Dutton and her husband, Fred Rinaldi, had

In renovating the kitchen, *above*, Dutton was careful to keep the new design simple and functional. It's an easy–come–easy–go place that doesn't require work at the beginning or end of their sojourn. Now there's room for two to cook—and for children to help.

the house hoisted and set on a new foundation. The roof was repaired, beamed ceilings painted white. A new kitchen and dining room were carved from four tiny closet–sized rooms. ¶ The renovation took long months. New bathrooms were built, the bedrooms renovated, and a mudroom (for snowgear in the winter and boating equipment in the summer) was added just inside the back door. Electrical wiring had to be updated, and a new heating system installed. A new stairway to the children's bedrooms was added. White paint brought a new feeling of lightness to the wood–paneled rooms. The new kitchen now has excellent storage, a serious range, and room for children and friends to gather while the couple cooks. In summer, Fred brings boxes of tomatoes from their Ross garden to make flavorful tomato sauce. Cooking and eating remain two of the family's favorite pastimes, and they seldom dine at any of the local restaurants. ¶ Just outside the dining room is a stone terrace with a fireplace and chimney of lake–edge stone, built in the 1930s. "Throughout the year, we light a fire and eat dinner under the stars. At this high altitude, summer evenings are cool. In winter, we'll bundle up, clear away the snow, and gather around the fireplace. It's a wonderful break from city life," said Dutton.

Opposite: The great stone fireplace and terrace make an all–seasons outdoor room. The fire blazes on cool summer evenings and warms their toes during the winter.

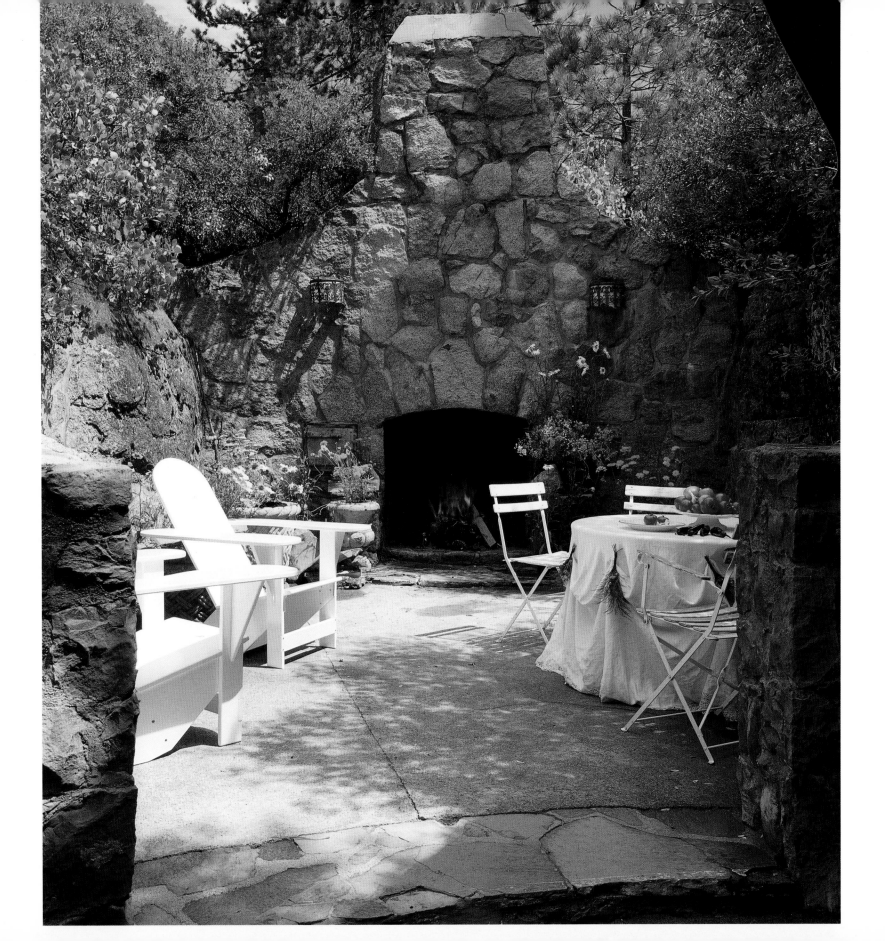

The Coast

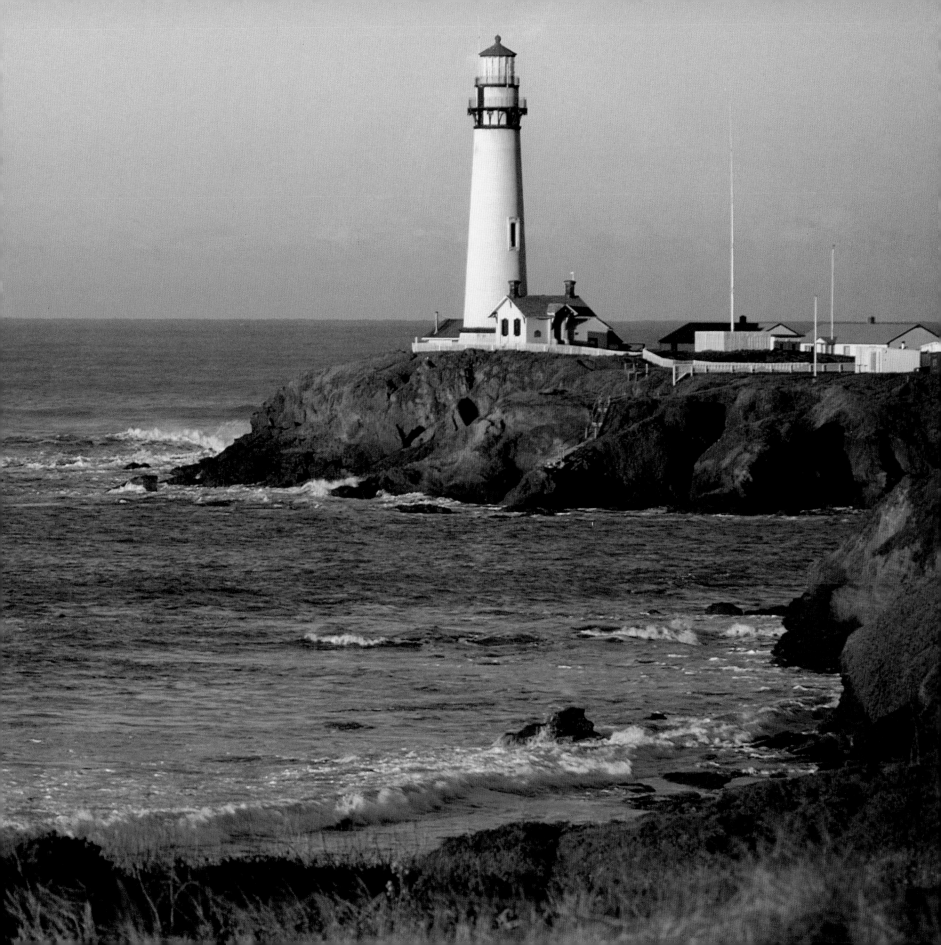

*I*n the popular culture, California's coast is a sunstruck collage of see–through

beach houses, palm trees, surfers, multi–million–dollar palaces–of–the–

stars, and a mercurial ocean. In fact, remarkably few houses take in the views

along California's Pacific shore. Santa Monica and San Juan Capistrano

feel like the Mediterranean, but north of balmy Santa Barbara, palm trees and

wide–open beach houses are rare. Cliffs and ridges and beaches from the Oregon border to Baja California

Norte are often fog–shrouded and too remote, too steep, or too rugged even for adventurers. Hundreds

of miles of coastline are protected for eternity from any kind of development. An alert driver following

Highway 1 through legendary Big Sur may spy just one or two ridge–top houses—by design. For decades,

Big Sur residents, along with state and federal agencies, have worked to protect this extraordinary stretch of

the coast. Sightlines are guarded, and new buildings may not be constructed in plain view. Even explorers

who head down the bumpy road to Pfeiffer Beach or wind up the hills to stay at Ventana will see few houses,

so carefully are they concealed. ¶ Kipp and Sherna Stewart's house has a remarkable view of the Big Sur

coast and the Santa Lucia Range. Its weathered timbers are hidden among gnarled old oaks that shade the

house in summer and shelter the Stewarts from winter squalls. Only in enclaves like Newport Beach and

Malibu will exploration reveal architectural experimentation and giddy diversity. In coastal towns

like Carmel and Anchor Bay and along the Sea Ranch coast, weatherworn timbers and graying exteriors

disappear among rocks and fields of dry grass. ❡ Stinson Beach and Bolinas, an hour's tortuous drive over

Mount Tamalpais from San Francisco, are a funky hodgepodge of shingled houses. Escapees from the

idealistic Haight–Ashbury sixties scene made this coast and farther north a haven, and a visit may feel like a

time warp. On a sunny day, in the moisture–laden air left by the departing fog, wildflowers take on an espe-

cially vivid hue and deserted beaches beckon. Farther north, following Highway 1, towns like Point Arena,

Elk, Manchester, Albion, and Little River seem forgotten by time. Mendocino on its rocky point looks

like a New England village, all verandahed Victorians, curtained parlors, and ships' captains' retreats. Stay

a day or so, dine at Café Beaujolais, and discover that Mendocino is pure California, down to its summer

fog and star–filled nights. ❡ Still, the best way to see the California coast is to spend a day picking up sand–

smoothed abalone shells and sand dollars, dancing in the waves, chasing skittering sandpipers, and sitting

on a quiet rock as the setting sun bursts into flame on the horizon.

Previous pages: **The view from legendary Highway 1 near Santa Cruz. In summer, the Pigeon Point lighthouse is often obscured by fog. Still, beaches are popular with surfers and hikers.**

Malibu Beach
A HOUSE BY ARCHITECT JOHN LAUTNER

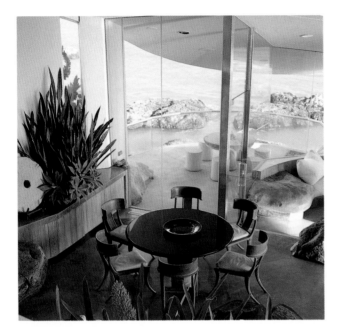

Together the architecture and the decor offer a superb setting for ocean–viewing. The slate floor provides a stage for cushy chenille–upholstered sofas, rush–seated chairs, and Taylor–designed tables. Lautner's asymmetrical hearth was inspired by the curve of a cresting wave.

I t was the idea of San Francisco interior designer Michael Taylor to commission Los Angeles architect John Lautner to design a house on a rocky point north of Malibu for his clients. The wild site overlooking a quiet cove and the deserted coastline called for a visionary, an extraordinary talent. The initial conversations with the architect took place almost 20 years ago, and Lautner, now in his eighties, recalled that the planning took four or five years. The ever–vigilant California Coastal Commission and several other regulatory agencies had to be appeased. The pie–shaped site at the water's edge was challenging, even for Lautner, who has built more than 60 houses. It is to Taylor and Lautner's—and their clients'—credit that neither the architecture nor the interior design has dated since being completed in 1984. ❡ "The important thing to know about the house is that it has nothing to do with styles or trends or fashion. It was designed specifically for that site. It is a one–of–a–kind house," said Lautner. Like all of Lautner's houses, it was shaped by the site, the view, the climate, and the clients. "There are always about 500 elements that decide my design direction," said Lautner, a former

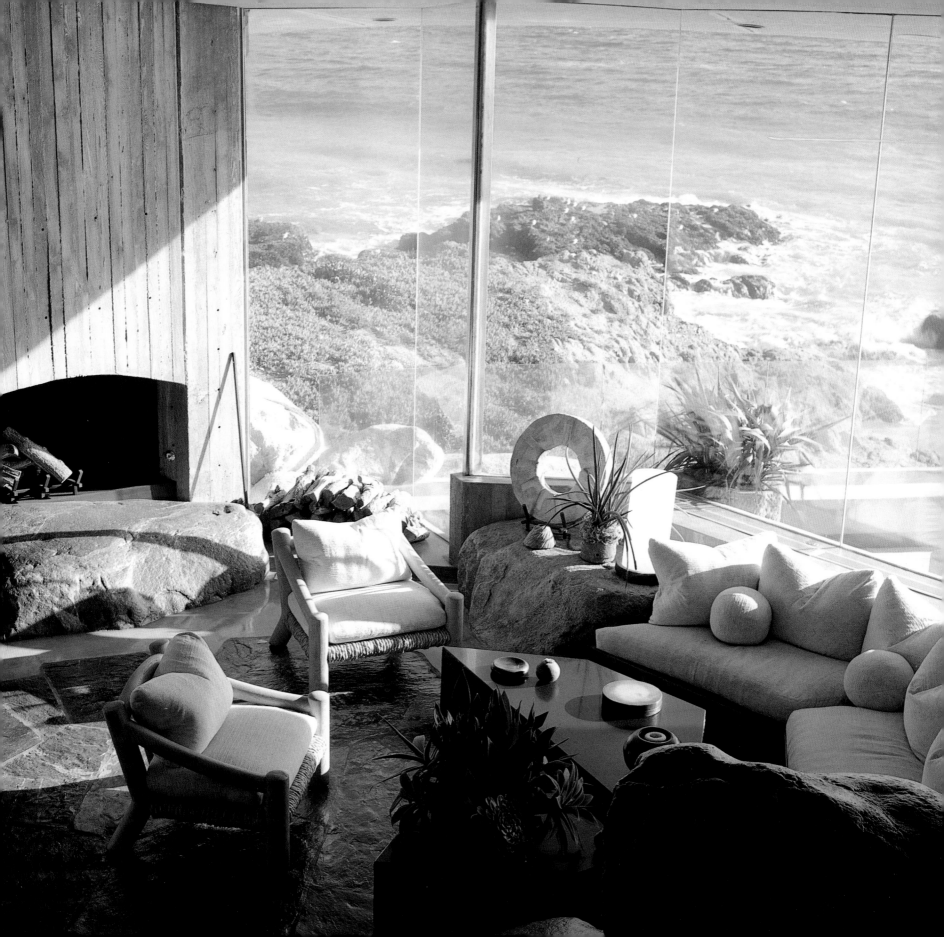

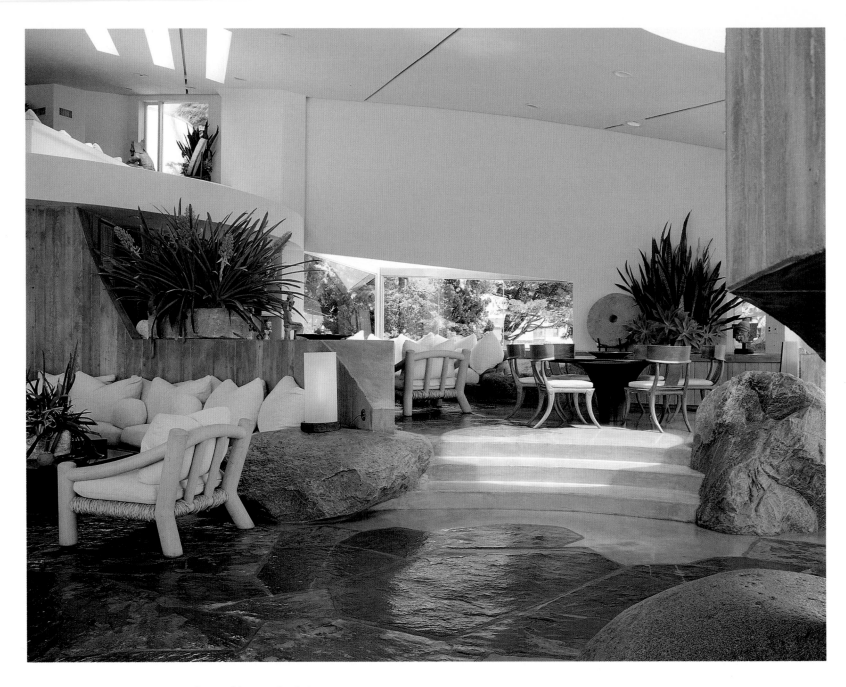

The graceful curves of Taylor's
Klismos chairs add to the
visual rhythms of the dining
room/study. The owners,
a businessman and his wife,
display pre–Columbian sculptures
throughout the house.

apprentice of Frank Lloyd Wright. "This is a very beautiful location, so I wanted to incorporate the rocks, the trees, and make them part of the design. The 90–foot, single–span roof suits the shape of the land. The house is like a segment of a cylinder and creates a sheltered free space for living and for viewing the ocean." By cutting the fascia of the roof in an irregular curve, Lautner provided a durable and varied outlook to the ocean. The more typical design solution, visible all along Malibu Beach, places the house parallel with the shore. Lautner perfected the details. He provided skylights and backlight to balance the daylight, so that uncovered windows do not glare but rather seem to disappear. ¶ Originally, Lautner wanted to build the whole house of concrete. "It's durable and gives you complete design freedom," he said. The finished construction is clear–span wood beams, plaster walls and ceiling, and slate floors. "Everything I do is exposed. I don't like extra finishing or painting," he noted. The exterior walls and fireplace are board–formed concrete left exposed to show the resulting wood grain. Lautner ran the window glazing clear to the ceiling with no interruption of

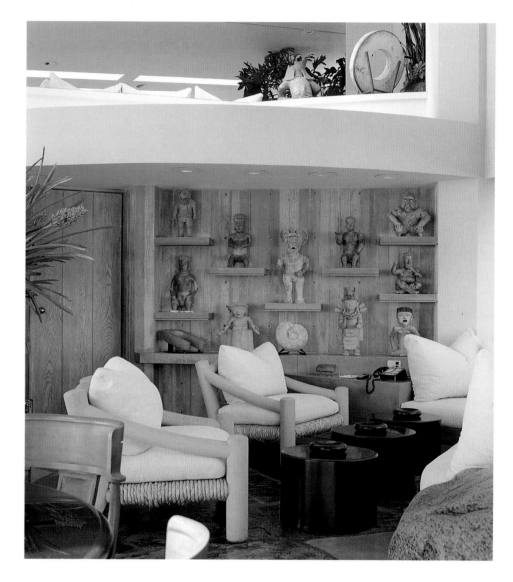

From the beginning, the owners wanted their house to be in harmony with its natural setting between ocean and mountains. The glass entry doors seem to disappear. Taylor's grand plan: luxurious handwoven fabrics, no color, furniture of timeless design that is at once assertive and rather self-effacing, bare walls.

moldings. "All of this takes extensive planning and engineering. You have to carry the idea through and watch every square inch. Skylights were planned as perforations in the roof, rather than just big holes for light. You have to maintain the integrity of the architecture," he said. Lautner noted that he does not design from the facade in. "The facade does not contribute to your life. It's the interior that counts." The architect also noted that the house is designed to be at once very solid and transparent. It is engineered for rigorous earthquake specifications and for high winds. The glass has great strength and will easily weather the occasional storm. "This is a house that was designed just for the people—not for history, not per square foot, and certainly not for any architecture fad. I did it just for the owners—and I know they are very happy."

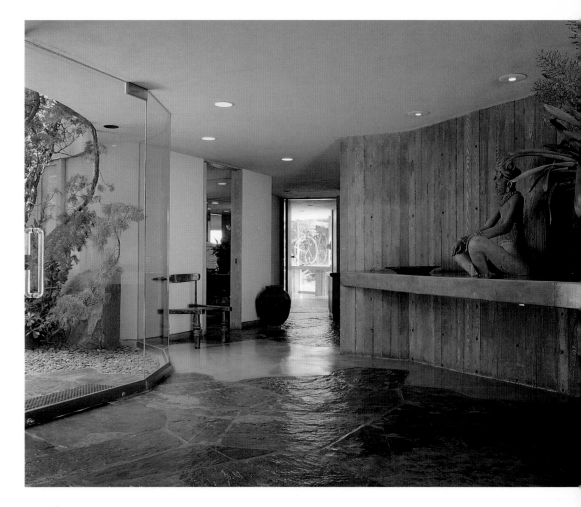

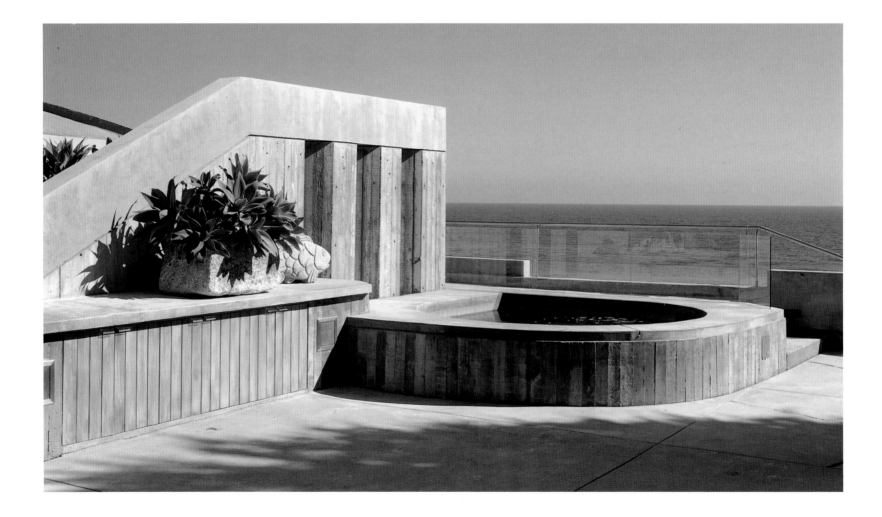

An almost invisible glass wall shelters the patio overlooking the ocean and Zuma Beach. Out there, the owners enjoy extraordinary tranquility and privacy—and a house that is likely to be as comfortable and satisfying 30 years from now. "Living in our house is thrilling every day," said the owners. "It's cozy and comfortable for two people, and marvelous for 150 guests. At night, it's not like living at the beach. It's very romantic."

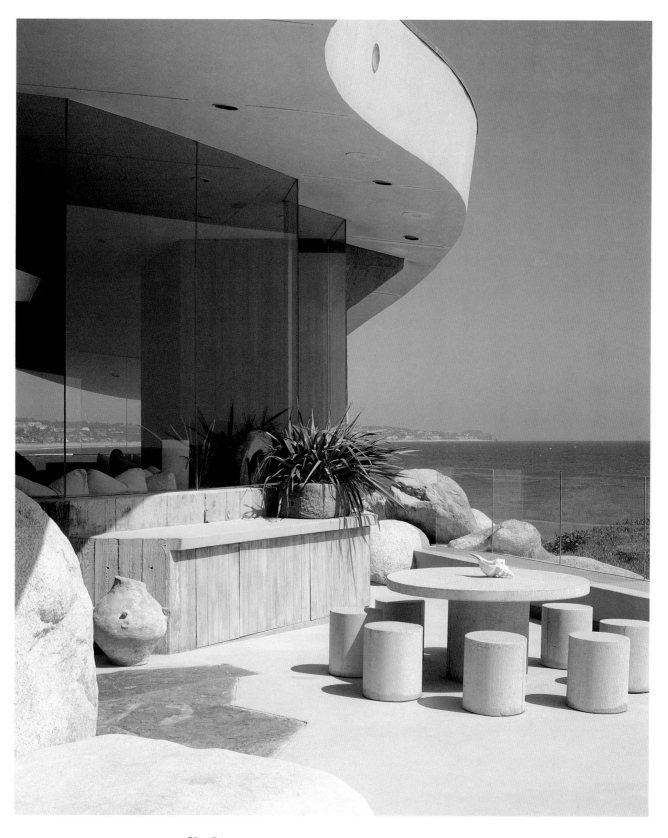

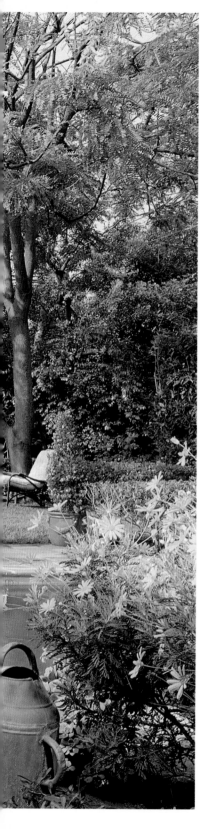

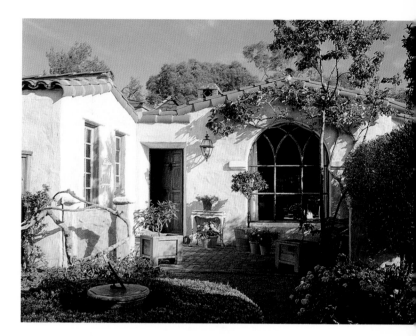

T wenty years ago, antiquarian G.R. Durenberger (known to his many friends as Gep) made a felicitous find. Certainly in all his years of scavenging for antiques in Europe he had made some wonderful discoveries, but this encounter involved a cottage. Above Capistrano Beach, Durenberger found a 1928 cottage that had originally been built as guest quarters on the Doheny family beach estate. (The main house stood regally on the bluffs.) ¶ Over two decades, along with running his antiques business and championing many civic causes, Durenberger has slowly remade the house. With paint and stucco and plaster, and help from a talented entourage of friends, he has made new rooms, corners, and sky–lit halls with beautiful surfaces to house his growing collections. Antique cottage windows, stone pilasters, hand–painted tiles, ancient French doors, and lots of ingenuity give the rooms character and the suggestion of age.

A rustic wooden gate leads past a sundial to the enclosed courtyard and the cottage door. From his living room window, Gep has a handkerchief–sized ocean view. Gardens like Durenberger's, *above* and *opposite*, take time, talent, lots of patience, and the kind of warm weather that blesses Capistrano Beach all year. Surrounding the pool are a series of outdoor "rooms," furnished with tables and chairs and as much care as his indoor rooms.

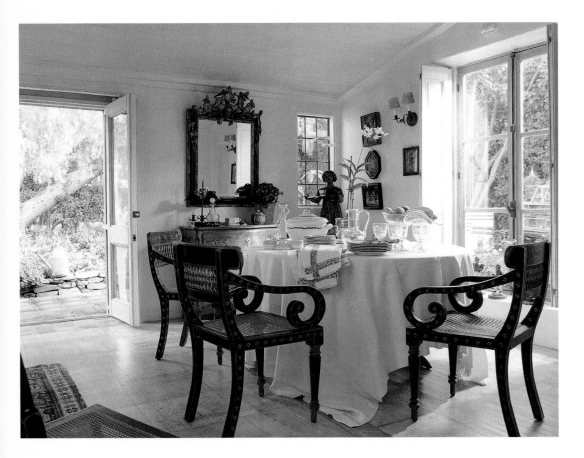

Painted caned chairs, possibly Portuguese, possibly Tyrolean, surround the dining table draped with an antique linen sheet. Open doors lead to a sheltered terrace. The floor is painted *faux* stone.

Durenberger often calls on his favorite artists to create special effects. The dark hardwood floor in the dining room was painted to look like stone, then sanded to give it a softer worn look. Living room and bedroom walls were plastered (with pieces of straw mixed in for authentic texture) and left unpainted. Their rustic finish offsets the glazed walls and ceilings of adjacent rooms. ❡ "I don't like *trompe l'oeil* to be too serious or realistic. It should be tongue in cheek," said Durenberger. ❡ Throughout the house, the antiquarian has used time–worn windows and doors wherever possible. In the kitchen is a pair of seventeenth–century European leaded oak–framed windows. The bedroom has Gothic–style church doors. Thus, he says, you begin to create the appearance of authenticity.

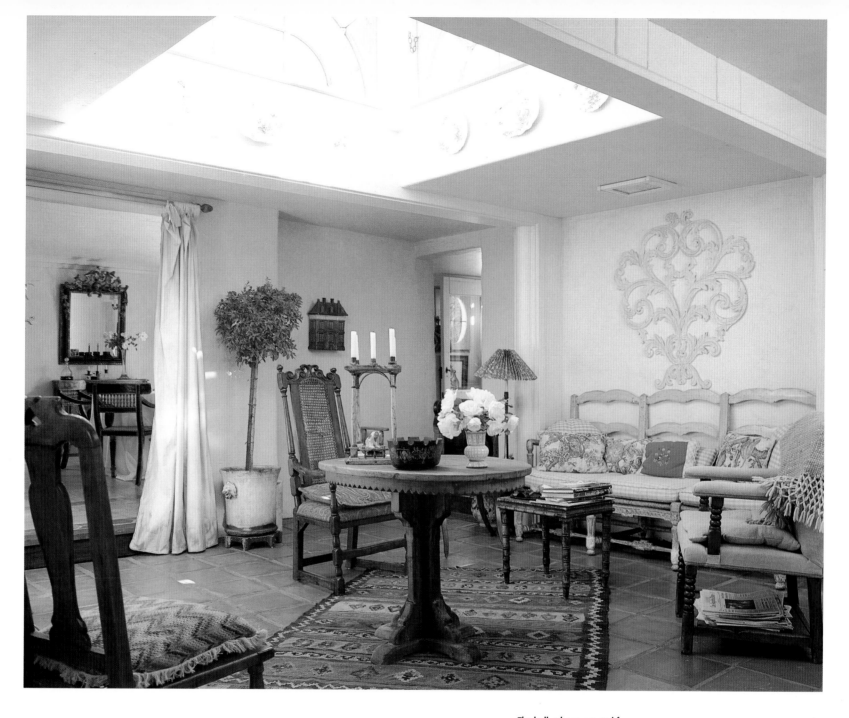

The hall, *above*, created from an
enclosed atrium, is lit by a dec-
orative skylight. Typical of Gep's
worldy mix: a Gothic Revival
table, a Louis XVI bench, and
pillows made with antique fabric
remnants.

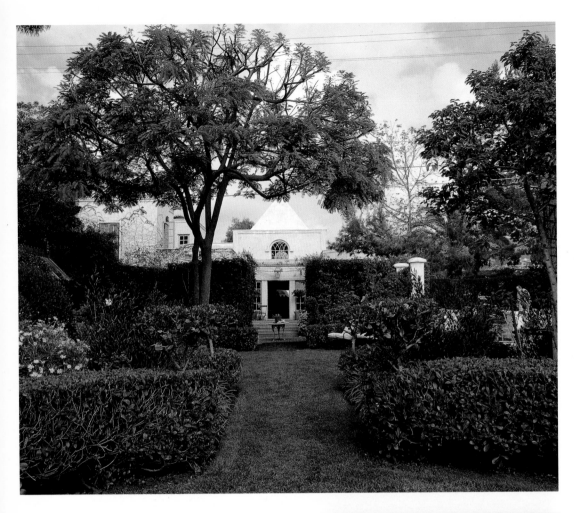

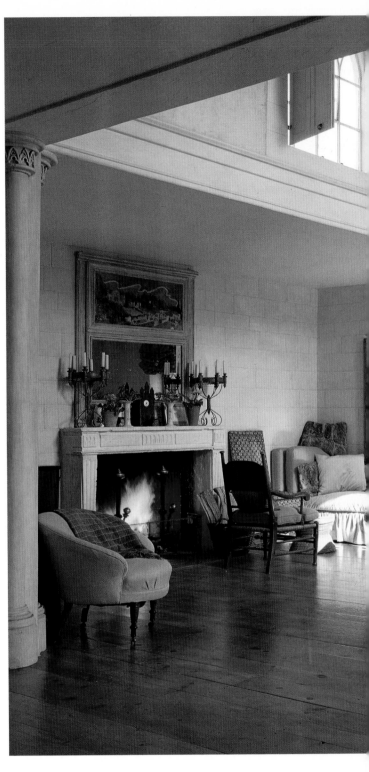

The Gothick Folie Gep, *above* and *opposite*, which Durenberger originally used for decorative arts seminars. It's situated across the half–acre garden from his house. Of late, it has housed guest lecturers and is occasionally used as a showroom. Above the mantel, a theatrical candelabrum and a Gothic–style clock. The trumeau of the Louis XVI mirror has a painted bird's–eye view of the Capistrano Beach property. Traditional in tone, the interior, *far right*, nevertheless has the visual drama of antique clerestory windows, *faux* marble walls, and a handsome plank floor.

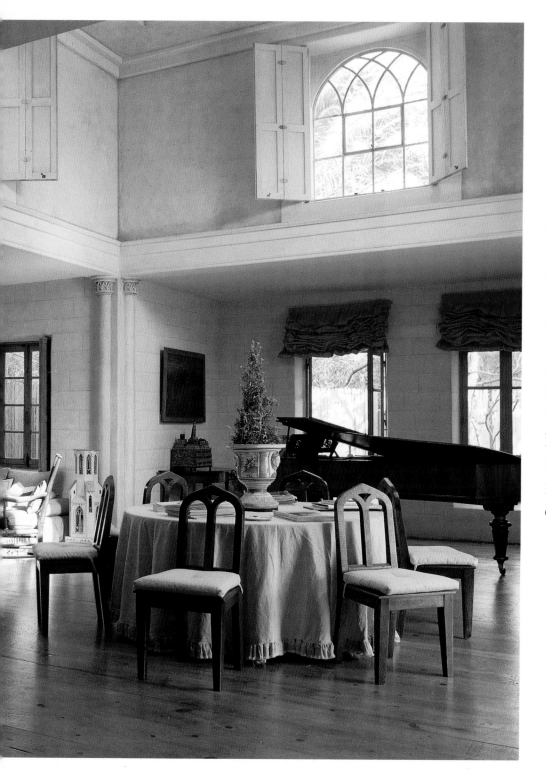

For more than 20 years, Gep Durenberger's show-rooms have been a very popular source for European antiques. Clients come from Los Angeles and Pasadena and San Marino, and fly in from the East Coast and London. ¶ The gregarious antiquarian is also credited as a catalyst for San Juan Capistrano's cultural awakening. Durenberger, originally from Minnesota, was founding president of San Juan Beautiful, and president of the San Juan Historical Society. Recently, Durenberger has been the volunteer director for The Center for the Study of Decorative Arts, housed in the former Durenberger premises adjacent to the Michael Graves–designed San Juan Capistrano Library.

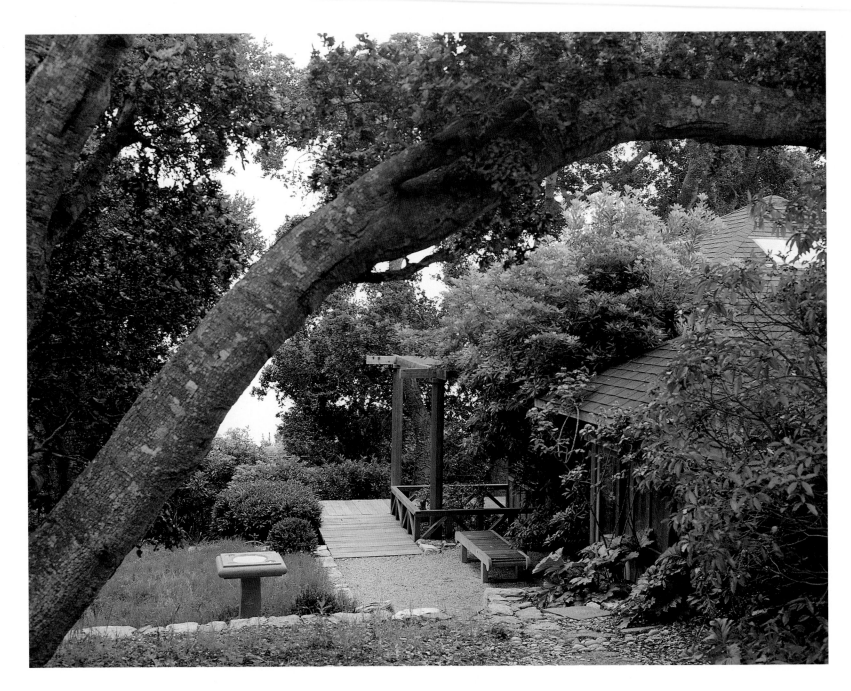

The Stewarts' garden is circum-
scribed by old oaks, *above.*
On a terrace 800 feet above the
ocean, *opposite,* French garden
chairs make a perfect vantage
point for viewing Big Sur. On
clear days, they can see 30 miles
south to Cape San Martin.

On a remote oak–covered ridge in legendary Big Sur stands one of the most beautiful houses along the California coast. Its power lies not in lavish construction or over–done decoration, but in elegant simplicity and superb integration into this remote setting. Still, when Kipp and Sherna Stewart first saw their 1¹/₂–acre property in 1972, it was hardly love at first sight. The redwood shack perched on it was solid but unremarkable. Mist shrouded the land and the rugged coast, dampening their enthusiasm. ¶ "A few months later, after we had added the new living room and completed our first round of renovations, the fog cleared. We had a wonderful feeling of being right on the edge of the continent, surrounded by a rolling serenity. We saw that this is paradise," said Sherna. The sun leaps the Coastal Ridge and lights upon their land all the live-long day. And the Stewarts are not at all blasé. They take dinner out on the deck and sit in their garden to watch the last rays disappear beyond the horizon late in the evening. ¶ Like the Stewarts themselves, the house is quiet and rather low–key, not at all flashy. Painter Kipp was the designer of the Ventana Inn. He designs a highly successful furniture collection in plantation teak and mahogany for Summit Furniture. Landscape

Rustic painted furniture fits the Stewart's mood perfectly. The garden provides lemons, limes, and acorns aplenty.
Left: Wild nasturtiums arranged by Sherna above a painted chest.

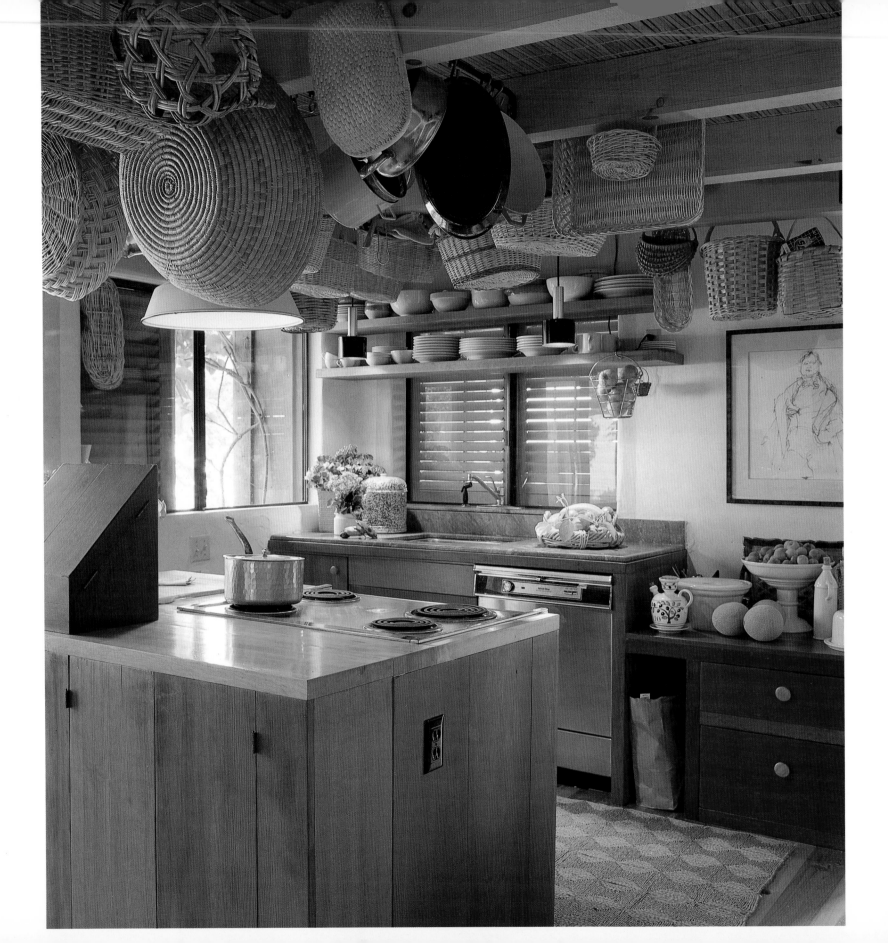

designer Sherna, who planned the original Ventana land-
scaping, has planted their land with olive and fig trees
and citrus hedges, along with a bountiful organic garden
outside the kitchen door. Thick, glazed plaster interior
walls, well–placed windows and French doors, and smooth
timbers for floors and ceiling beams all create interiors
that are timeless in mood and extremely friendly to the
spirit. Monterey pine planks were used for floors in the
kitchen, bedroom, and entry. End–grain Monterey pine
blocks give the living room floor its distinctive pattern
and superb insulation. Neatly clipped Meyer lemon trees,
Mediterranean flowers, and ancient oaks shade the house
from intense heat and ocean gales. Sherna has built
a series of sheltered garden terraces for repose and con-
templation of the changing seasons and light. ¶ One
reason for its highly refined design is that the Stewarts
have been polishing the house since they first purchased
it 20 years ago. Using the original house as core, the
couple has added a living room, an extensive new deck,
and a sunny bedroom overlooking an enclosed garden.
The walls were framed as thick as possible to give the

The Stewarts don't care for kitchen
cabinets so they use baskets for
storing utensils, light bulbs,
candles, and linens. Sherna ragged
plaster walls with pale ochre
French wash. French doors open to
a shaded deck with mesmeric
views of the coast.

Opposite page: The silk *tulle bal-dachino* above the bed is not simply decorative. At night, the Stewarts unfurl the netting to protect them from marauding mosquitoes. Plaster walls have a pale golden patina. Sherna and Kipp designed the elegant pine–and–forged–iron campaign tables, topped with an Italian glass lamp.

house substance. ❡ "We kept working on the exterior and the interior, always redesigning for comfort and honest aesthetics," said Kipp. "Now we're happy, and I think we'll stop. The house is 1,600 square feet, and not a bit bigger than it needs to be. We spend much of our time with the doors open, so the house seems to go on forever." Each room is uncontrived, and calming in its Shaker simplicity. Handwoven white cotton and heirloom linens drape their bed. ❡ "Living here, the weeks seem to flow along without interruption. Our days are about work and painting and gardening," said Sherna. "We are distant from the world but far from solitary. We have a very strong sense of community with our fellow ridge dwellers." ❡ In the summer, all seven pairs of French doors stay open to gardens and terraces. Indoors and outdoors become one. Sherna noted that the garden and the Big Sur scene are constantly changing and they are not for a moment bored with their blessings. In winter, the house closes in against lashing storms. Shutters are pulled tight to shelter the windows. The Stewarts sit by the fire and happily listen to the rain drumming on their roof.

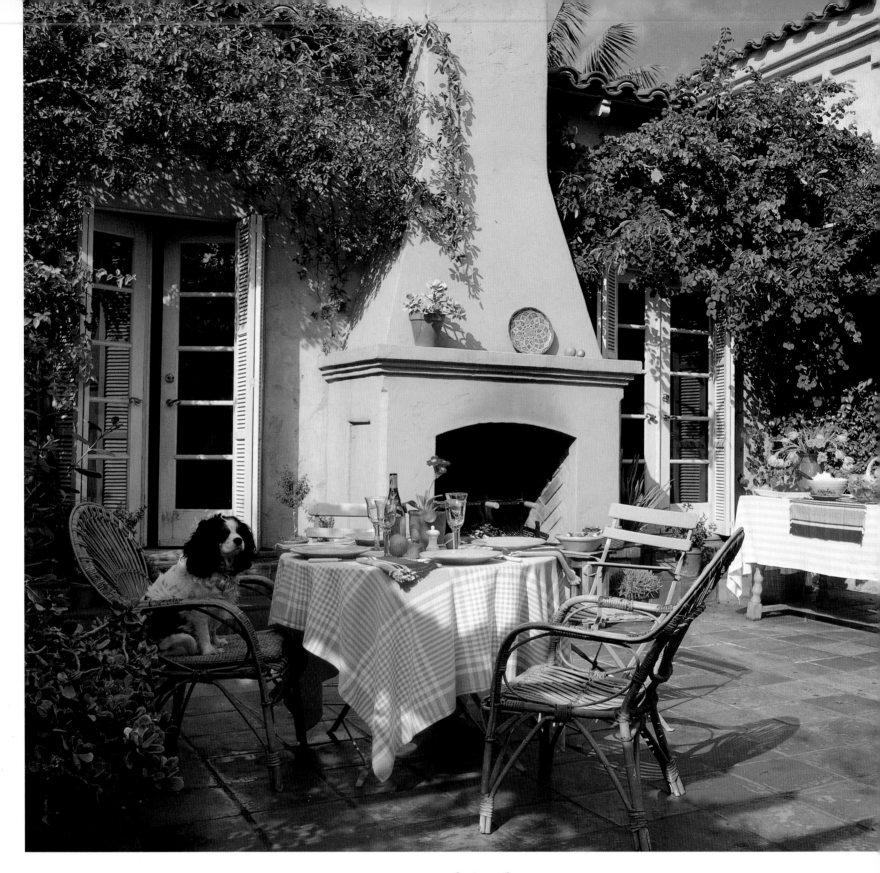

Interior designer and garden designer Nancy Goslee Power, her English husband, Derek, and their young son, Oliver, moved to California from the East Coast just over 12 years ago. Nancy had enjoyed great success as a design magazine editor, fashion buyer, and food editor and decided to focus on landscape design. ❡ "I think the broader my interests, the more fields I know about, the richer and better my work becomes. Good design principles cut across the arts. I study all the time, too," said Nancy. Under the tutelage of eminent landscape designer and horticulturist Philip Chandler, she learned swiftly. She now designs landscapes all over the United States, and as far afield as Melbourne, Australia. ❡ The Powers have made their house quintessentially Southern Californian, with sheltered terraces, gracious rooms, and lovely glimpses of the lush landscape. And their garden, a precious small lot near the ocean, is the very best kind of California garden—a series of verdant outdoor rooms. The Secret Garden, with an iris–filled pool, has a hidden path and no direct access from the house. Creating their green and private realm in years of drought has taken hard work, ruthlessness, and a lot of patience, she said. The best gardens take the longest to create.

"The courtyard is the true center of our house," said Nancy Goslee Power. "It's probably the room we use most in all seasons." Their King Charles Cavalier, Rupert, enjoys it, too. They grill in the fireplace and huddle around the blaze on cool winter evenings.

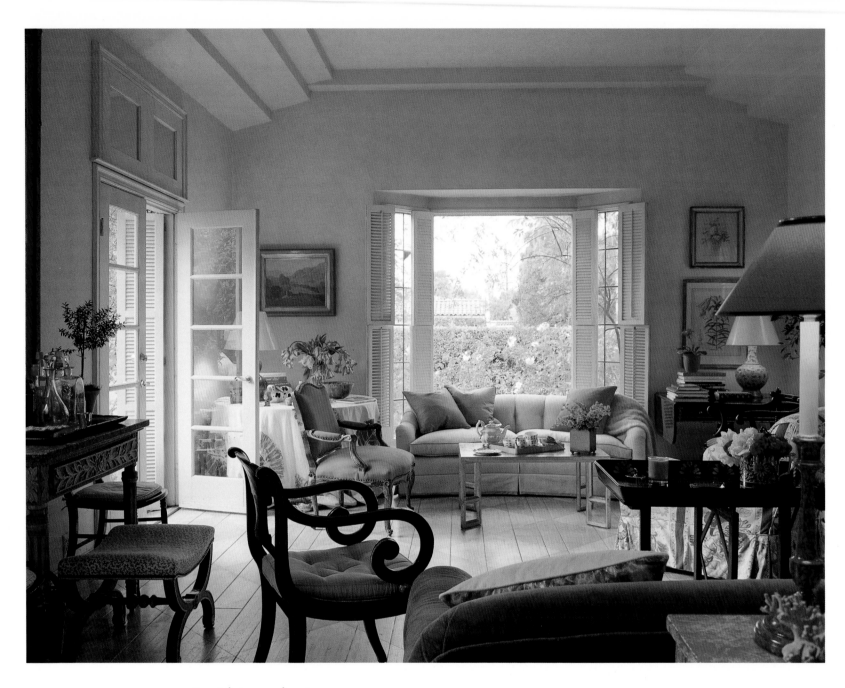

Nancy's first career, after art
studies in Florence, was in interior
design. (She lived, first, in sight of
the Boboli, later near Giotto's bell-
tower.) Her skillful mix of period,
styles, and color—and talent for
furniture placement—are evident
in the living room.

Nancy Power was raised by a family of avid gardeners in tidewater Delaware. But it was living in Florence that became the best education of all for the work she has done since. ¶ "In Florence, I gained a sense of how people lived and how things look in one of the great cultures of the world," said Power. Still passionate about travel and history, she consults the ancients for ideas and lessons in civilized living. ¶ Among her role models are Beatrix Farrand, who worked on the Santa Barbara Botanic Garden in the twenties, and Lockwood de Forest and Edward Huntsman–Trout, who labored on the great estates in Pasadena and Santa Barbara in the twenties and thirties. Power takes a very creative but pragmatic approach to landscape design in Southern California, where years of drought can discourage all but the most dedicated gardener. "Look at old photographs of Beverly Hills and Santa Monica and you see that we are living in a watered desert. My own garden has no grass. Lawns take unconscionable amounts of water. Instead, I have courtyards and parterres and trees," she said. Gray and green santolina form a billowing "carpet" outside her bedroom doors.

"Even if a room is new, I like it to feel mellow and a little bit worn," said Power.

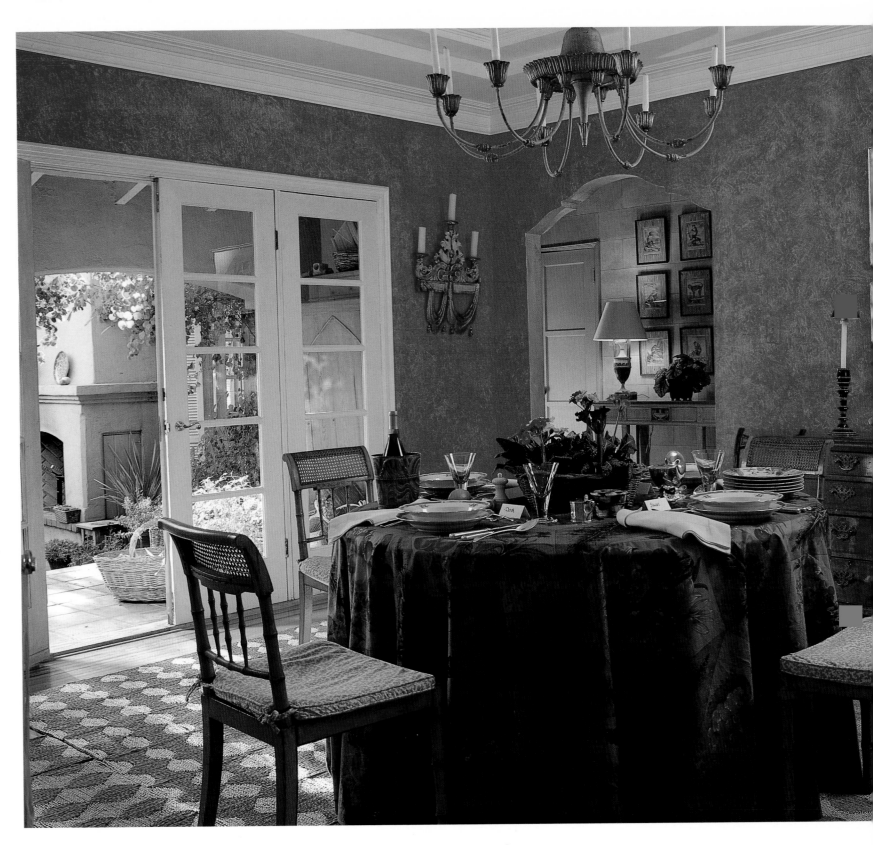

A nineteenth–century Spanish chandelier and Moorish sconces both gleam with candles when the Powers have dinner guests. French doors, luxurious fabrics, and Nancy's bountiful plants give the dining room a light, spacious feeling. The same forties shades Power loves in her gardens are at home in the urbane rooms of her 1930s house. Clay–red, umber, vermillion, and gold with the spike of acid green are used with great confidence and a generous hand—possibly because they remind her of her youthful love of all things Italian. Dining room walls are glazed Pompeiian red, which looks especially glamorous at night.

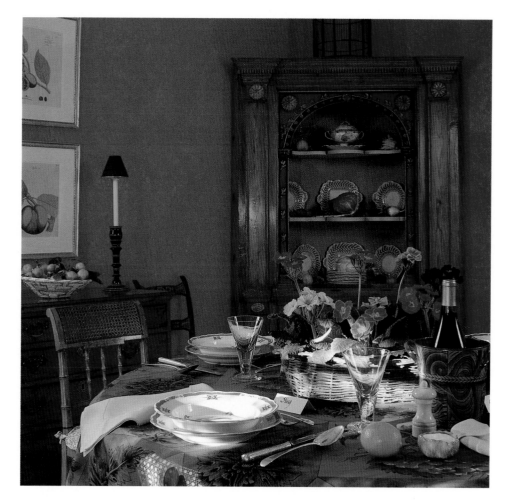

Montara
A HOUSE DESIGNED BY MICHAEL MOORE

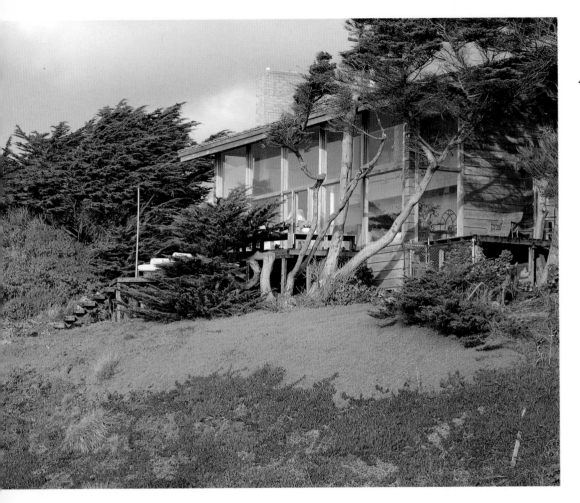

The house, sheltered by wind-sculpted trees, faces almost due west. It's perfectly sited for watching sunsets and sudden storms and daily *son et lumière* entertainment.

Montara sits on the coast a wild 25–minute drive south from San Francisco, but it has never really caught on as a retreat from the City like Stinson Beach and Bolinas. Perhaps the rock–strewn stretch of patched–up road that traverses Devil's Slide deters romantics and escapists. More likely the gloomy gray presence of fog in the summer scuttles the plans of sunseekers and frightens away all but the most imaginative. Designer Ron Mann once lived there, but most San Franciscans who head down Highway 1 are passing through to Carmel. ¶ One young executive hired San Francisco designer Michael Moore to update his house and give it a new, timeless design. ¶ The point was to make it more than just a beach house. It's a suave mix with pillows covered in Fortuny fabrics, tassel trims on chairs, and a Venetian gilt mirror, along with country pine chairs, Mexican mercury glass vases, a forged metal chair, and piles of books. ¶ "You feel comfortable here after a hike along the windy shore, but you can also throw a very chic cocktail party," said Moore. This house is also perfect for the proverbial dark and stormy night. With a glass of chenin blanc, a flickering fire, and opera on the stereo, what could be better than to hear the sea scream and howl.

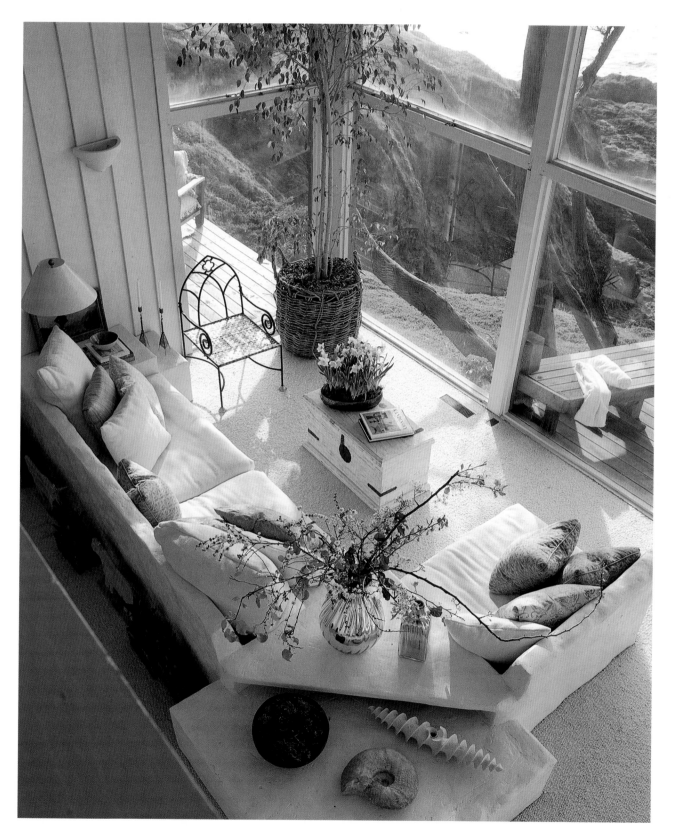

Left: Full–length windows in the living room bring California's silver–white light inside. With its monchromatic scheme, the room appears to float above the rocks and rushing tide. *Above:* The endearing hall table was made by the owner with driftwood found on the beach below. Other lucky finds include turquoise beach glass and intriguing stones, but shells seldom reach the rocky shore intact. Pewter–inlaid mirror is from the Ginsberg Collection.

West Marin County
SARAH HAMMOND HOUSE AND GARDEN

Near the weaving studio, drifts of
annual white forget–me–nots,
nepeta, and pink penstemon.

I n the misty early morning, Sarah
Hammond's Northern California garden is
particularly beautiful. Scented *Jasminum polyanthum* flourishes over the pergolas, pink *Clematis montana* 'Rubens' is just coming into bloom on the weathered fence, and pale pink musk roses open their petals to the sun. This garden's style is subtle and extremely pleasing to the senses. No gaudy annuals, stubby stalks, or regimented roses here. Instead, Sarah favors time–honored graceful perennials for year–round pleasure. She likes English hybrid musk roses and English flowering shrubs. Some, like pink flowering *Lavatera thuringiaca* 'Barnsley', are award–winning English cultivars she has introduced to the U.S. Her *Achillea* 'Salmon Beauty' is the classic yarrow in a new pink hue. Silvery artemisia, santolina, purple salvias, and other Mediterranean plants provide the perfect "canvas" for her roses. ¶ Sarah's domain looks idyllic, but in reality this is gardening against all odds. When she bought her 2/3–acre property, about a mile from the rugged coast, it was a daunting sight. ¶ "That winter, my nephew rowed a canoe across the flooded land. I first had to dig hundreds of feet of ditches for drainage. It's taken ten years to raise the soil level and grow windbreaks

Above and opposite: From
her garden, Sarah Hammond
arranges pink *Lavatera
thuringiaca* 'Barnsley', white
phlox, *Adenophora liliifolia*,
Jasminum polyanthum,
and *Trachelium caeruleum*.
On the wall, an Indian winnowing basket.

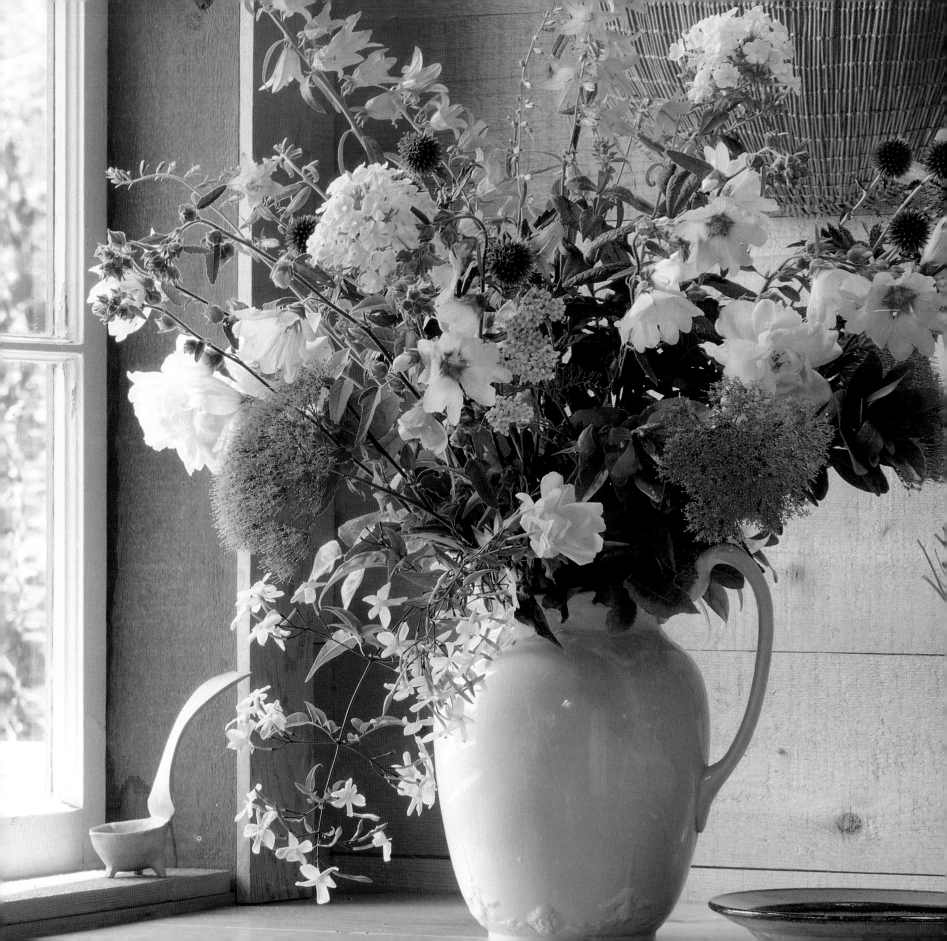

Drifts of purple nepeta (catmint), upright rosemary, and apricot pink 'Penelope' roses "paint" a garden view. Delicate flowers on graceful stems look as dreamy as a Degas pastel. "The plants I use may look fragile, but they're all quite hardy and mostly drought–tolerant," she said.

against howling winter gales," said the hard-working Hammond. The garden is also besieged by gophers. Dozens of large wire baskets protect the roses. Fences keep out marauding deer. Water is scarce in summer. ❡ "Gardeners can create great beauty by choosing carefully. Mediterranean plants like lavender do particularly well here," Hammond said. She uses very little water in her garden and doesn't have a drip system. Instead, Sarah hand waters with care and mulches deeply, saving precious water for her beloved old roses and David Austin English shrub roses. Fine plant choices, hard work, turkey manure, and Sarah's green thumb keep plants healthy through the seasons, in spite of water shortages. Among her favorite new cultivars: white flowering English lavender, golden *Santolina neapolitana* 'Lemon Queen', pink *Oenothera berlandieri* 'Siskiyou', the purple spikes of *Salvia nemorosa* 'East Friesland', and deep pink *Saponaria ocymoides*. ❡ "Varied and harmonious foliage is just as important in garden design as flower colors," said Hammond. Near her weaving studio, Sarah plants flowers with intense color to offset paler blooms. Red *Euphorbia griffithii* 'Fireglow' is one of the few reds she uses. Favorite flowers include the purple cloud of *Nepeta* 'Six Hills Giant', delicate

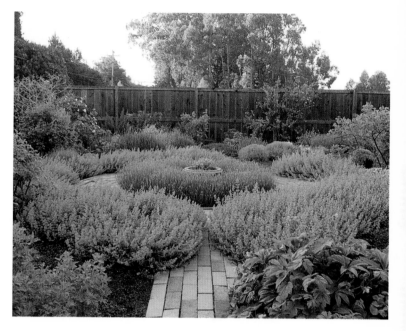

A circle of purple *Nepeta x faassenii* surrounding newly budding *Lavandula angustifolia* 'Martha Roderick' show Sarah's preferred garden palette. The design of this corner, with large–leafed white *Crambe cordifola* in bud beside the fence, and budding pink roses, is still in progress. Shrubs will eventually cover the fence. Hammond is Smith & Hawken's director of horticulture in Mill Valley.

Right: Rough–sawn western red cedar plank walls, pine board countertops, and cedar cabinets were all installed by Sarah, with a little help from her friends. Countertop marble and windows were salvaged from an old house in the neighborhood. *Below:* A reward for Sarah's labor: a glorious bouquet of *Echinops* 'Veitch's Blue', phlox, a noisette rose ('Mme. Alfred Carrière'), jasmine, and David Austin's English shrub rose, 'Tamora'.

pink *Penstemon* 'Evelyn', the hybrid musk rose 'Penelope', and tiny white annual forget–me–not *Omphalodes linifolius*. Sarah built large windows to view her garden from every room of the house. ¶ Sixteen years ago, Sarah's cottage was an "unattractive and unloved" tract house. "The first few years were spent pulling out aluminum windows and hollow–core doors, and keeping out the winter storms," she recalled. With little money but years of slow, quiet labor, she built the new kitchen out of an old concrete–floored workshop, transformed a two–car garage into the airy living room, built floors from salvaged fir boards. She added a studio, where she now practices on her grand piano in the early morning. After Chopin: a walk in the garden to gather armfuls of flowers. ¶ "I prefer simplicity, hate pretension," said Sarah. "The house is my retreat. I find humble materials very comforting and a perfect background for seasonal bouquets. The exterior was built to weather and mellow, as a fine setting for the garden." The house, she said, is by no means finished. "I'm forever improving things, bringing home new treasures from annual horticultural trips to England. Like my garden, the house is definitely a work in progress," said Hammond.

In the dining room, last summer's perennials hang to dry under a skylight. A French pine table, Scandinavian dresser, and comfortable Irish pine chairs in a sunny corner make a wonderful setting for morning tea with Sarah's fresh–baked bread.

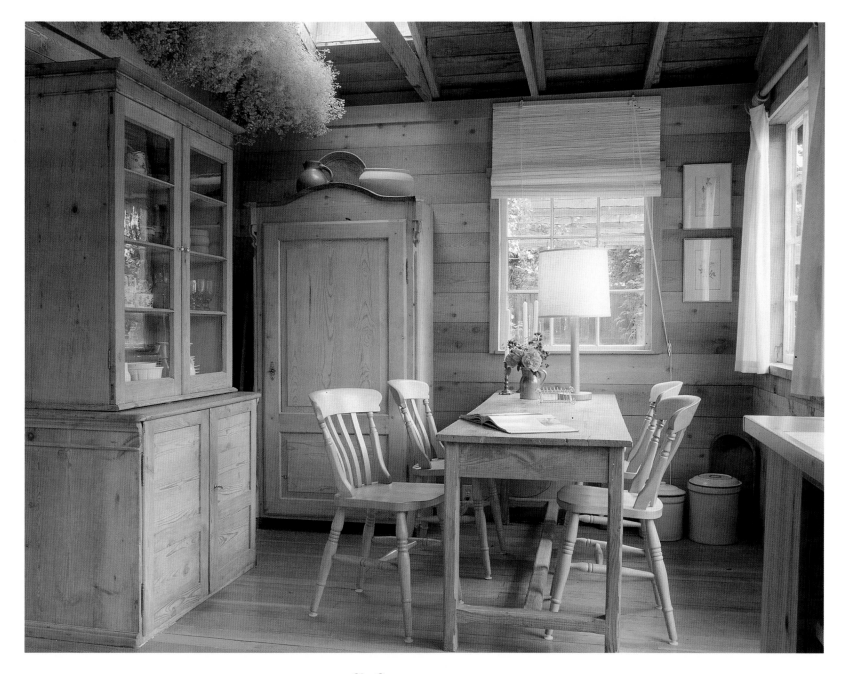

Hill Country

There's barely a square mile of California that couldn't be labeled Hill Country. From the Siskiyou Mountains and Salmon Mountains in the far north to the Sierra Nevada in the west, the arid Chocolate Mountains and Sand Hills near the Mexican border, and the vast Coastal Range that sweeps down the state from Eureka to Santa Barbara, all Californians live in sight of a mountain range. Even from the endless, flat San Joaquin Valley, the foothills, the Tehachapi Mountains, and the Temblor Range soar in the gray distance. Mount St. Helena stands high above the Napa Valley, giving the landscape stature and a bold outline. The Santa Ynez Mountains rise like a rocky backdrop to the genteel towns of Santa Barbara and Montecito, giving these pretty towns a little grit, a bit of backbone. Skiers heading up to Squaw Valley from San Francisco pass towns like Rough and Ready, Emigrant Gap, and Gold Run as they drive from the Central Valley to the Sierra. It's these dramatic uprisings that shape the state and provide some of the most stirring landscapes. ¶ Palm Springs and Rancho Mirage, fabled winter escape routes, are sheltered between the San Jacinto Mountains and the Little San Bernardino Mountains. Craggy ochre hills rise above brilliant green golf courses. In spring, the desert blooms

bright and brave before flowers fade and all that's left are cactus and rocks. Pioneers of the desert had no

architectural precedents and were free to design houses with echoes of Spain, Morocco, New Mexico,

and the space age. Occasionally, high–falutin' Tudor and Gothic styles, quite unsuited to desert climes,

enter the landscape like unwelcome guests. Farther north between the glorious San Rafael Mountains and

the coastal Santa Ynez Mountains, knolls and valleys near Santa Ynez township and Los Olivos have

attracted horse afficionados, talents from Hollywood, and wine makers. People there live in the landscape

with great style and generous spirit. Entertainment lawyer Wally Wolf noted that days are crisp and warm

and that the Milky Way glitters in the evening like a potentate's jewel hoard. Above the towns of Sonoma

and Boyes Hot Springs, on an oak–shaded hillside, the house of a San Francisco family welcomes children

and guests with openhearted hospitality. Tall French doors open to terraces and wisteria–covered loggias.

Over–scale sofas comforted with fat pillows are accompanied by vibrant paintings, cheerful hand–painted

tables, and garden flowers in crystal vases. Jack Russell terriers and children scamper in and out. ❡ On all

these hills, architects and designers have thrown open the doors of their imagination. Houses are graced

with windows that frame the *plein–air* views, and life is lived indoors and outdoors.

On the previous pages, sunset tints the Santa Ynez Valley. Douglas Cramer has created his own verdant territory among ancient oaks and flourishing vineyards.

Santa Ynez Valley
DOUGLAS CRAMER HOUSE

Ambitious gardens designed by landscape architect Craig Johnson include two waterfalls, a pool, a pond containing rare Japanese fish, boulders brought down from the mountains, and many native Californian trees, shrubs, and flowers.

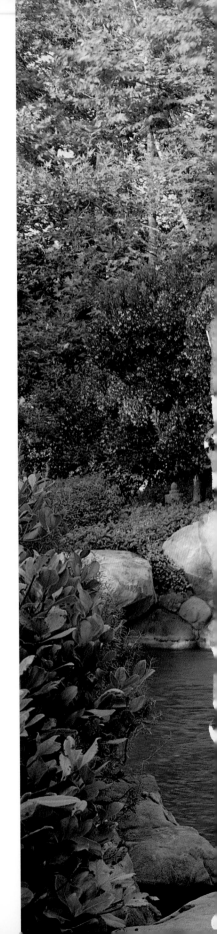

Television producer and art collector Douglas Cramer first came to the Santa Ynez Valley an hour north of Santa Barbara in search of solitude. He had researched properties from as far south as San Diego and north to Napa Valley, but finally settled on this quiet region as his escape route. Cramer, whose career successes have included co-production of "Hotel," "Dynasty," "Love Boat," and mini–series of Danielle Steel's *Crossings* and Jackie Collins' *Hollywood Wives,* lives in an art–filled house in Bel Air, but liked the idea of a country retreat. ¶ Cramer, originally from Cincinnati, engaged Peter Choate Associates to draw up the house plans. He flew north to San Francisco and per-suaded interior designer Michael Taylor to design the 21,000–square–foot house and a 4,000–square–foot guest house. That was the beginning, recalled Cramer, of the three–year project creating La Quinta Norte. Cramer and Taylor found the floor's gold–streaked slate near Yosemite. Taylor designed everything, down to slate tables and great outdoor planters, for his perfectionist client.

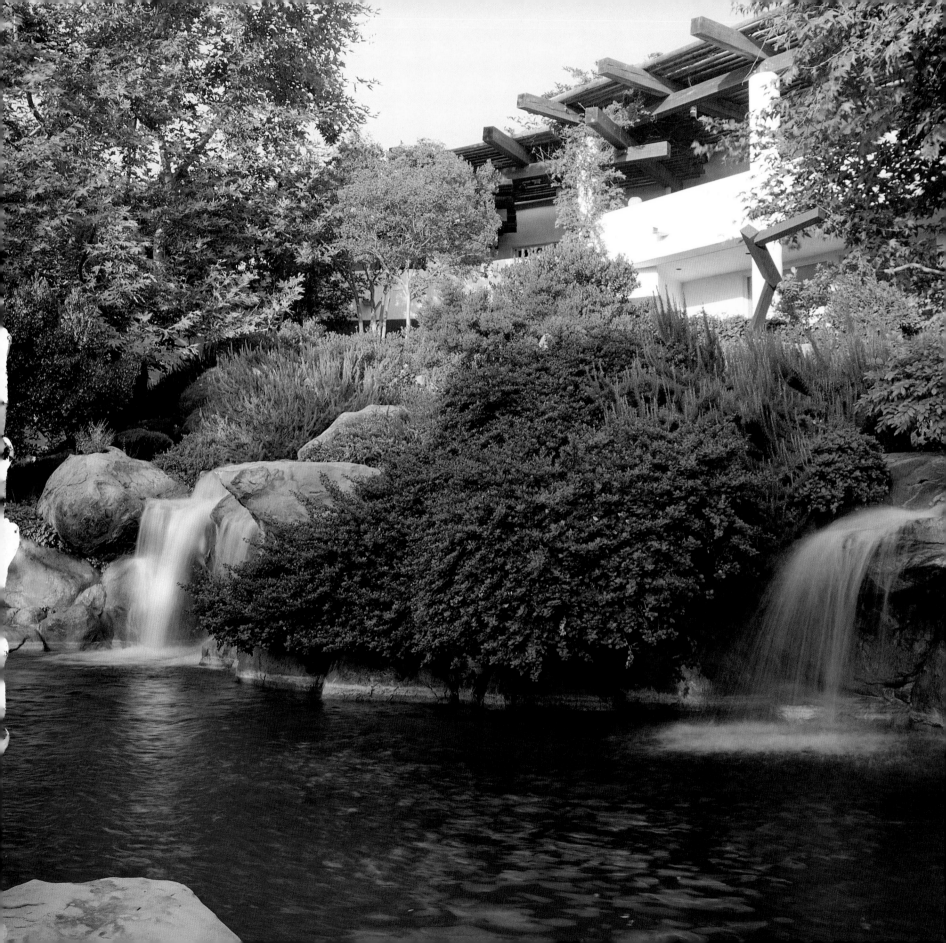

Above: A sculptural old winepress stands in contrast to the curves of the entry stairway. In summer, the cool interiors are a welcome respite from days that may reach 100 degrees. *Opposite:* A 1983 sculpture, *Sleeping Muse,* by Roy Lichtenstein, is shown on a mantel.

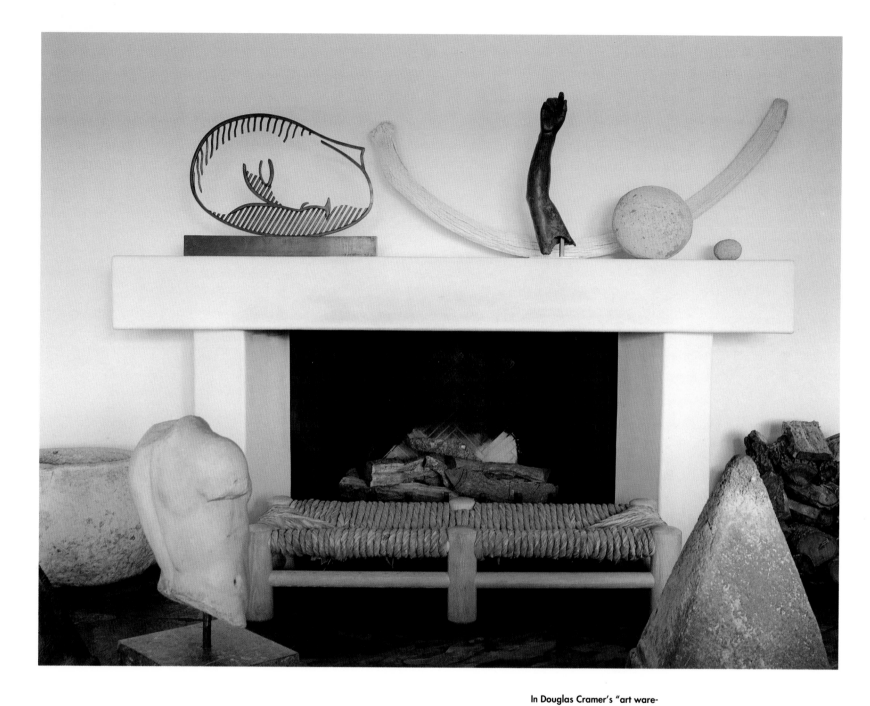

In Douglas Cramer's "art warehouse," he displays works from his considerable collection of art of the last two decades, including pieces by Anselm Kiefer, David Salle, Jim Dine, Jasper Johns, Frank Stella, Eric Fischl, John Baldessari, Ross Bleckner, and Barbara Kruger.

Michael Taylor was the master
of a sopisticated mix of natural
materials finished in the most
luxurious way. Colors inspired by
the great outdoors are soothing,
timeless. Here, cushy armchairs
surround the plaster fireplace.
Taylor, a man of stature himself,
preferred over–scale furniture.
He designed generous tables and
rustic pine dining chairs,
opposite, and oversaw every
detail of the house.

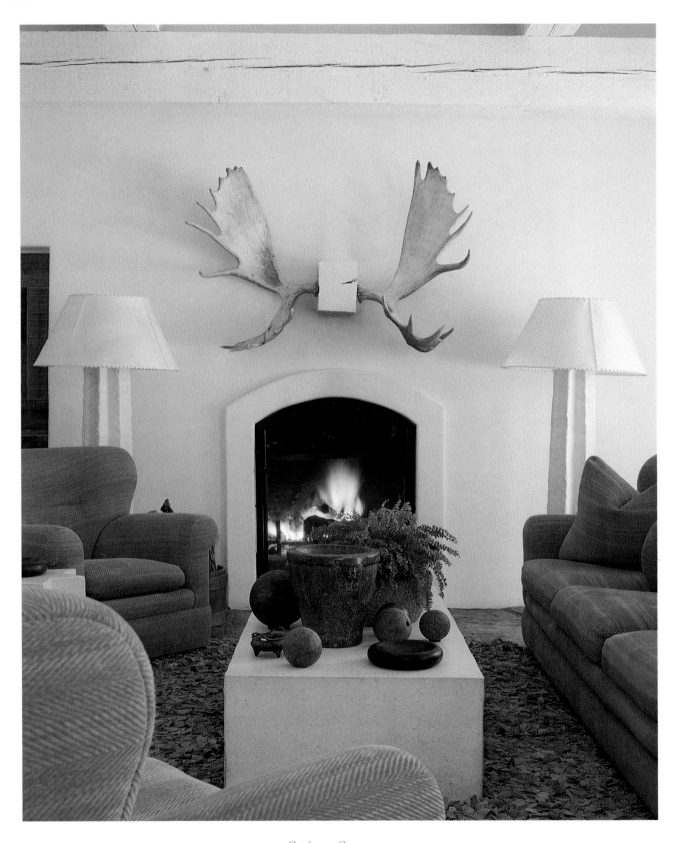

Sweeping terraces and shaded loggias surround the house and provide Cramer with a place that is visually exciting. In each room, Taylor's signature may be found. Plaster banquettes are pillowed with natural handwoven Haitian cotton. Rush–seated pine chairs, weathered redwood sofas and chairs, a refectory table, cachepots, coffee tables, dining chairs, *chaises longues*, and sconces are all part of Taylor's enduring design legacy. And on each wall, in hallways, on mantels, and hanging from ceilings are but a small portion of the art collection. Fortunate, indeed, is a guest in Cramer's kingdom.

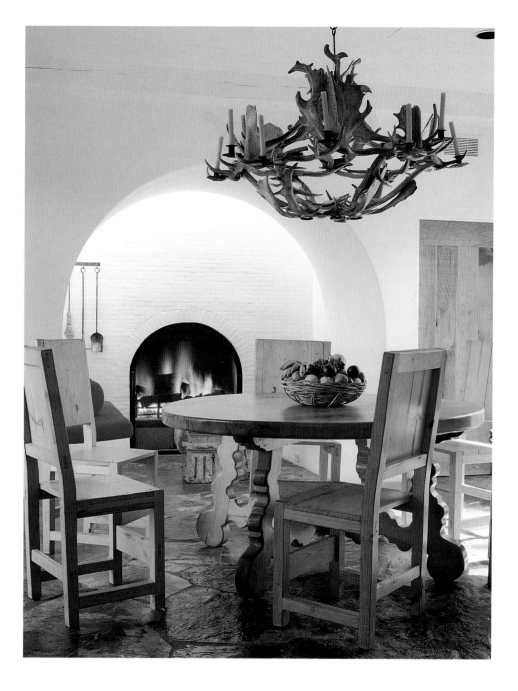

The two–story house has a rustic board–and–batten exterior. Giant granite boulders surrounding the house create a powerful private landscape. Hummingbirds love the red flowers in the bottlebrush and sometimes even fly into the house. After a soothing sojourn, it's always hard to go back to the city, said Webb.

Montecito, situated between the rocky Santa Ynez Mountains and the Santa Barbara coast, is simply one of the most beautiful towns in California. The powerful setting reminds some visitors of historic Deya, Majorca, which stands in a similar verdant valley between the towering craggy massif of the Puiq Mayor and the historic cliffs of the balmy Balearic shore. Designers Kalef Alaton and Ralph Webb discovered Montecito under the happiest circumstances. Friends moved there from Los Angeles and encouraged their chums to find a house nearby. ¶ "We ran around and finally found a renovated fifties house in the middle of a citrus orchard. The rooms had such wonderful light. From every window, we could see trees and flowers and boulders. It was quiet and very secluded. We took it without a second glance," said Webb, who runs a silk importing company in Santa Monica. Alaton had been an interior designer since he was a teenager in Istanbul. Webb's early design training was by fire with Alaton's firm more than 20 years ago. ¶ "We loved the idea of going country. Our house in Los Angeles was very oompahpah, with grand chandeliers, serious antiques, and gilded furniture. In Montecito, we wanted a playful look. We wanted

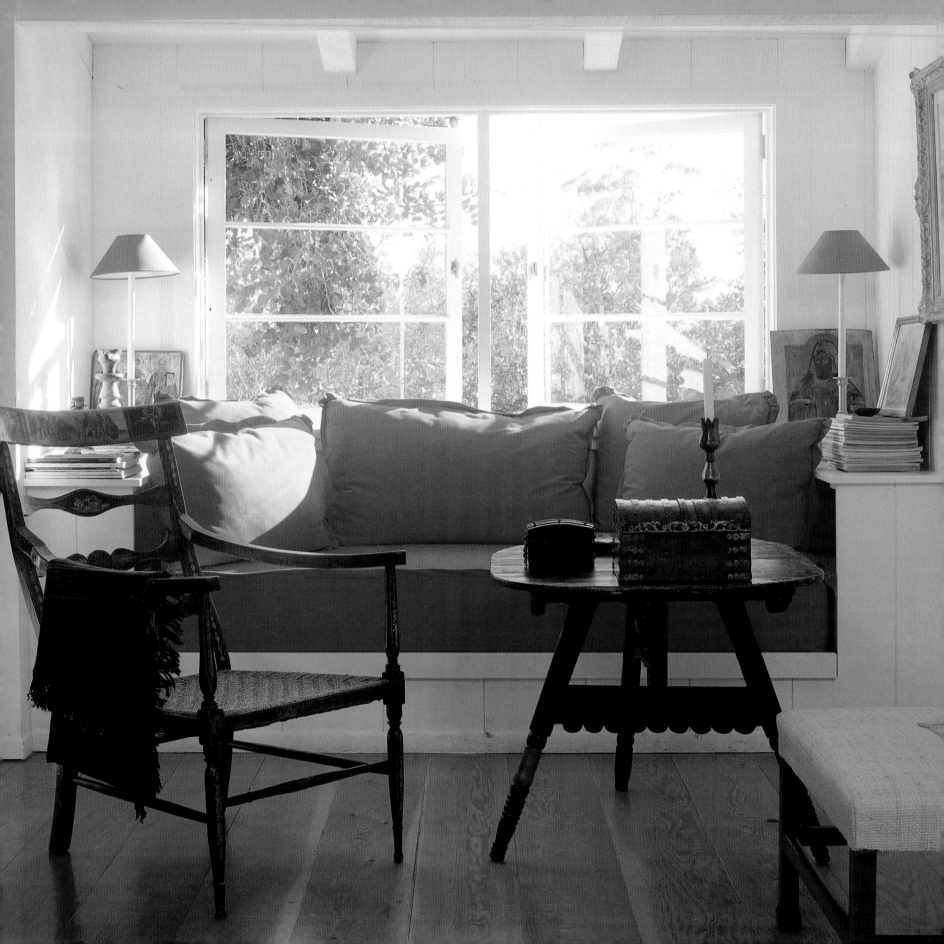

In the living room, a crimson cotton canvas banquette adds a jolt of color. Webb's collection of American antique wooden toys—including rocking horses, wooden trains, and a menagerie of animals—animate the scheme. Furniture looks like the accumulation of years; it was purchased in less than a month. Working toward a rustic, low-key design, they nonetheless pulled it off with a certain élan. Georgian wing chairs, an 1820 American painted chair, a Victorian spindle chair, a George IV light rosewood chair, and a nineteenth-century French fruitwood chair upholstered in French calico bring the rooms variety and vitality.

"Friends and food, that's what it's all about," said Webb. The well-equipped kitchen is open to a spacious dining room with a ten-foot-long pine table and capacious wicker chairs. An off-kilter American carved and painted wooden goose makes a witty centerpiece. Antique Turkish cooking vessels were collected by Alaton.

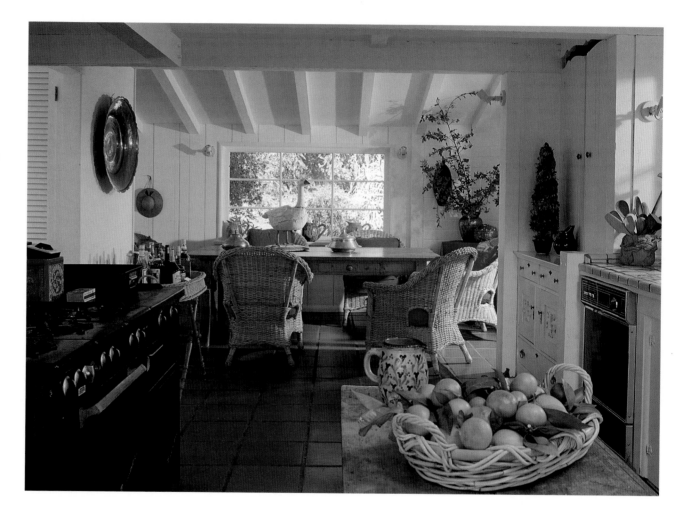

Opposite: A carved and gilded English hunting lodge mirror hangs over a seventeenth-century Spanish walnut table. The pine chair is a reproduction of a Regency "bamboo" chair.

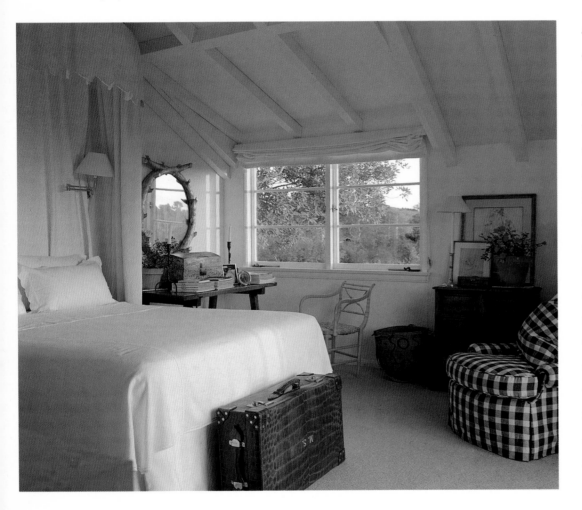

"Keep It Simple" was the motto. In the white-on-white master bedroom, the bed draperies and canopy were custom-made from French cotton *matelassé* wedding blankets. Windows overlook the orange orchard.

a break from design," recalled Webb. ❡ "We gave ourselves a month to get it together. We ran around Los Angeles furiously and took a quick trip to Paris and London. I bought the fabric, shipped it to the upholsterer overnight and asked for delivery in four weeks. Everything materialized. They were just finishing laying the carpet as we brought furniture into the house," Webb said. "Years of experience in the design world give you the confidence to make decisions fast." They had a month to buy glasses, cutlery, candles, quilts, towels, lamps. They couldn't procrastinate. ❡ "We wanted the house to feel cozy so that you could wear Gap clothing and walk around with bare feet. Cotton was our fabric of choice. Kalef and I dyed the cotton draperies with tea in the washing machine. They hang on unfinished pine poles," said Webb. The floors are Mexican pavers or 12-inch pine planks. The living room, sunroom, and kitchen all have doors leading to shaded terraces. ❡ "We love to have our friends come and visit. Montecito is a great retreat from the cacophony of lives in the big metropolis," Webb commented.

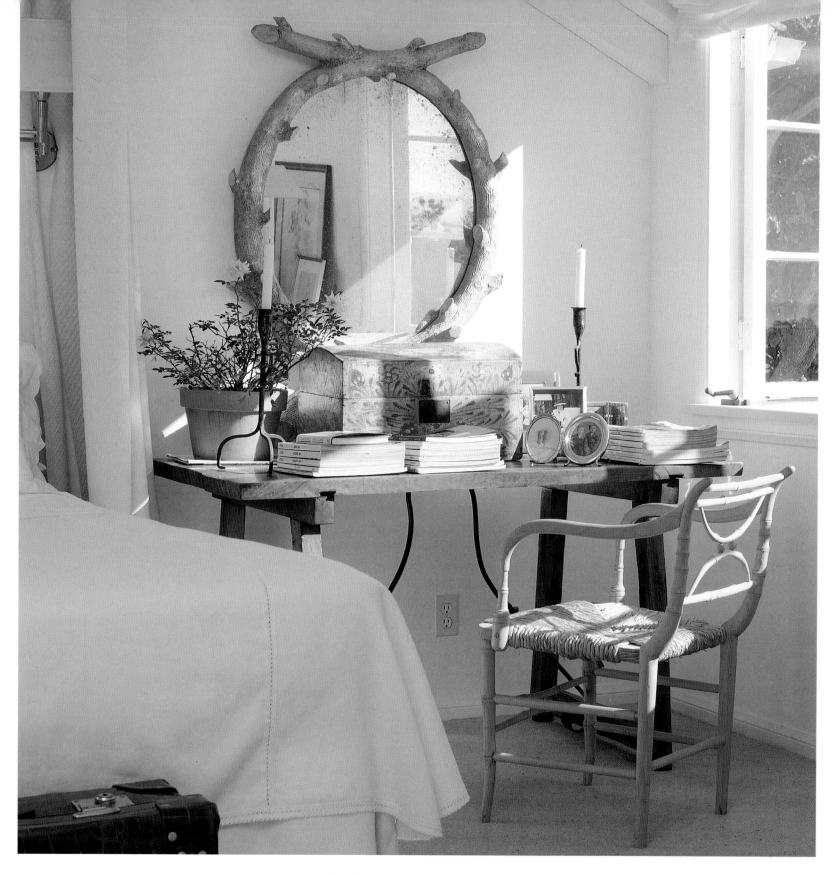

Santa Ynez Valley
CAROLYN AND WALLY WOLF HOUSE

O riginal interior design is no accident. It takes vision on the part of the designer and the appreciative, open minds of his clients. San Francisco interior designer John Dickinson often said that clients could hamper good design in seconds. ¶ Entertainment lawyer Wally Wolf, his wife, Carolyn, and children, Lori Anne Grillias and JonWolf, made a formidable team to encourage and complete San Francisco designer Ron Mann's ideas. "I wanted to make a miniature villa for my clients," recalled Mann. He skinned the house back to the roof, opening up the ceiling and exposing beams and structure. Mann changed the floor plan, switching the kitchen and living room. Without extending the roof line, Mann moved an exterior wall out to create a new dining room. He created multiple floor levels by rebuilding the floor on a lower level. New floors were made of 2" x 16" Douglas fir planks milled at the turn of the century and salvaged from an old commercial building. Between each plank are white cement "ribbons," an idea originated at Mann's Montara beach house and often emulated. The new

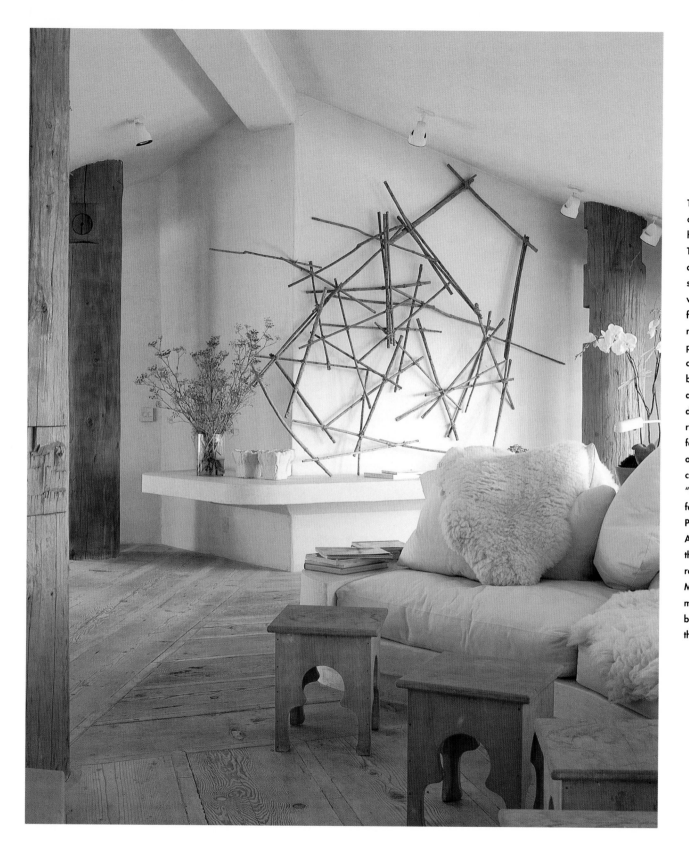

The board–and–batten house, completed eight years ago, has been superbly maintained. The living room fireplace stands as part of a central support system. Hand–cut eucalyptus wood is stacked ready for evening fires. *Left:* A wall sculpture was made by Lori Anne Grillias from pieces of a Mexican packing crate. Pine tables, designed by Ron Mann, were inspired by antiques salvaged from the dressing room of an ice–skating rink. "The rooms are all about forms and texture. The repetition of shapes and natural colors creates the pattern," said Mann. "I stay away from patterned fabric. I like interiors to be simple. Patterns are too decorative. Anyway, people add the color, the interest. It's peaceful in these rooms, and people look great." Mann made the small house seem much larger by creating free–form banquettes and plastered shelves that keep the floor free of clutter.

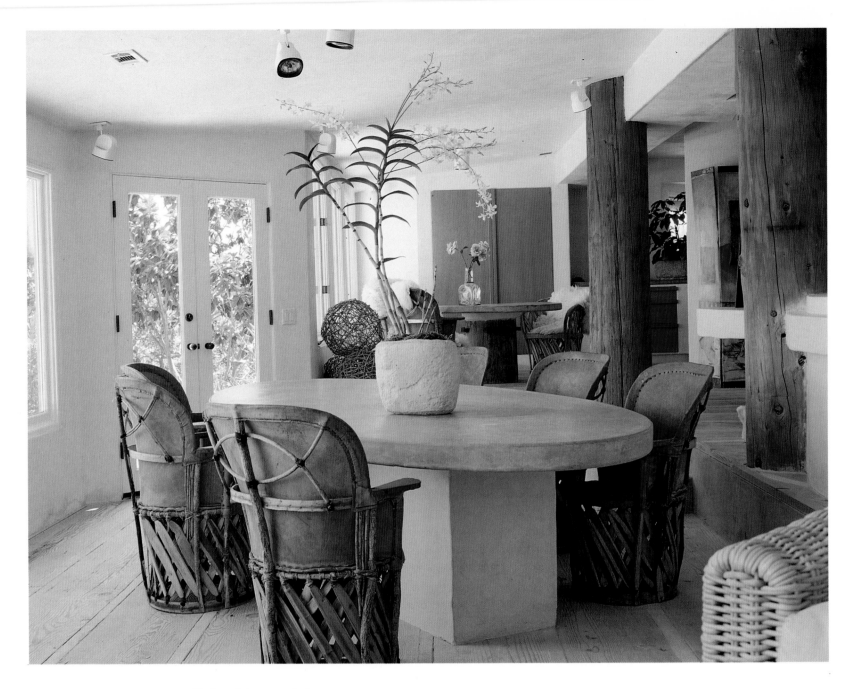

The house is in a very private
setting on a knoll, and windows
were left bare. A poured–in–place
concrete table seats 12 guests.
Orchids by Grant Grow and Rick
Shattuck of In Bloom, Santa Ynez.

interior walls were finished with rough stucco intended for exterior use, another idea he pioneered in 1975 at his highly influential beach house. "It was quite radical. We removed cross-beams and ties, took out walls. We left all load–bearing walls and then added support structures like the fireplace columns. These eight 22"–diameter stands of Douglas fir, salvaged from a Canadian World War II blimp hangar, became at once architectural elements and an imposing part of the new design. The Wolf family also gives great credit to contractor Tony Urquidez for his imaginative and brave work on their house. ❡ "From every window, we can see centuries–old oaks and glorious vistas," said Wally Wolf. "There's a spiritual magic about this valley....We enjoy a very comfortable freedom here. We're just 15 miles as the crow flies from the ocean. Every evening when the sun goes down, the house takes on a magical mood. Out in the garden, the air is so clear, we can see all the constellations of the Milky Way." ❡ With professional and family ties to Los Angeles and a country house that gives them great pleasure, the Wolfs seem to enjoy the best of all worlds.

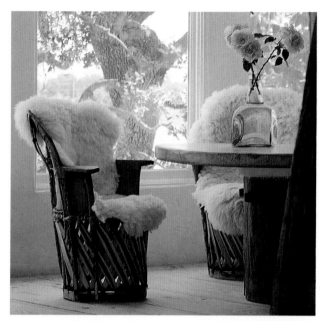

In the informal dining area, Mexican equipales chairs surround a pine–topped table. An old timber door was found on a farm in Majorca.

Opposite: In the guest bathroom, a sculpture of *objets trouvés* was made by Lori Anne for her father. All of the roses in the house were grown by Carolyn Wolf. In the study, wide fir shelves back a plaster desk. In the master bedroom, *right,* over–scale chairs by Wicker Wicker Wicker and a Mann–designed stone pillar lamp surround the fireplace. Sculpture by Lori Anne Grillias.

The cottage is surrounded by great old black oaks, ponderosa pines, Douglas firs, California bay laurels, madrones, and manzanitas. Deer nap in the leaves underneath the firs at the end of the covered porch. Four-legged birdhouse made by Max.

Around 1927, a retired San Francisco shipbuilder built a summer cottage on the slopes of Cobb Mountain, halfway between Calistoga and Clear Lake. In summer, the Johnstone family would head north to Anderson Springs and stay for long weekends. Outfitting the cabin, penny-wise Johnstone *père* salvaged treasures, including a massive cast-iron wood stove retrieved from a naval vessel that had sunk in San Francisco Bay. From a Matson cruise liner, he salvaged two wooden panels intricately carved with classical urns and chrysanthemums and built a new fireplace mantel around them. Galley cupboards and a draining board were foraged from another vessel and rebuilt in the kitchen. ❡ Sixty years later, San Francisco graphic designer Laura Lamar and her husband, illustrator Max Seabaugh, happened upon the cottage while on a ramble with friends. They eventually bought the house from the builder's grandson and immediately began a three-year renovation. ❡ "The house had never been used year-round," recalled Lamar. The remodeling encompassed new telephone lines, insulation, rewiring, replumbing, and eventually installing an EPA-approved, low-emission woodstove in the old living room fireplace when the chimney was deemed

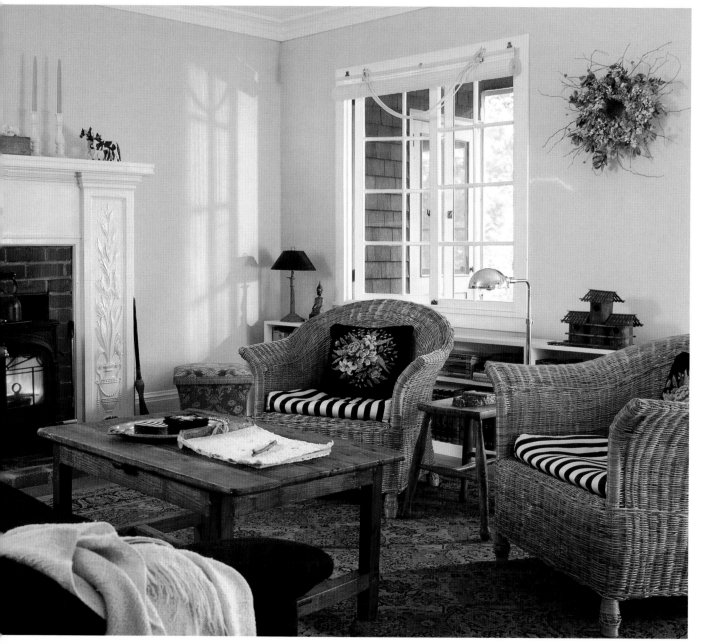

In the evening and on winter afternoons, friends gather in the living room with its wicker chairs, an antique Irish pine table, and bamboo birdhouse. The dining table, *above,* was originally an elementary school library table: it still has crayon scrawls on top and bubble gum underneath.

The wonderfully renovated
and art–directed summer
and winter kitchens show
Lamar and Seabaugh's
appreciation of the past.

unsafe. ¶ "At first, we were always up at the cabin cleaning, scraping, and painting. We're finally enjoying the fruits of our labors," said Seabaugh. ¶ The couple was fortunate to find a team of local contractors, Old Timers Construction Company, which adopted them and the old house. "The house had such good bones that we just had to uncover what was there. It had been beautifully crafted. You have to look twice now to see what was original and what's new," said Lamar. "We based our color scheme on an old German vegetable seed packet engraving. It's a complex but subtle combination of pastels, neutrals, and brights." ¶ "Now we go up to the cottage almost every weekend and usually invite guests," said Lamar. Max is an accomplished cook, so the usual program at the cottage is to eat, drink, and relax. Guests can go antiquing in nearby towns, go for long walks in the woods, take bicycle rides, stack wood, collect pine cones, or swim in the icy, spring–fed swimming hole down at the neighborhood recreation center. "Our cottage seems to evoke everyone's childhood memories and adult fantasies. We call it Butch and Lulu's Summer Camp for City Kids," said Lamar. "We can't believe how lucky we are."

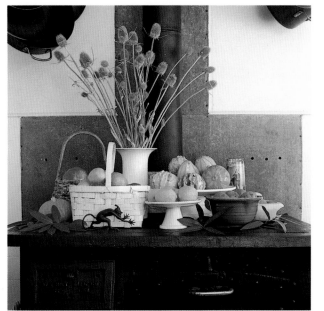

One kitchen is old–fashioned with a wood–burning stove. The other, formerly a dining porch, is now all–electric, with a stove and refrigerator. Windows overlook the forest. Painted floorcloth in the winter kitchen from Fillamento. A collection of Bauer and Catalina pottery bowls and vases line old galley shelves. "Many of the collections in the cottage started from seminal pieces from our grandparents," Seabaugh said. Lamar's grandmother's and great–grandmother's ivorine hand mirrors (ecologically correct collectibles today) inspired a large cache of ivorine and sparked the creamy yellow color scheme for the bathroom and guest bedroom. A fine old Wallace Nutting print that hung in Lamar's grandmother's guest room led to a search for Nutting's hand–tinted photos that now hang throughout the house.

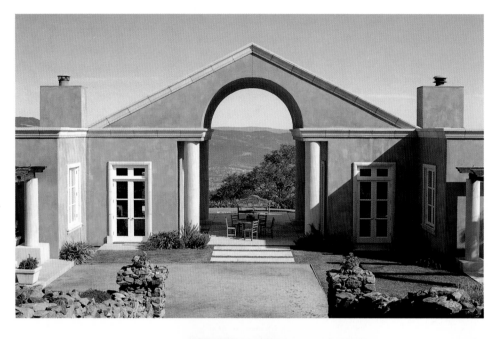

I n the hills above Sonoma, a San Francisco executive, his wife, and their three children treasure a house they expect to belong to the family forever. "This is much more than a weekend house for us. We move up there in the summer. We have Peruvian ponies, thoroughbreds, and a quarter horse that require a great deal of time and attention, so we're always down at the barn," they said. There are also two deer–proofed gardens, where the family grows vegetables and fruit and flowers. The children play beneath a majestic spreading oak tree near the house. ¶ When they first decided to build on their 200–acre property, the owners consulted San Francisco designer Chuck Winslow on siting and on shaping the rooms. "We planned each room for complete flexibility. Nothing is static. As the children grow, rooms change," said Winslow. ¶ "When we walk outside at night, we can hear coyotes and bobcats and see the stars twinkling. We feel close to nature. It's really wonderful," said the owners. They view the architecture as an on-going process. Eventually they'll build a pool and a pool house below the terrace, plant more old roses, add trellises for grapevines. The life of this house will only grow richer.

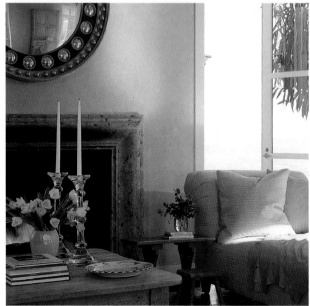

Working closely with interior designer Chuck Winslow and with architect Nan Hearst, the owners fine–tuned every detail. The house measures just 3,000 square feet. Thick walls, tall windows and doors, and a soaring central arch give the two pavilions stature and grace. In the living room, an over-stuffed chaise and sofa afford comfort around the welcoming fireplace. Lead crystal candlesticks and painted tables from Flush, San Francisco.

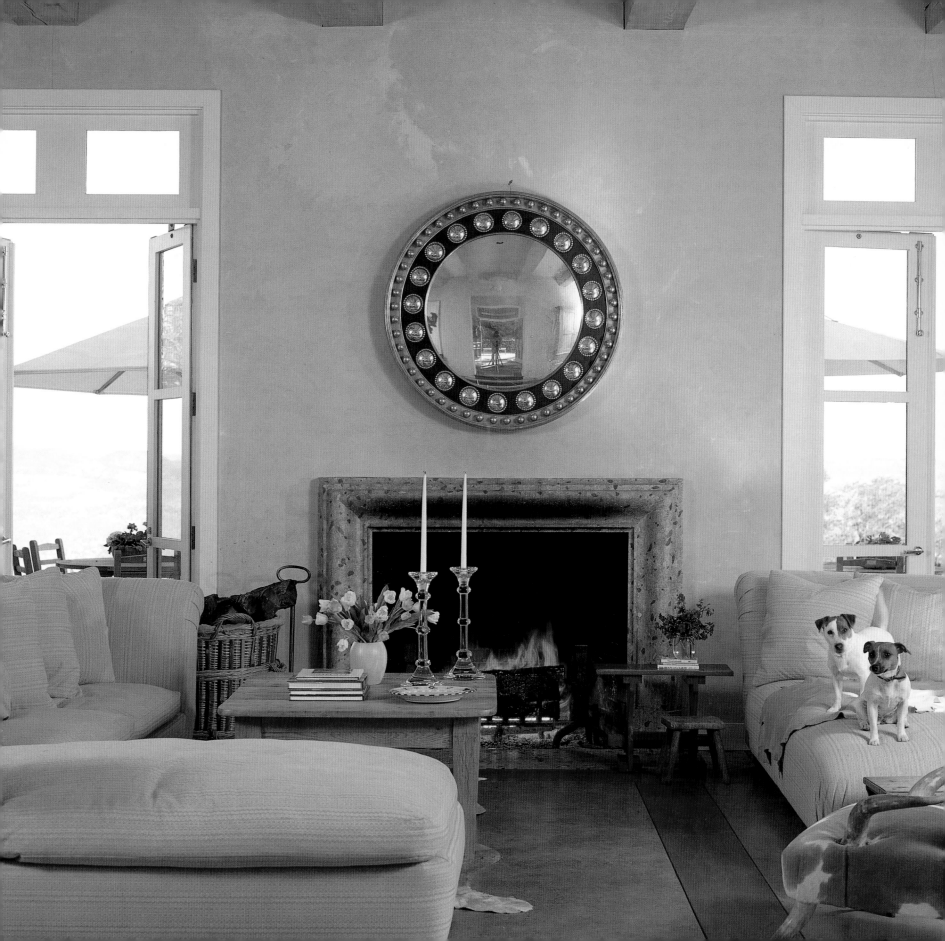

With an inviting, pillow–plumped sofa set on the diagonal, a chrome–yellow painted table and chairs–of–character, this corner of the living room invites children and adults to sit and read. "We wanted the rooms to look a bit offhand, not planned or stiff. The chairs and sofas say, "Come and sit in me," said San Francisco designer Chuck Winslow. Painting by Billy Sullivan. From the front of the house, vistas open to San Pablo Bay to the south and the Sonoma Valley to the northeast. Ponies and cattle in the meadows enhance the bucolic scene.

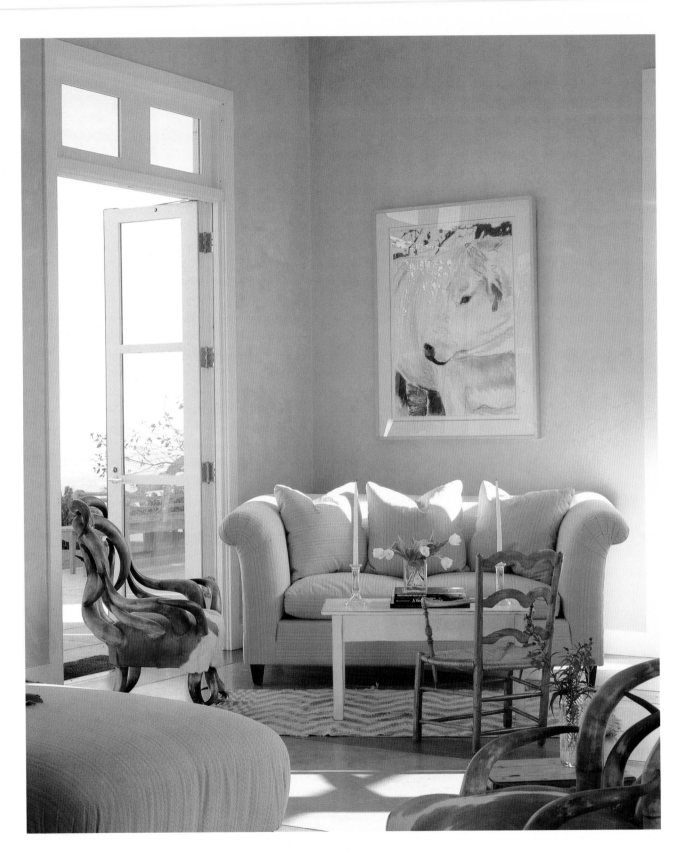

The owners have made the dining room and living room into one grand gathering room for the family. Doors on all four sides lead outdoors. Winters in Sonoma are usually mild, so they eat breakfast and lunch out on the terrace year–round. Rush–seated chairs have pillows upholstered by Fitzgerald in a Manuel Canovas cotton. Walls are pale ochre integral–color plaster. Gouaches by Robin Bruch. The floors are *faux*–stone painted concrete with bands of waxed oak planks.

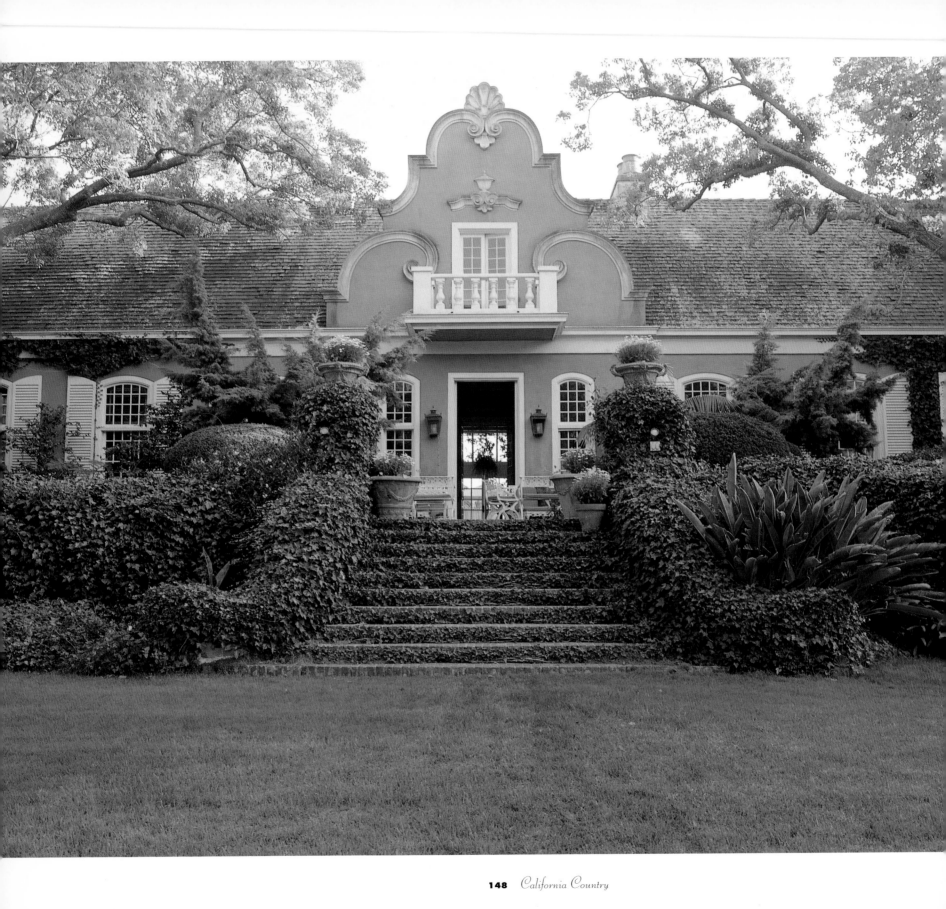

U p in the hills beyond Santa Barbara, some of the most beautiful houses in the state are hidden away behind bosky thickets of native trees, tall hedges, and carefully tended gardens. Unless an invitation is offered, it's impossible to see the facades, even from a distance, so carefully planned is their privacy. So it is with Stewart and Katherine Abercrombie's Montecito house, Constantia. The Dutch Colonial estate had originally been designed by Ambrose Cramer in 1930. ❡ Across the horizon of their swimming pool, beyond a well–tended citrus orchard, they can see the horizon of the Pacific Ocean. From the French doors of their living room, they enjoy magnificent views of the surrounding trees and the craggy hills . No man–made structure destroys the fantasy that they are far from the cares of civilization, on their own island. Guests like the Dalai Lama and the crème de la crème of Montecito and Santa Barbara approach the house along a dusty road, then enter a walled courtyard. The house reveals itself slowly as visitors walk first to the loggia, to be offered a cool drink, and then out toward the pool or the lake. ❡ When the stylish Abercrombies bought Constantia in the late sixties, it needed careful restoration. Katherine had been

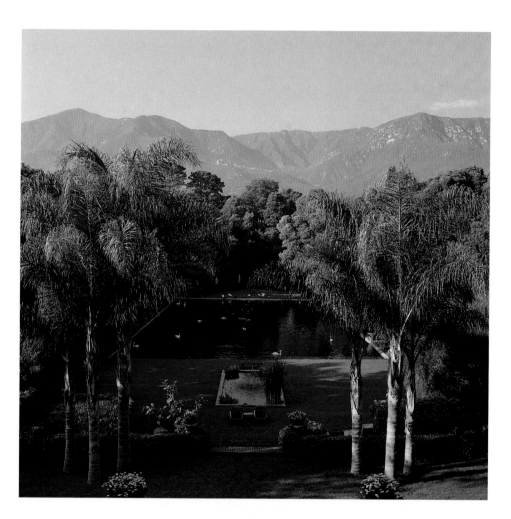

From Constantia's windows and front terrace, the Abercrombies can see Lockwood de Forest's formal gardens. The Santa Ynez Range rises above their swan lake. The view from the garden, too, is extraordinary. Ivy–cloaked stairs lead to the house, its design inspired by Cape Dutch architecture.

Venetian red silk–upholstered walls
were Katherine Abercrombie's
choice for the beautifully propor-
tioned living room, *below*. An Italian
chandelier, several polychromed
santos, a grand limestone fireplace
show her cosmopolitan approach.

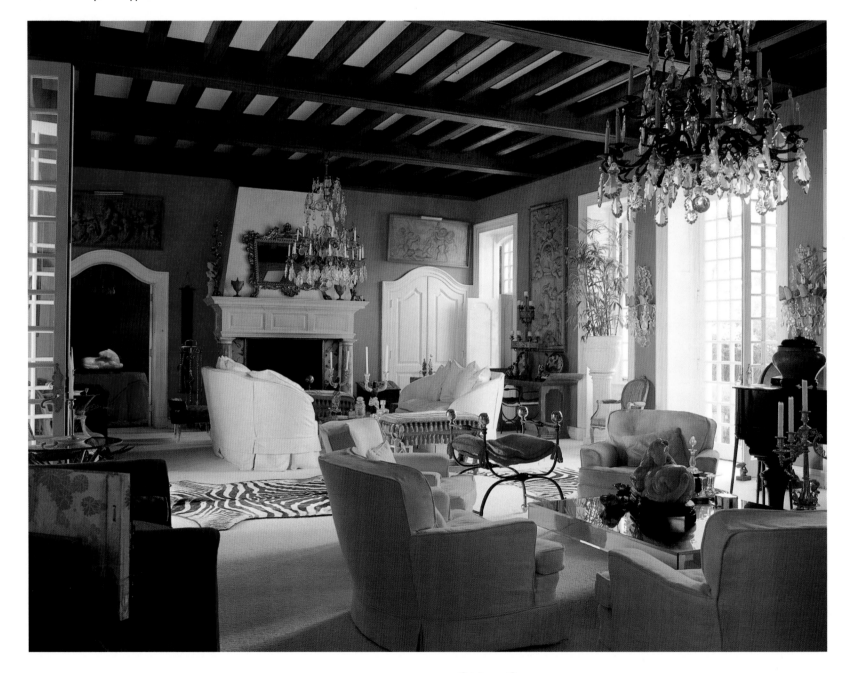

living in Cuernavaca, refurbishing and designing houses. Stewart was a very successful cattle rancher. Together they set out on the long path of renovation, doing much of the work themselves. Made–with–her–own–hands cotton canvas slipcovers show Katherine's fearless approach to interior design. She also designed and made bed draperies that have as much style as a Balenciaga ballgown. ¶ Doors in the living room lead to a stone terrace, a privileged position for swan–watching and mountain–range contemplation. It's on the quiet terrace that the couple like to gather their friends as the sunset paints the hills first golden, then pink. The evening turns cool, the swans turn in for the night, and still it's not easy to go inside and leave this wonderfully symmetrical scene. ¶ Both Stewart and Katherine Abercrombie love to cook. They're consummate entertainers. Their pleasure may be a spur–of–the–moment invitation to new friends met at the nearby San Ysidro Ranch, a thought–provoking meeting with the merry Dalai Lama, or a superbly planned dinner for 20 in a draped and decorated marquee. As the Abercrombies make hors d'oeuvres or prepare a pitcher of lemonade in their kitchen, they're surrounded by favorite things, the collections of rich lives.

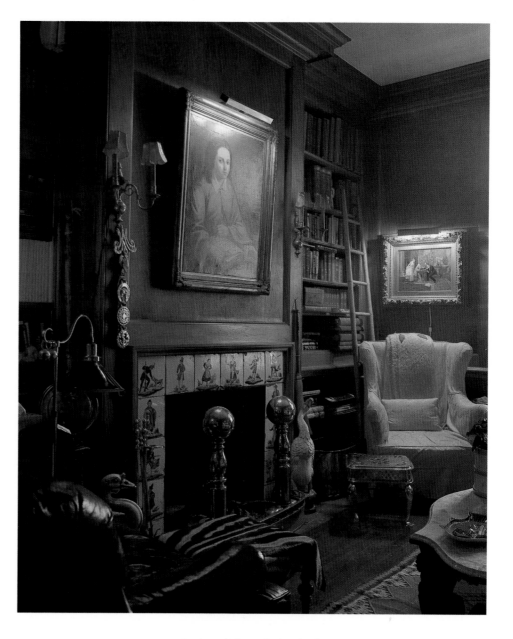

Specimen shells are displayed with precious sculptures, Mexican paintings hang beside a collection of grisailles. Warm colors enrich the library, *above,* with its fireplace of hand–painted tiles.

I n Rancho Mirage, southeast of Palm Springs, where summer temperatures of up to 115 degrees sear the landscape and exhaust the mind, a house becomes much more than shelter. It's a cool, calm refuge for rest and reflection. Come November, of course, desert days are gentler. That's the time when "snowbirds" fly down from the north to escape long, cold, rainy winters. The air is fresh and clear, and tennis courts and golf courses spring to life. ¶ For clients of more than ten years who found their "winter" house with glorious views of the hills, a lake, and a golf course, Seattle designer Terry Hunziker has brought together interiors of great character and timeless style. The couple, like Hunziker himself, are passionate collectors of art and fine crafts. It was obvious from the start that the house would be designed as a fine showcase for superb modern glass sculptures, museum–quality paintings, hand–loomed fabrics, and well–chosen antiques. ¶ "The colors were a very important part of the design," said Hunziker. "They had to establish a refreshing, calm feeling. Tones of celadon, gray, taupe, pale oyster, steel blue, and pewter predominate."

Wooden shutters filter the intense desert light and re–emphasise the large–scale art. At night, *opposite*, doors are opened to the cool twilight and the hills. Hunziker designed the steel game table.

The living room was given dimension and light with a wood, glass, and steel screen. Hunziker's masterful mix of textures includes a coco rug, natural linens, wool twill, smooth wood, and frosted glass. *Right:* A quartet of etchings by Terry Winters and an Empire–style canapé. The round metal and wood table was designed by Hunziker.

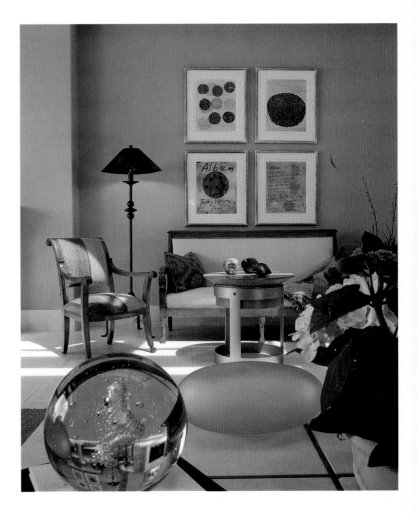

The designer, who seldom uses pattern, has achieved a look that is at once rich and rather spare. Nothing is overdone, exaggerated, or excessive, but everything necessary for a comfortable southern sojourn is there. It is also orderly and uncluttered. In this house, the slight formality is rather soothing. ¶ "I decided to use a minimum of floor coverings. The floors are custom-colored cast concrete pavers laid in a grid. Except for coco matting and a fine antique Bessarabian-style rug, the floors are mostly bare," said the designer. ¶ Paintings and sculpture by northwest artists predominate. Several art glass pieces are by craftspeople who work with glass master Dale Chihuly. Han Dynasty vessels, a collage by Paul Horiuchi, wood-block prints by Helene Wilder, and a glowering-bird painting by Cheryl Laemmle combine with Hunziker's interiors to make this a very personal retreat.

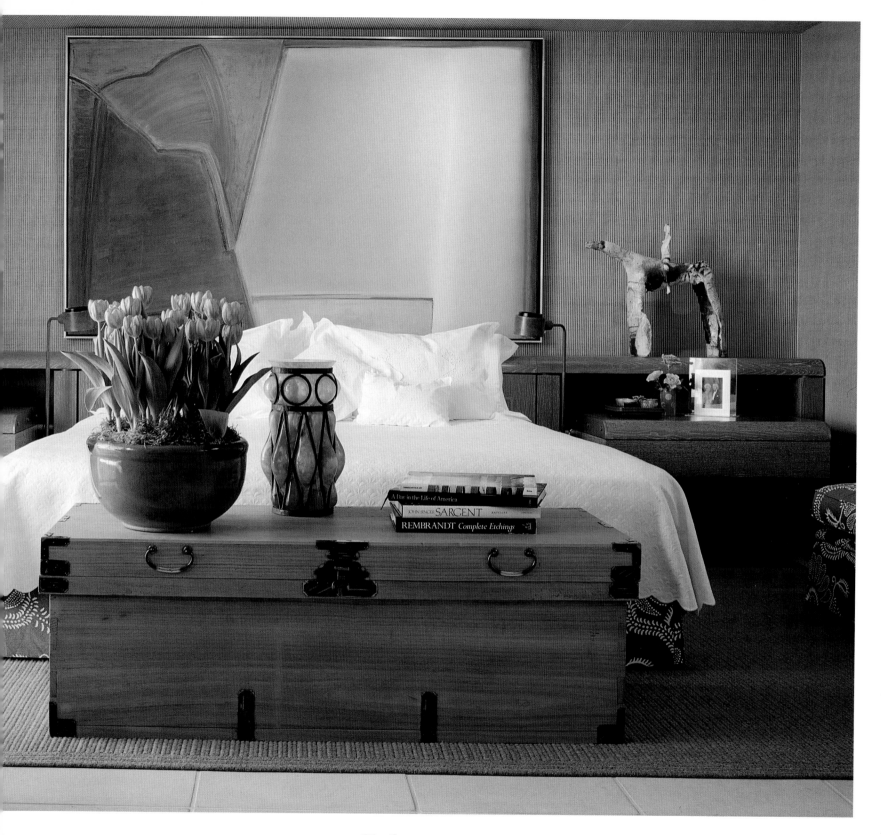

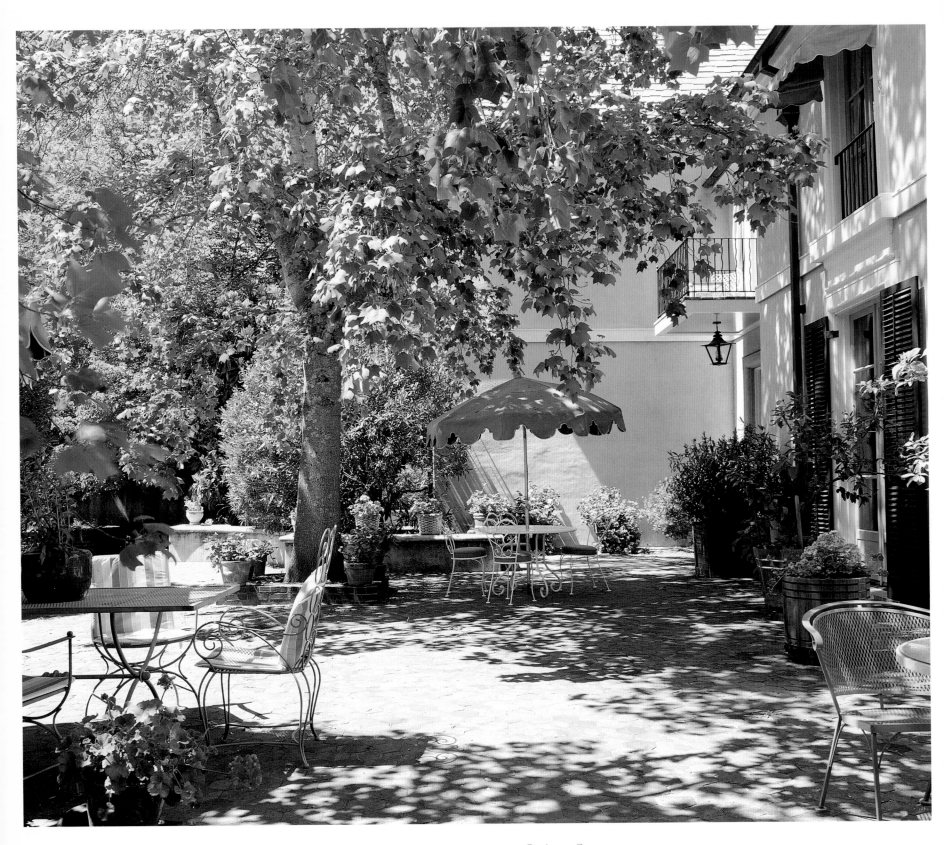

In the western foothills south of San Francisco are several friendly, horsey towns, home to some of the most handsome estates. In the middle of a beautiful meadow surrounded by old redwood trees stands a house whose design was inspired by the owner's travels and her admiration of Austrian architecture. It stands on 40 acres, and an adobe cottage built in 1850 still stands in the garden. ¶ The owner, a woman of great taste, is not afraid to mix styles with bravado. Fabergé cozies up to Cost Plus, Victorian family heirlooms are placed next to new leather chairs, elegant French furniture, and several important French paintings. Fine French silk brocade pillows accompany rather rustic Pierre Deux cotton pillows. Belvedere interior designer Corinne Wiley has worked on four houses for this owner, and the two have become great friends. Now Wiley has an ongoing role designing, updating, and refurbishing this house. ¶ "My client has always been surrounded by beautiful things. She was not of a generation that worked, so she has educated herself in the fine arts and has been a mentor to me," said Wiley.

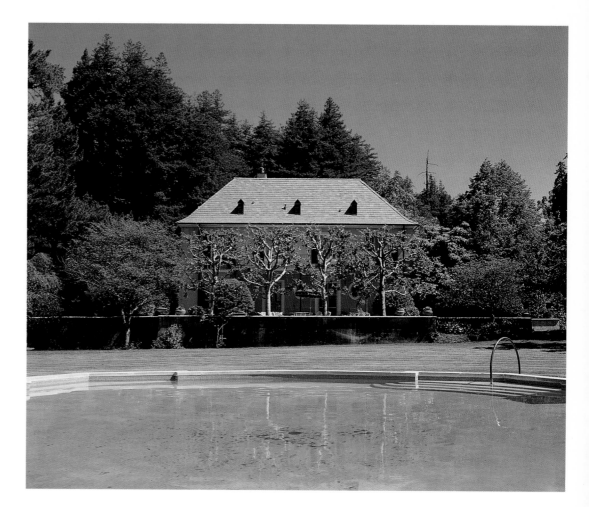

Plane trees shade the Thomas Church–designed terrace. Golden yellow was chosen for stucco walls in homage to the rococo Schönbrunn Palace near Vienna, Austria. The circular pool in the garden has a striped canvas cabana. The house was built in 1966.

Hand–painted dime–store lanterns were left hanging after a party because the owner doesn't want the room with its 16–foot ceilings to feel too grand. Still, with a fine Sarouk rug, 30' x 45' dimensions, and tall windows overlooking the garden, the room has great presence. The gold–framed landscape, *opposite,* is by Gustave Courbet.

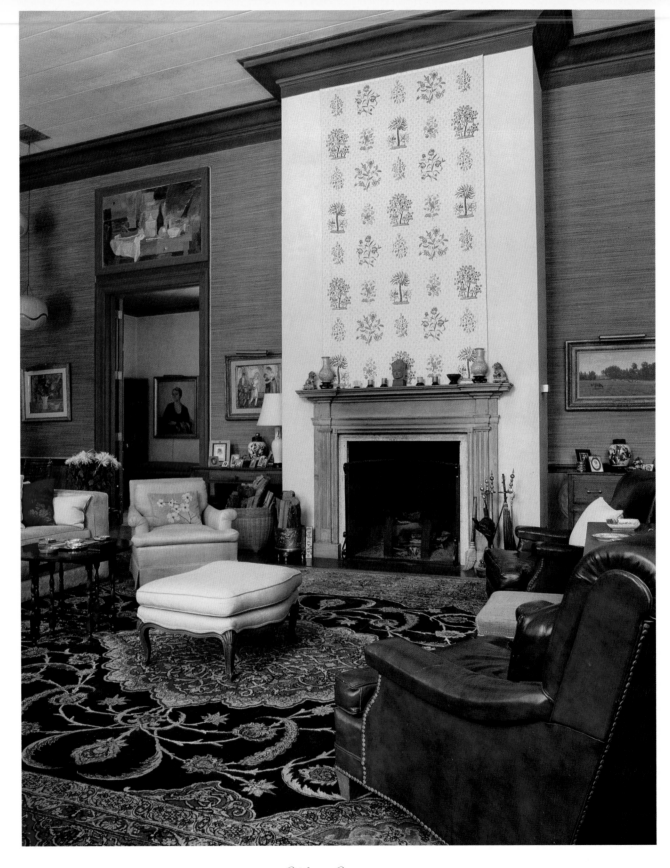

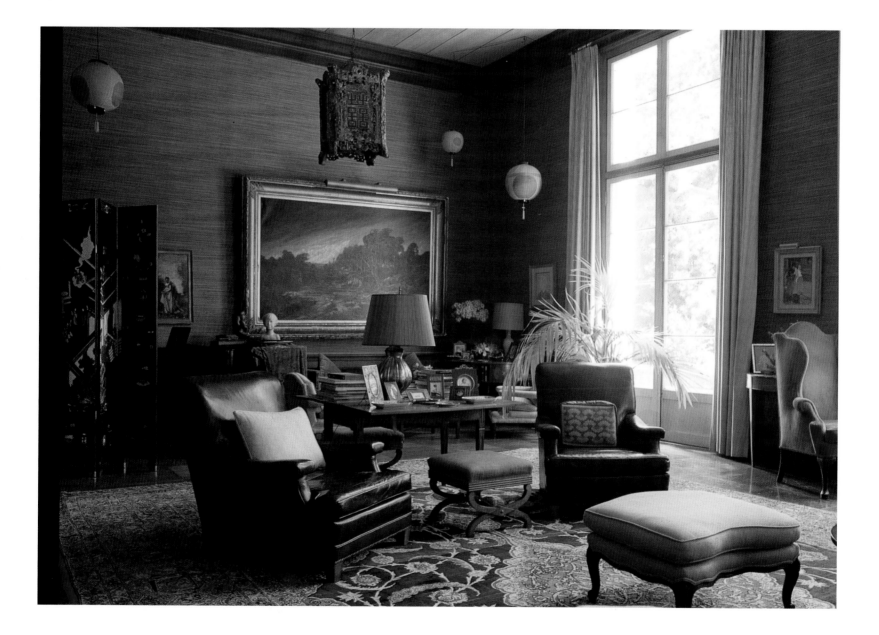

The pineapple-topped library
houses a collection of first
editions, many concerning Russia.

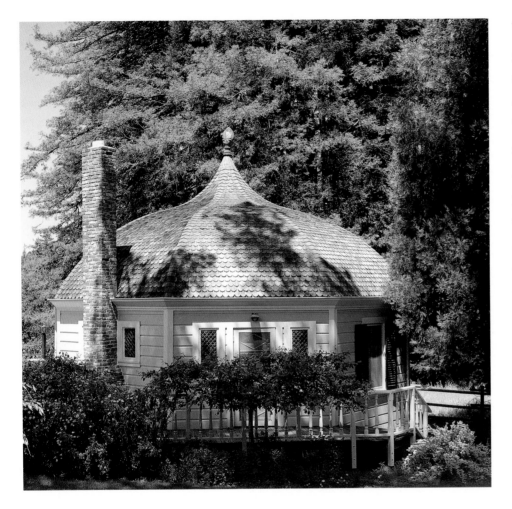

Wiley said her client loves to mix fabrics most people wouldn't dare bring together. She'll combine colors like lavender and blue, or red, blue, and gold. It's never the expected or the usual. "It's a truly gemütlich house—comfortable and intimate, with wonderful places to sit indoors and outdoors," said Wiley. "It's an ongoing project. As fabrics get a little worn, we replace them. The hand-blocked linens, Fortuny prints, chintzes, and big leather armchairs are holding up well." ¶ The garden surrounding the house was designed by revered San Francisco landscape designer Thomas Church. It's very relaxed and not over-styled. Behind the house the redwood-ringed meadows, all visible from the tall living room windows, have been left *au naturel.*

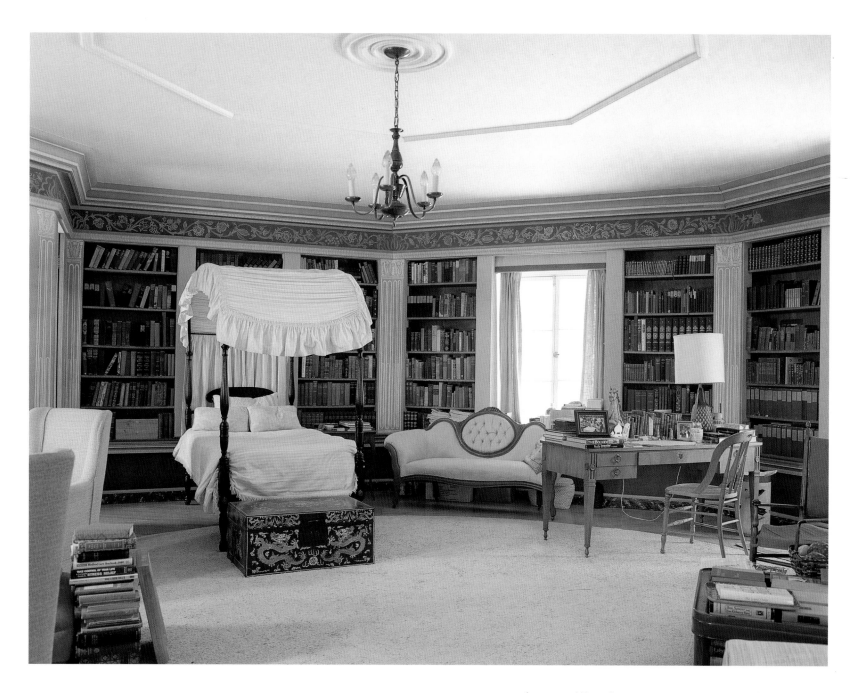

The octagonal library has now also become a guest suite complete with an English tester bed, a Victorian settee, and a fruitwood desk.

Town & Country

Living close to the city is demanded by livelihoods and friends, favorite restaurants, the opera, bookstores, and a certain longing to be in the thick of things. No Californian thrives on a long daily commute, even if it leads across the heart–stopping Golden Gate Bridge and ends an hour later in the middle of a vineyard in the Napa Valley. Times are green and tranquil in Topanga Canyon and Trancas, but unless you have a driver or a Daimler the daily trip may leave you too tired to love the wilds. Realists as well as romantics, many Angelenos and San Franciscans dwell in the heart of the metropolis in country settings of their own creation. Windows and doors are flung open to sheltered gardens; dreamy white curtains billow in the breeze. Windows stay uncovered. Leaves and flowers and a flourish of foliage become the "shades." The many blessings of the California climate allow city dwellers to live on a boulevard as if they were beachside. Hardwood floors remain bare; sofas and chairs may be covered in canvas as white as the driven snow. ¶ In a state barely a century old, tradition does not press upon the imagination. Designers experiment. Of–the–moment is fine, but timeless is better, period. The cottage of legendary costume designer Theadora Van Runkle is a fast five–minute drive from fabled Sunset

Boulevard up a steep, dusty canyon. Her genteel tree–shaded setting feels as if it's hours and miles away from Hollywood. She parks her Mercedes, steps through an antique door, and is suddenly in her own movie. Banana Republic visual merchandising director Stephen Brady likes a relaxed, country mood in his City apartment. He sets a rustic iron table on his garden terrace and surrounds it with cushy ruffled pillows of vintage rose–print chintz. The streets of San Francisco seem many miles away. Obiko boutiques owner Sandra Sakata lives in a stately Edwardian building on a busy street in downtown San Francisco. Her apartment reflects Sandra's interest in the best tribal arts and folk crafts. Designer Stephen Shubel's sunny apartment feels like a weekend retreat. It's on a hillside high above the Bay in Berkeley. Jack Dellett and Dan Worden took a chance on a tiny, tumble–down post–earthquake shack behind an imposing apartment building on Nob Hill. It now has everything they need for civilized city living: a jasmine–shaded deck, balconies, a grand fireplace, day–long sun, and endless privacy. It's a house in the country—within sound of the cable car's clang. Joe and Marni Leis rescued a former estate cottage—and gave it city chic to spare. ❡ Being true to themselves, following their own vision, these talented people enjoy the country's quiet pace steps away from the city's hubbub.

Previous pages: **Even in the city, Angelenos and San Franciscans live within sight of the ocean, the mountains, a bay, green hills, and vast parks. The view from a house in Tiburon or the Hollywood Hills, Buena Vista Park, or even Nob Hill can be very bucolic—and the city can be forgotten for the moment.**

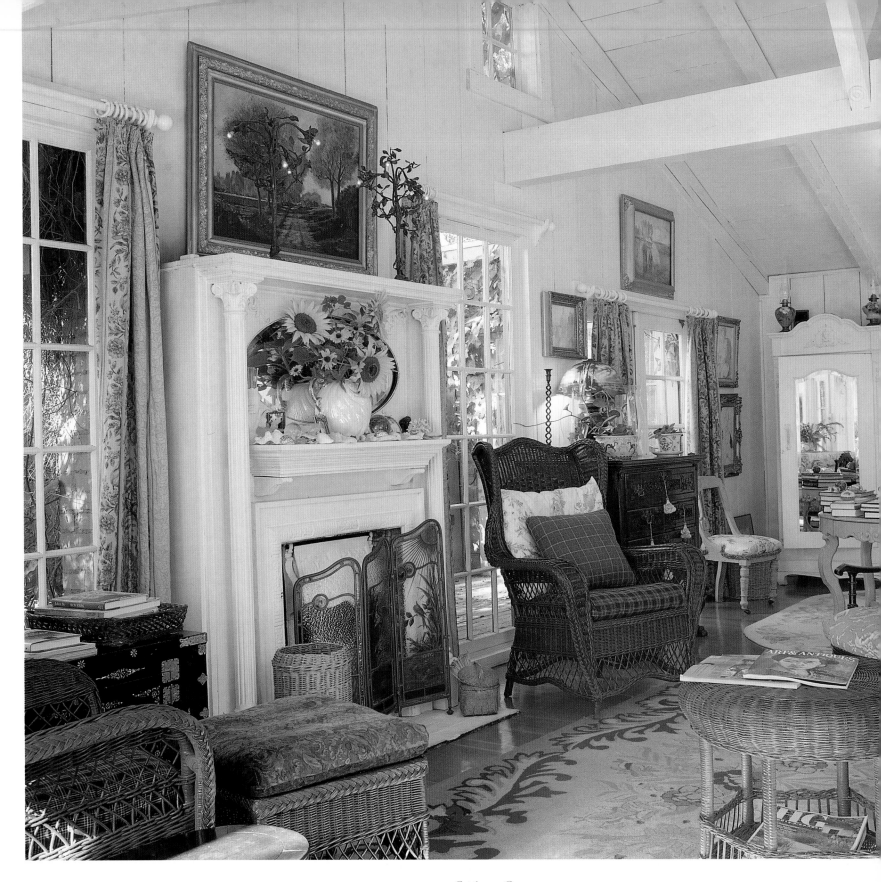

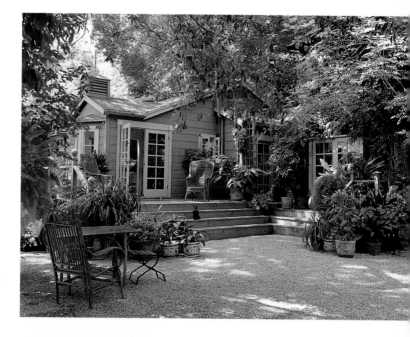

Take a left off Sunset Boulevard—you are surely coming from Spago or Book Soup or the Bel–Air—and head up toward Laurel Canyon. The dry green smell of eucalyptus wafts across the convertible as you take another left and wind higher and higher up the dusty hill. Just ten minutes from Beverly Hills but eras away in feeling, the cottage of costume designer Theadora Van Runkle stands in a quiet walled garden sheltered by an Italian stone pine, ash and laurel trees, and fragrant pittosporum. Visitors climb raw granite steps, pass through a carved wooden portal, and walk beneath trellises laden with jasmine. The scented garden beguiles the senses, especially in the evening when the exotic perfumes of night–blooming flowers are borne on the warm air. ¶ Van Runkle, a legend since her costume designs for *Bonnie and Clyde* burst upon the screen in the sixties, has lived in this garden since 1968. "I was looking for a shack in the canyon to fix up. I liked the look of this 1923 cottage. It reminded me of a little upstate–New York farmhouse, in an offhand kind of way. The realtor told me the owner had been a Las Vegas showgirl who had rented it to Paul Newman and Joanne Woodward," said the designer.

Van Runkle's house stands on a very private 7/8–acre. On an adjacent lot, she grows flowers and vegetables. *Left and opposite:* Sunflowers beam in a Belleek pitcher. Chippendale, Chinoiserie, wicker, and painted wood welcome guests.

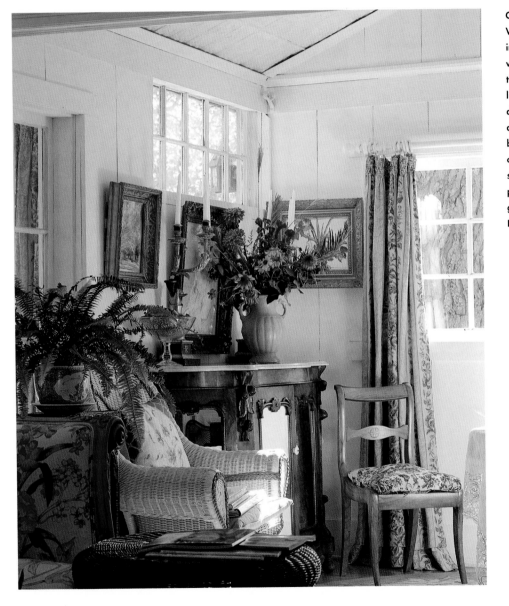

On Sunday mornings, Theadora Van Runkle's sketch club gathers in the sitting room. A model will pose on a chair or sofa, and the group quietly draws. "The light is so good here. Everyone does wonderful paintings and drawings," said Van Runkle, who bakes breads and brews fresh coffee for her friends. The yellow storage chest holds paintings, paper, scarves, hats, and favorite glasses. Flowers from Van Runkle's own garden fill a vase.

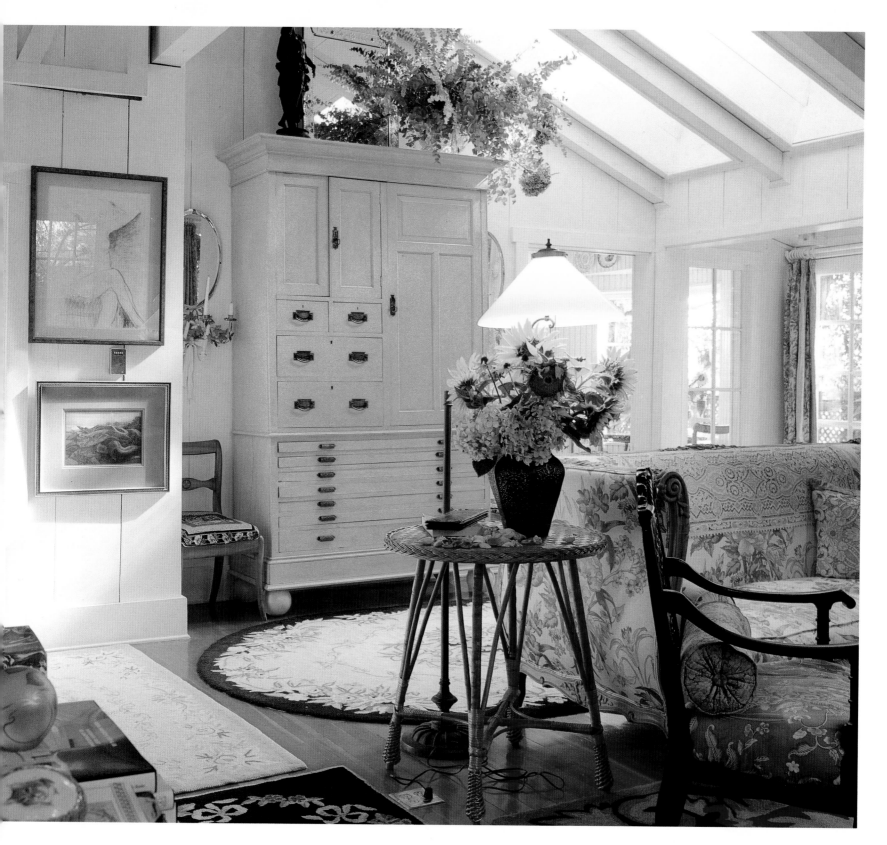

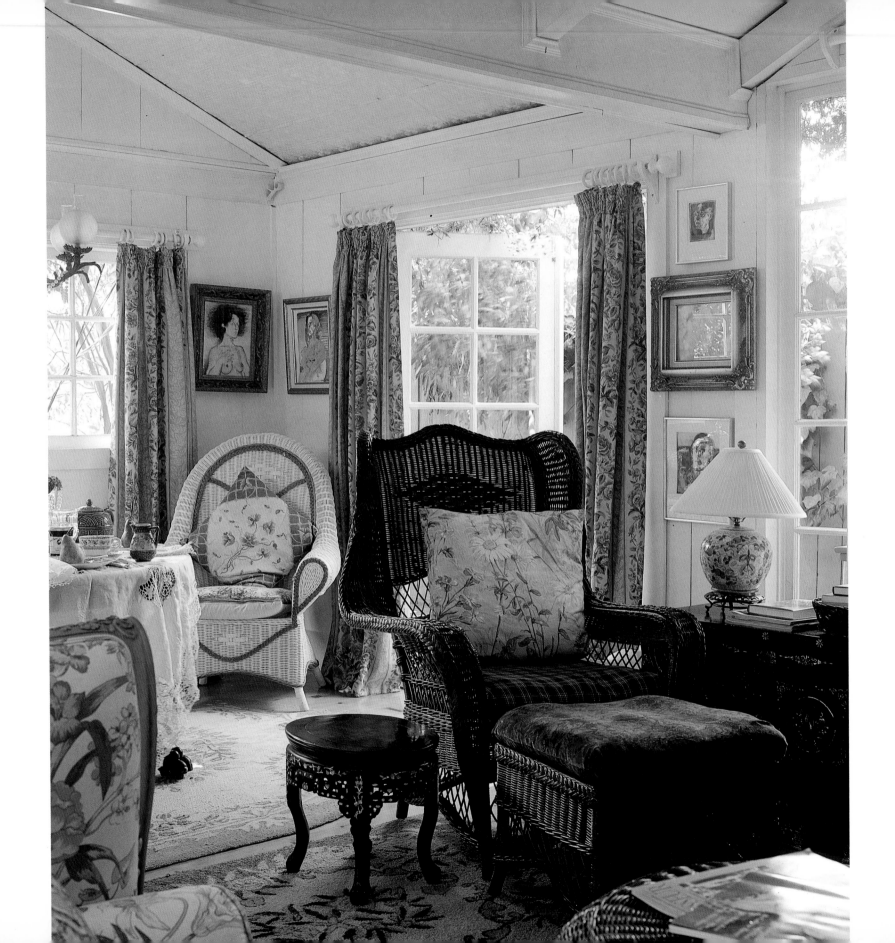

Over the 24 years she has lived in the cottage, Theadora Van Runkle has made frequent forays to far-off places on location—for films like *The Godfather II*, *The Butcher's Wife*, *Peggy Sue Got Married*, and *New York, New York*. ¶ The house has been completely recast to her own vision. She raised the ceiling in the sitting room, and built in skylights to give the room dimension and light. "I'm always making improvements and changing the furniture. I look upon this house as an ongoing creation," she said. "Blood-red bookcases used to flank the fireplace. I built more windows and six sets of French doors all around the house. A few years ago, I added a wide verandah to give the house some architectural integrity," said Van Runkle, who did, indeed, work alongside the carpenters and cabinetmakers on the job. The designer also finds and displays a bravura collection of bronze figures, shells, rare books, lamps, and urns. ¶ Theadora Van Runkle enjoys living in her white-walled cottage and it shows. She forces paperwhites in bulb vases, rearranges furniture, paints. Her cats—Hazel, Charlotte, and portly Basil—stalk in from their canyon adventures. It's truly far from the world.

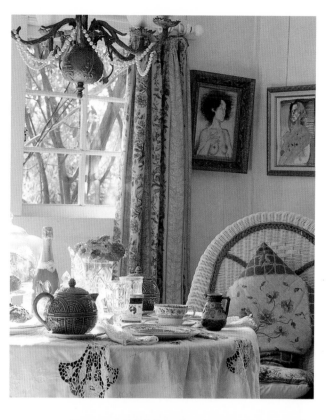

When friends are expected, Van Runkle moves stacks of art books from her dining table and sets a fine tea with heirloom linens, fine china, delicious jams, and cakes on stands unearthed in Ventura. Many of the pastels, pencil sketches, and watercolors are Van Runkle's own. Friends are encouraging her to publish them in a book.

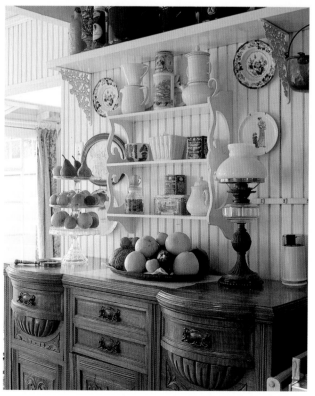

"I love pressed glass, *majolica*, and scent bottles, all things I use. And I search out vintage printed cottons and forties cotton plaids to upholster chairs and pillows," Van Runkle said. Occasionally, and dramatically, she stages an homage to the art of the moving picture. The designer sleeps, surrounded by books, in the bed in which Merle Oberon as Cathy "died" in *Wuthering Heights*. She has draped it in embroidered white linens and antique laces.

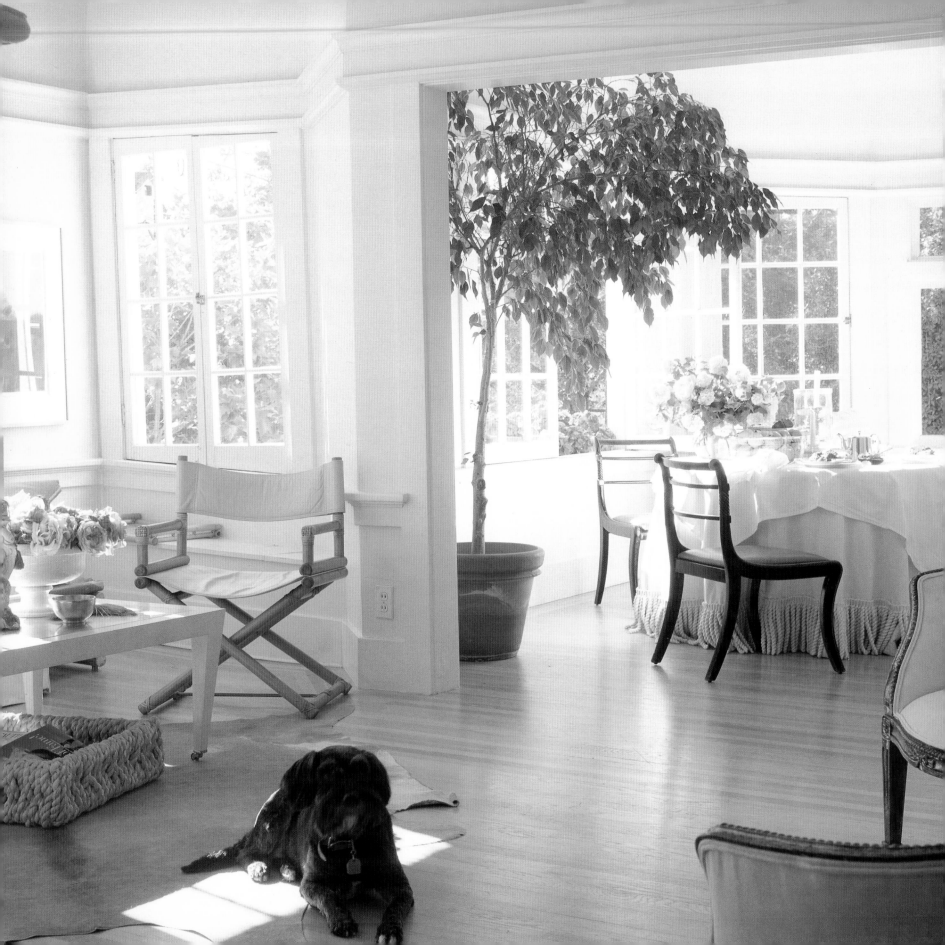

The arrival of summer always gives interior designer Stephen Shubel a perfect excuse to create his hillside apartment anew. To celebrate the season, he decided to paint the walls pale cream outlined with white molding, bare the bleached floors, and open windows to flower–filled windowboxes. Best of all, he loosened the look with a lighthearted collection of could–have–clashed–but–don't chairs. The down–stuffed sofa and a favorite armchair were dressed in a new summer wardrobe—zip–off white linen/cotton slipcovers piped in lemon. Pillows in sorbet colors, vivid flowers, white–on–white linens, and a table set for tea enhance the languid mood. ¶ Summer sunshine pours through undressed windows and fills every corner of Stephen Shubel's Berkeley flat. The designer's confident mix includes gilt–edged Regency dining chairs, Donghia's stylish tippy–toe table–on–wheels, Woody Biggs' framed pastels, and a pair of graceful linen–upholstered armchairs. Shubel's unpretentious scheme invites guests to pull up a chair, read, or gaze out the window past a line of sycamores to the Julia Morgan–and–Maybeck–

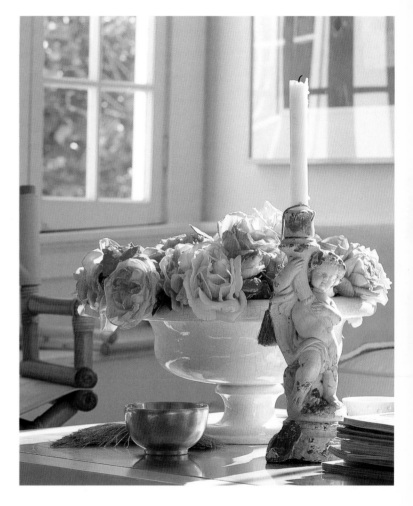

Above: Fragrant garden roses in an Italian ceramic pedestal bowl.
Opposite: Fletcher basks in the sun. Shubel's style: ficus trees, fat fringes, Fine French Furniture.

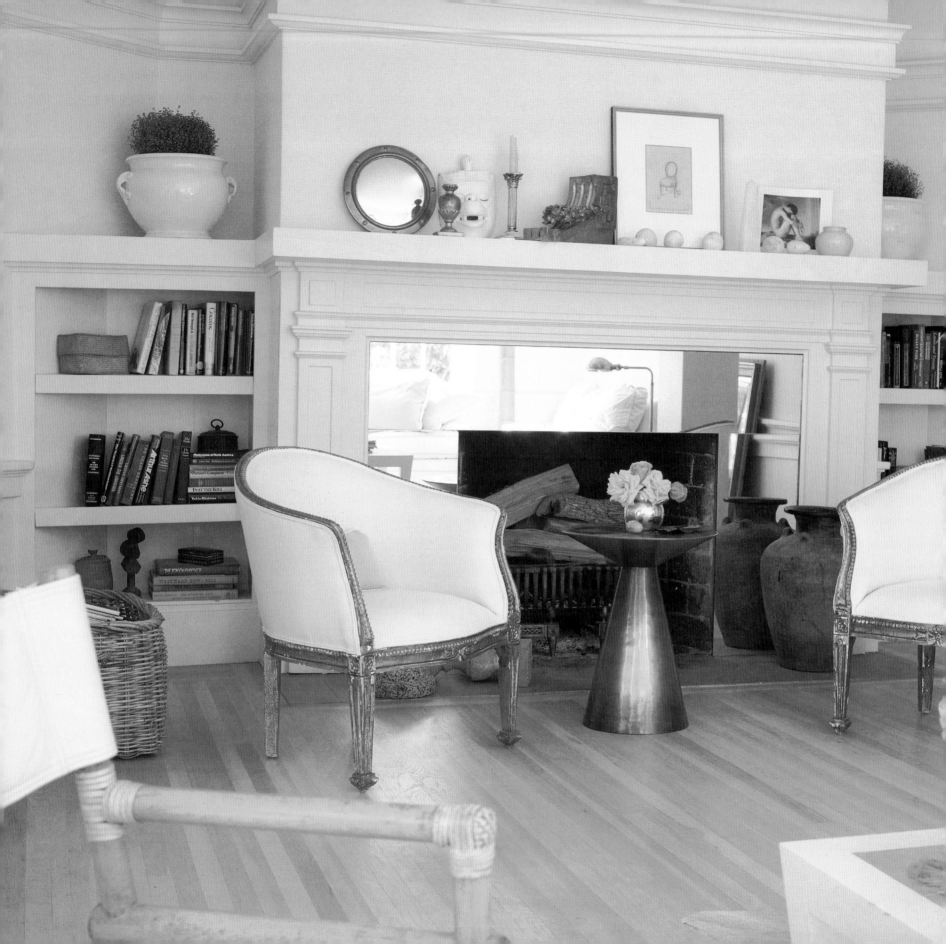

designed neighboring houses. Shubel's mutt, Fletcher, loves the smooth bleached hardwood floor. ¶ "Decorating can be too serious. I decided to have fun with my apartment and forget the rules," said the designer. "On hot summer days, you really need something more relaxed." ¶ Shubel purchased his flat in a venerable 1919 Berkeley building ten years ago. In another life, the rooms had been more uptown with black leather upholstery, Fortuny silk velvets, and Biedermeier and Louis XVI–repro chairs. Holidays in Paris, a big birthday, and weekend flea–market trips encouraged Shubel to lighten up. ¶ With a pretty pair of gilded *fauteuils*, Gary Hutton's "Ciao" table, and an eye–pleasing mantel lineup, Shubel created a charming setting around the fireplace in the living room. Mirror surrounding the hearth adds dimension and sparkle to the room. Now the rooms are ready for spontaneous entertaining. His versatile dining room serves up a lazy breakfast for two, or candlelit dinners for six. Friends linger and watch the fading light make tracks across the cool vanilla walls. In this apartment near a Berkeley municipal rose garden, Shubel has captured the essence of summer.

The collection on the mantel, *above,* includes architectural fragments, a lacquered Indonesian mask. A large gilt–framed mirror, a Paris Marché aux Puces find, reflects on Shubel's stacks of design books.

In 1906, Jack Dellett and Dan Worden's Nob Hill cottage had a rather shaky start as a hastily built post–earthquake shack. Like many of the flimsy cabins and cottages put up that year, it was never meant to last. Eighty–six years later, with thoughtful redesign and plenty of hard labor, they've made it a solid winner. ¶ "No one else wanted this shack. Even our contractor told us to tear it down," recalled San Franciscan Jack Dellett, an architect with Fisher–Friedman Associates. He and Banana Republic senior store designer Dan Worden gambled on the vine–covered house five years ago as part of a tenants–in–common property purchase with friends. Their five chums got spacious flats in the main house. Jack and Dan won the modest cottage hidden at the end of the garden. The two initially cleaned the sadly neglected house and painted it so that they could live in it for a while and figure out what they wanted to do. ¶ "It took us some time to discover the spirit of this cottage," Dellett said. "It had no style at all. What it did have was a sort of dumb simplicity." Dellett based the architectural design on a 1910 Arts and Crafts house style, but they lightened it up by painting all the woodwork white. To fit a living

Opposite: The shingled cottage, which stands in a garden behind imposing apartment buildings, feels very spacious. It's a neat 1,150 square feet. Planning their renovation, Dellett and Worden were required by City codes to stay with the original "footprint" of the 86–year–old shack. The cottage has windows on three sides with views of neighboring gardens and a handsome red-wood tree. "We wanted it to feel like a house with a bit of history," said Worden. The basic symmetry of the house plan followed the essential purity of the original hastily built shack. "The whole house has a single idea to give it integrity and volume. There's a large central space—the living room—and repeated pairs of columns, windows, and doors," said Dellett. *Left*: The fireplace, mantel, and furniture are deliber-ately over–scale to give the small living room stature. Columns sup-porting the mantel were salvaged from a dismantled Richmond house. The pair of ornate brackets over the mantel originally supported a cornice on the City of Paris store.

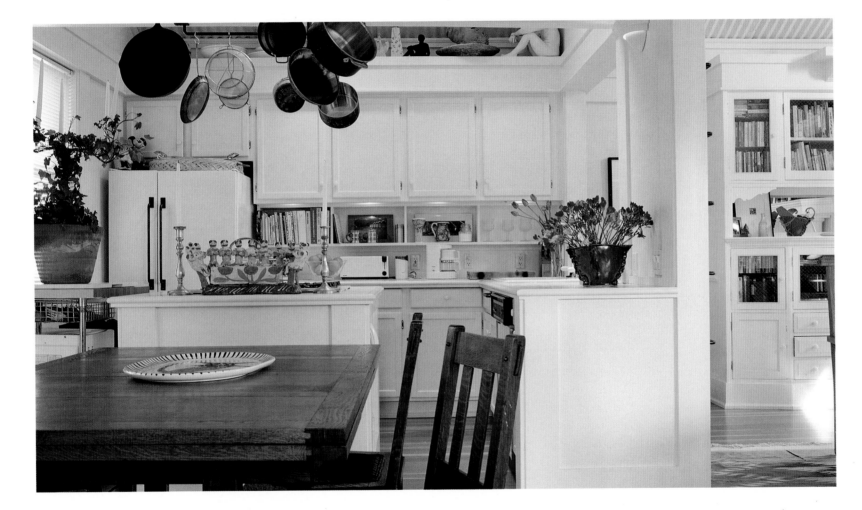

The kitchen fits in one corner,
open to the living room and the
dining room. Into this limited
space, they've managed to fit
everything they need—including a
gallery for Worden's art works.

room, dining room, and kitchen, plus two bedrooms, a loft office, a bathroom, and entry foyer into the parameters required nimble planning. ¶ "This is a 24' x 24' house that was designed to feel much bigger. High ceilings and open balconies give it some height and a little grandeur, so it's friendly and doesn't feel too small," said Dellett. The sunny living room, dining room, and open kitchen are upstairs under the soaring 16–foot ceilings. ¶ Dellett and Worden first brought in a contractor to lay a new foundation and start the framing for their cottage. They built the rest of the house themselves, with the help of very loyal, very hard–working friends. From foundation laying to sheetrock installation to final painting took three years of their sweat equity. For all but three months, when they had neither running water nor electricity, the two men camped in their house. They learned as they went along. The cottage is well–crafted, but they note that paint and spackle cover a lot of sins. ¶ Now the two friends enjoy a cottage with all the ease and comfort of a country house—in the middle of the City. On a summer Sunday afternoon, balcony doors and windows stay open and light pours in. Friends drop by. The rewards for their dedication are sweet indeed.

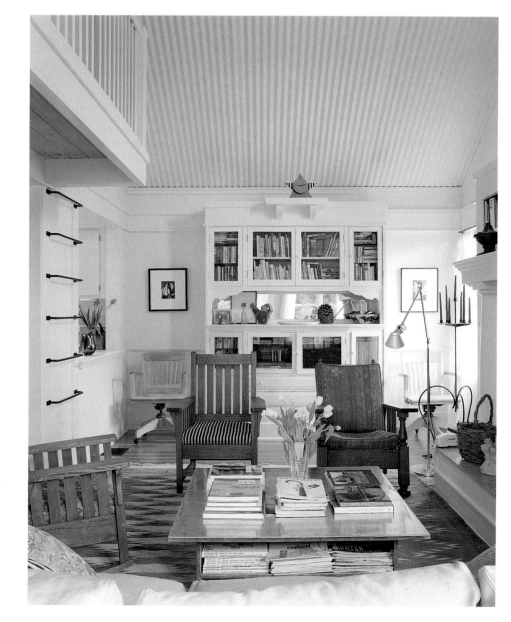

Mill Valley
MARNI AND JOE LEIS COTTAGE

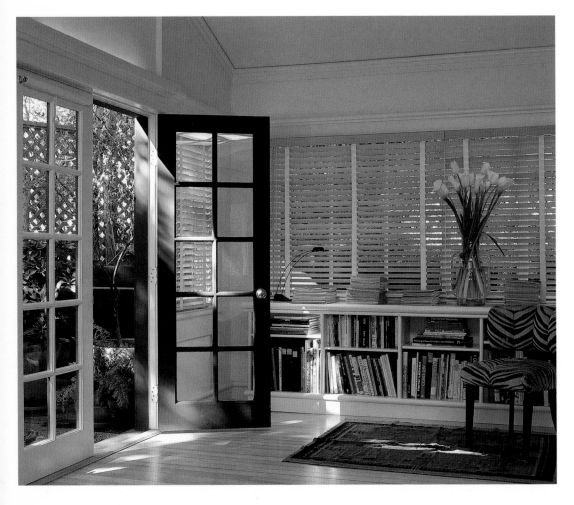

Above: Surrounded by great stands of redwoods, the house is splashed with light as the sun crosses the sky. Bleached floors and creamy walls lighten the entry. *Opposite, top*: Venetian candlesticks on the piano.

The hardworking owners of friendly Avenue Grill in Mill Valley, Embarko restaurant on San Francisco's waterfront, and Trudy's cafe in Berkeley, Marni Leis and her husband, Joe, need a retreat far from city bustle. ¶ In their newly renovated house, originally built in 1905 as the gardener's cottage of an estate, walls were painted the color of clotted cream, and floors were bleached to create a clean canvas for their collections. "The biggest pieces of furniture—sofas, chairs, tables—are all classic shapes with built-in comfort. Basic black, in interiors as in fashion, is truly versatile," said petite Toronto-born Marni. "I treat the paintings and collections just like fashion accessories. They're the spice, and—like jewelry—they don't have to be expensive to look good. I'm interested in creating a mood, so I'm always experimenting and moving things. I love to surround myself with things that lift my spirits, that nurture me and inspire me, and I always haunt the basements of secondhand stores, go to auctions, flea markets, garage sales. I've made some wonderful discoveries," she said. "Still, I don't feel that I 'own' my collections. I love them, and I care for them, but I could easily let them go if they became burdensome."

Below: Marni Leis' perfectly balanced compositions in the living room include zebra–striped Deco chairs, a basic black piano, and a shapely nude against smooth cream walls. A fat black leather chair and sofa anchor the room, with a fifties Bigelow carpet and a trio of Dutch silk rugs as islands of color in the light–filled decor.

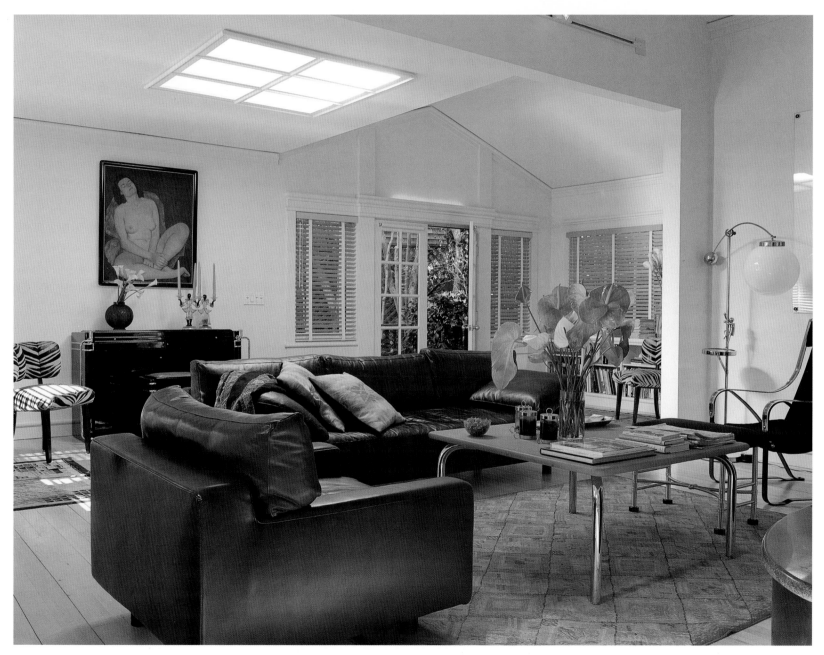

"I'll be honest," said Marni. "My bathroom collections are an altar to me! I'm joking, but the perfume bottles, photos, and scarves create a very 'girly' room that inspires me to get dressed up and play with makeup." On the black bathroom counter, the mirror multiplies Mexican flutes, a fifties cannister, favorite kitsch. Flowers are set in vintage Daum and Lalique vases. Marni's scent bottle collections are presented on bathroom shelves.

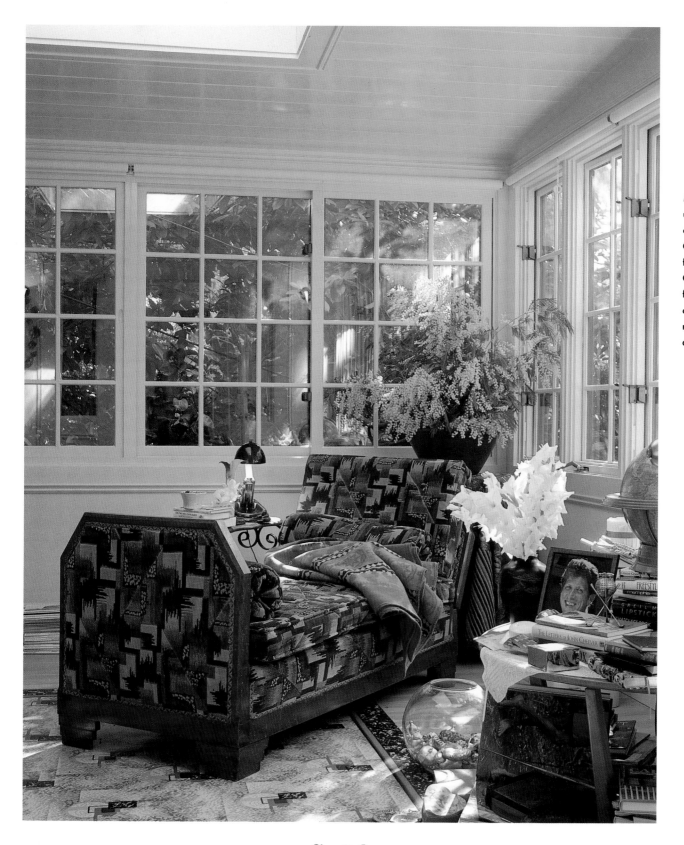

Left: Marni's chunky forties upholstered daybed holds pride of place in her "gossip room." Collected here: Chinese textiles, favorite books, bold ceramics, Christmas ornaments. The room feels like a refuge far from city cares. In fact, Mill Valley is just 20 minutes north of San Francisco, across the Golden Gate Bridge.

San Francisco
STEPHEN BRADY APARTMENT AND GARDEN

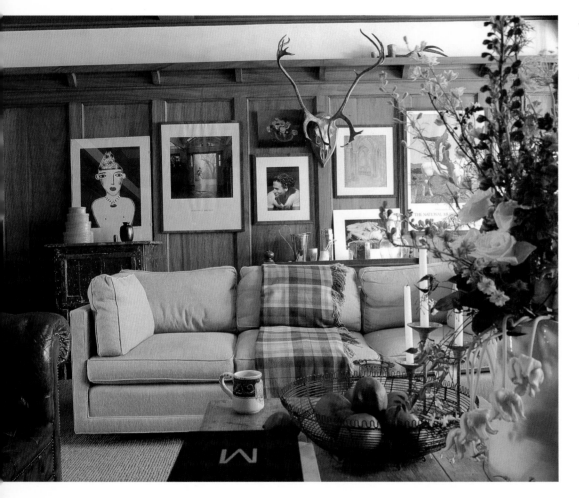

Above: Among Brady's gallery of favorite framed prints and photographs are Bonita Barlow's *Clown* from the Claudia Chapline Gallery, Stinson Beach, and works by Bruce Weber, Kurt Markus, and Herb Ritts.

Designer Stephen Brady is a very passionate collector. If he's spending the weekend at Stinson Beach, the designer will drive farther north up the coast, visiting small–town antique stores and junk shops along the way. In cobwebby places the cautious might hesitate to enter, he'll discover old kilim rugs, a brace of elegant horn–handled knives, a dusty lithograph, or a folio of architectural prints—and still have time to gather sand dollars on the beach and cook dinner for eight friends. In Paris, Saint Barts, Florence, Santa Fe, or London, he'll search out rare art books, thirties chintzes, vintage furniture, delicate etchings, and silver trophies. Now these finds and collections of more than 20 years add texture to Brady's new Buena Vista–district apartment. ¶ Stephen Brady, 40, is senior director of visual merchandising for Banana Republic and responsible (with his team) for creating distinctive in–store personalities for the company's 130–plus stores nationwide. He had previously worked on store design for Ralph Lauren/Polo and Calvin Klein in New York. It happens that Brady's vocation is also his avocation. ¶ "If I love something, I never think

In Stephen Brady's living room,
mahogany panelling and corner
windows overlooking the garden
were great design beginnings
for a City retreat. Brady added
comfort and ease with a cotton
twill-upholstered sofa by Fitzgerald,
a well–loved old Santa Fe table,

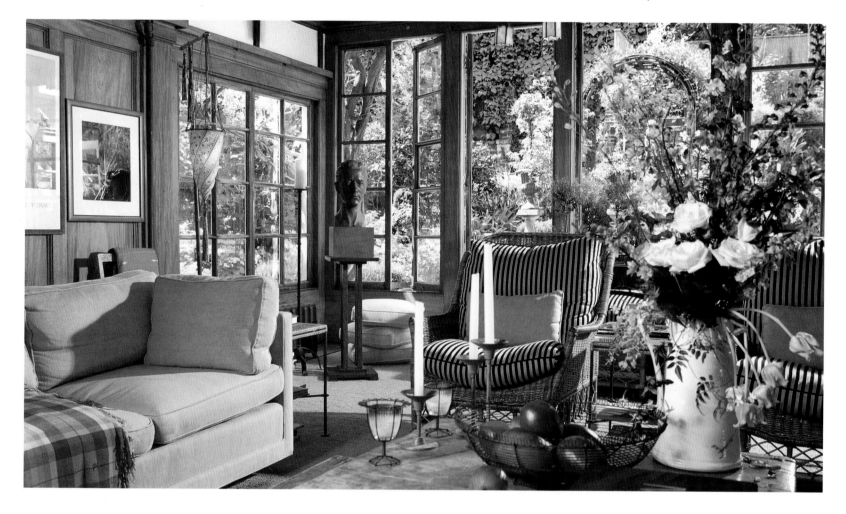

and inviting pillowed wicker
chairs. His tablescape includes an
Italian ceramic pitcher with
garden flowers, books, and wire
candelabra. The romantic
"Cesendello" lamp is by Mariano
Fortuny.

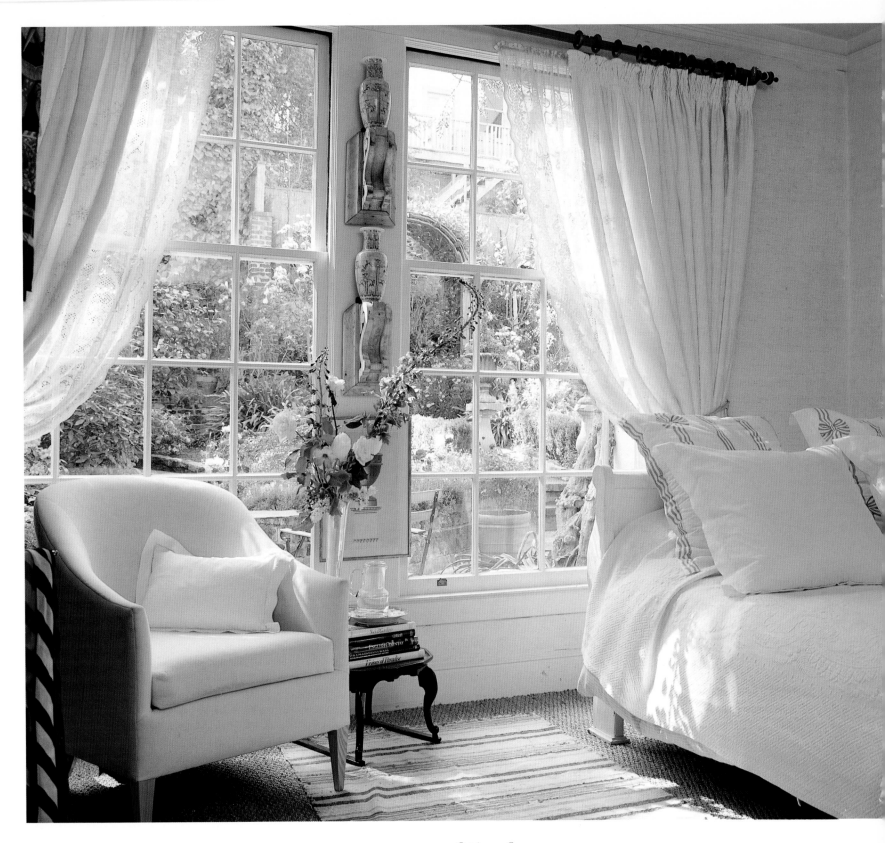

about its value, period, or provenance. I'll buy a funky green New Mexico chest, knowing it will be at home with Shaker boxes, English plaid, Philippine wicker, and an oversized contemporary sofa. A graceful arts–and–craftsy Fortuny lamp can be great company for a bold Navaho rug and an English mahogany table," he said. This is an ever-evolving apartment. The world is full of wonderful things. Stephen Brady will always find a place for his new treasures. ❡ Brady has lived in his City apartment for just over a year. Thanks to the collections and furnishings that traveled with him from New York, it seems as if he's been there for years. "I loved this apartment from the beginning because it speaks of no particular time or place. I knew I could bend the rooms in any direction I pleased," said Brady, who grew up in Washington, DC. ❡ Dynamic scale is important to Brady, who filled his rather sedate bedroom with a dramatic steel sleigh bed topped with drifts of cushy comforters and down pillows. He designed a welcoming vignette including a bronze statue and a delicate Endymion etching on a massive chest in his entry

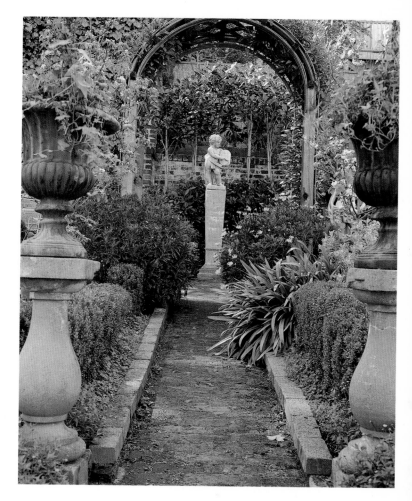

Stephen Brady's guests are treated to wonderful linens, a comfortable chair, and a glorious garden view. Brady kept the sunny room's design simple and crisp so that the seasonal abundance of his garden would color his mise–en–scène. In spring and summer, the garden is like a Monet painting. Gardener Patty Wilkerson filled the beds with colorful cottage flowers. "I love to plant when they're just coming in to bud. Then you have the full enjoyment of the flowers, from beginning all the way to fade–out," she said. The garden was also "furnished" with old stone urns, *above*.

Below: The structure of Brady's
hillside garden was all there
when he moved in to the apart-
ment. All he had to do was bring
out his metal chairs and table,
and cozy the chairs with fat
pillows in rose–patterned fabrics.

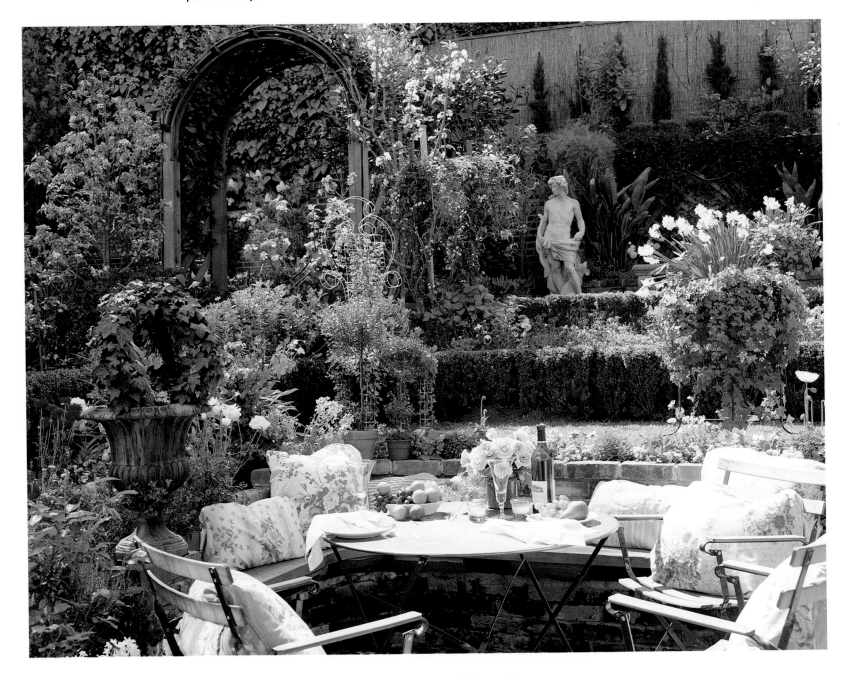

hall. ¶ "I love to entertain my friends. They can relax in wicker chairs, wrap themselves in a cashmere throw, and read a book. They can put their feet up on the old nicked table. I want them to get as much pleasure as I do from my photography and paintings," Brady said. ¶ On his sunny garden terrace, Brady sets up a Paris park table for summer entertaining. Ralph Lauren/Polo linen napkins and stoneware platters add to the luxe lunch setting. Folding chairs are plumped with pillows covered in antique English rose fabrics. Voluptuous garden planting includes 'Brandy' and 'Graceland' roses, jasmine, ranunculus, cineraria, miniature roses, wisteria, stocks, Iceland poppies, and primulas. 'Fondly' tea roses stand in a Swedish blue bucket on the table. ¶ "We planted the garden to look natural, loose, and very full within the formal structure of terraces and flowering trees and shrubs," said seasonal-garden designer Patty Wilkerson of Seaflower, Stinson Beach. Statuary, a heroic vine-covered arch, and ivy and myrtle topiaries lead the visitor up the garden path.

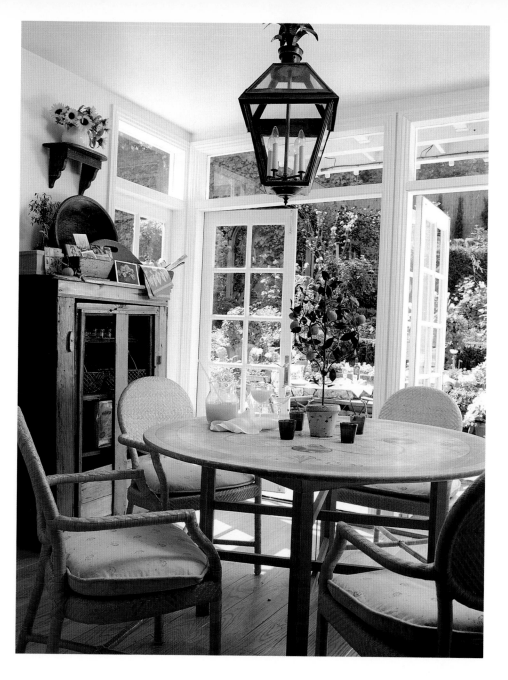

Brady has a very finely tuned sense of placement, harmony, and serendipity. His dining room opens to the terrace.

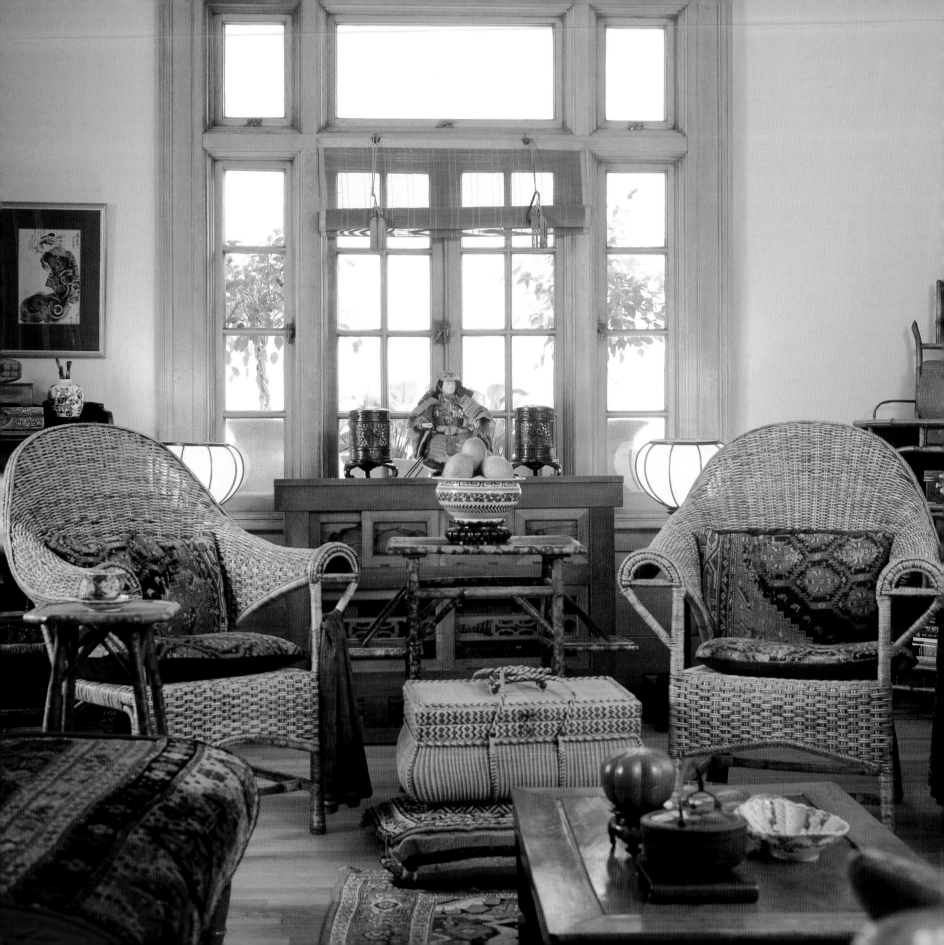

In her worldly San Francisco apartment, Sandra Sakata's cross–cultural collections show a lifelong love of the handmade. Her Obiko boutiques in San Francisco and at Bergdorf Goodman in New York celebrate the rare pleasures of extraordinary craftsmanship. Fearlessly crossing borders of the imagination, Sandra brings together a world of village–crafted treasures. ¶ "Everything I have in my apartment shows the hand and the spirit of the person who made it. I dream about their lives somewhere faraway, and wonder how these pieces came to San Francisco," said Sakata, who warms to traditional village crafts and tribal arts rather than refined city antiques. Signs of daily wear, sun–faded colors, nicks and tears only add character to Silk Route rugs, rare Khmer textiles, *japonesque* bamboo tables, stacked Korean pantry chests, and Thai bronze temple gongs. Still, while she celebrates humble everyday crafts, the effect is far from folksy. Rather, her expert art direction of these handsome high–ceilinged rooms (*circa* 1918) enoble the honest

Over five years, Sakata has created a singular salon with curvy Philippine rattan chairs, English Regency–style bamboo tables, and Japanese lacquer-ware, enlivened with pattern–on–pattern kilim rugs. The Grand Tour setting on a corner table, *left*, includes ancestral portraits, a tortoise–shell bamboo table, and highly detailed Imari plates.

Exotic affinities please Sakata's eye. Here, an Appalachian rocker, Afghani and Persian rugs, fine Laotian silk ikat fabrics, nineteenth–century Korean chests, and portraits of her Japanese ancestors evoke a time before technology.

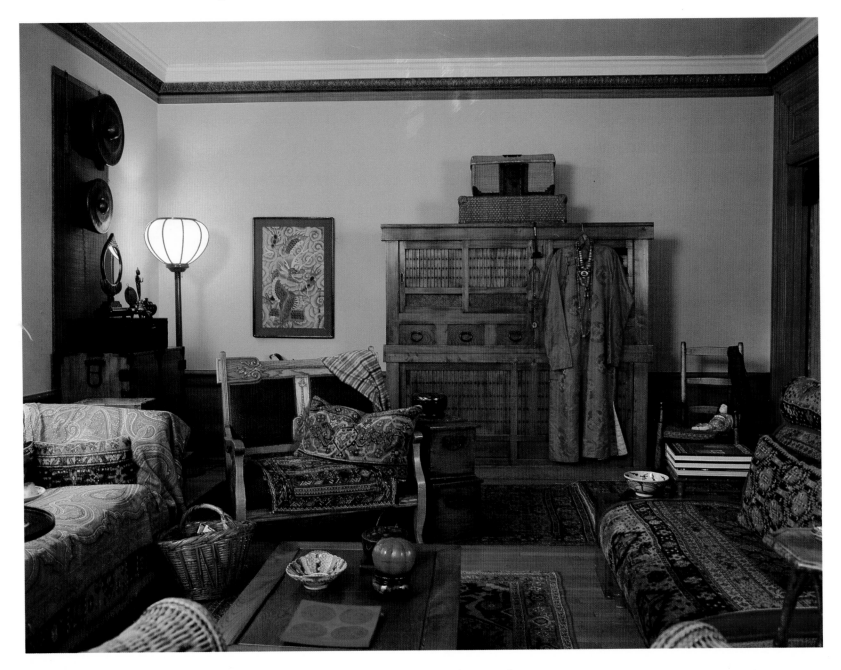

craftsmanship. ❡ Sakata's time—out from her Obiko design boutiques is spent all over the map at Oriental antique stores, flea markets, auctions, and tag sales. With her rooms now in harmony, she said, her goal is to edit rather than add to her global treasures. ❡ Sakata lives with a lifetime of collections, the heirlooms of her dreams. "I'm not the kind of collector who cares about the value or origin of a piece. Harmony, warmth, and the quality of craftsmanship are paramount," she said. "These intricate silks and cabinetry, hand—loomed rugs, and painted porcelains stand as a tribute to the people who made them. Each takes time and a great commitment to fine workmanship. I appreciate that whenever I'm here," said Sakata, who favors certain—to—fade natural—dye colors like indigo, tawny rose, and burgundy for this tranquil setting.

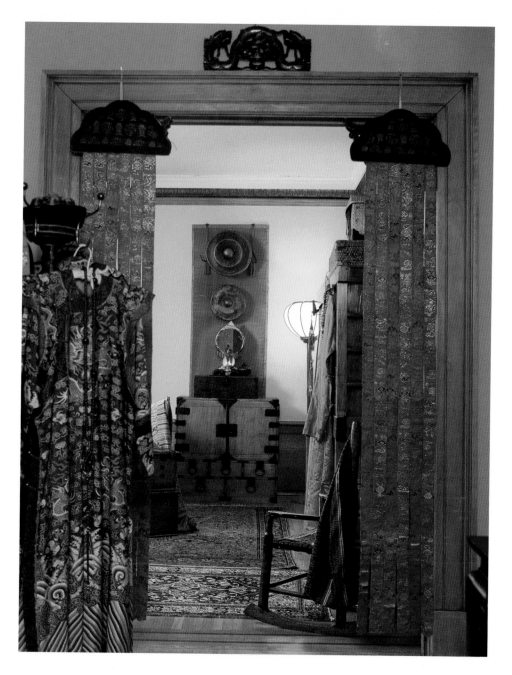

Sandra Sakata's passion: furniture with beauty bestowed by hand and by age. *Opposite:* A Lea Ditson silk dress hangs on a Japanese kitchen chest—on—chest. *Above:* Antique kimonos and ancient textiles frame the doorway with provocative patterns.

California Catalogue
DESIGN AND STYLE OF THE STATE

California is rich in architecture, historic houses, cutting–edge design stores, art galleries, museums, and country hotels. A visitor to Los Angeles could, with a map in hand, spend weeks viewing houses by Frank Lloyd Wright, the Greenes, John Lautner, Morphosis, Gehry, Schindler, Israel, Fisher, and Julia Morgan— with stops for sustenance at Spago and Chinois on Main designed by Barbara Lazaroff. ¶ Museums from the wonderful Getty in Malibu to the L.A. County Museum offer insight into the present and past lives of California. In San Francisco's Golden Gate Park, the M.H. de Young Memorial Museum beckons. At the California Palace of the Legion of Honor, Monet's water lilies inspire quiet contemplation. The City boasts a Mexican Museum, a Craft and Folk Art Museum, a Jewish Museum and the esteemed San Francisco Museum of Modern Art. ¶ To buy fine furniture usually available to the trade only, make appointments at Los Angeles' Pacific Design Center, San Francisco's Galleria and Showplace Design Centers, or Showplace Square West. ¶ Check calendar sections of the *Los Angeles Times* or the *San Francisco Examiner/Chronicle* for seasonal designer showcase houses (like the San Francisco Decorator Showcase each spring) and walking tours.

ART GALLERIES

A visit to the art and craft galleries throughout the state gives an instant sense of the zeitgeist. Every country and coastal town and every neighborhood, it seems, is blessed with galleries showing young artists, and undiscovered talent, along with major names.

In Los Angeles, go gallery hopping along La Brea, up and down Melrose, around the Pacific Design Center, and out in Santa Monica. In San Francisco, discover galleries South of Market, in North Beach, around Grant Avenue, in Pacific Heights, at Fort Mason, and near the Performing Arts Center.

Highly recommended for useful maps, diagrams, drawings, and insider information on architectural gems and house tours, design stores, restaurants: the Richard Saul Wurman Access Guides, available at bookstores.

FLEA MARKETS

Another way to see California design in action is to go flea–marketing. Special fleas include the monthly Pasadena Rose Bowl swapmeet, the weekend Sausalito market, the Long Beach antiques and collectibles market. See newspaper listings for dates of special antiques shows, fairs, and markets.

DESIGN AND STYLE STORES

California is the trend–setting land of original design. Here on the western edge of the continent, new ideas and styles come to life. Without the weight and worry of hundreds of years of history, tradition, and convention to hold them back, California designers, store owners, artists, and architects can dream and create breathtaking break–through design.

The following listing details a very personal pick of stores throughout California.

These shops and galleries offer no one look. They are inspiring, thrilling, and successful because one or two brilliant, hard–working owners (backed up by a great team) had the idiosyncratic vision and drive to make them wonderful. Shops we love—like The Phoenix shop in Big Sur, Shabby Chic, Indigo Seas, Fillamento, Postmark, Turner Martin, Bell' Occhio, American Rag Cie. Maison, Sonrisa, Wilkes Home, or Mike Furniture—are proud one–of–a–kind productions. Like the best Hollywood movies, they are quirky, original, beautifully presented, and fun to see. When you walk out of the store, your day— your life! —feels better.

SAN FRANCISCO

AERIAL
The Cannery
2801 Leavenworth Street

The out–there owners sell only what they love—an ever–changing collection.

AGRARIA
1148 Taylor Street

Maurice Gibson and Stanford Stevenson make the most elegant potpourri and soaps. A very chic (and wonderfully fragrant) store. Catalogue.

ARCH
407 Jackson Street

Architect Susan Colliver's colorful, graphic store sells supplies for designers, architects, and artists. Fun place.

The "Montecito Collection" of iron furniture from Michael Taylor Designs, San Francisco.

BELL'OCCHIO
8 Brady Street

Claudia Schwartz and Toby Hanson offer hand–painted ribbons, charming tableware, antiques, and wonderfully quirky treasures.

BLOOMERS
2975 Washington Street

Bloomers blooms with glorious flowers, vases, French ribbons, and baskets.

VIRGINIA BREIER
3091 Sacramento Street. Also at Ghirardelli Square, 900 North Point Street

A fine gallery for viewing contemporary and traditional American crafts, including furniture and tableware.

BUILDERS BOOKSOURCE
300 De Haro Street. Also at 1817 4th Street Berkeley

With an accent on the practical, this well–stocked store includes books on interior design, gardens, architecture and materials. Catalogue.

CANDELIER
60 Maiden Lane

Wade Benson's ode to the candle. Superb collection of candlesticks.

CHEZ MAC
812 Post Street

Store owners Jerry, Chris, and Ben Ospital are San Francisco treasures. First they were leaders in fashion; now they also offer a diverting selection of linens, crafts, furniture, lighting—plus the George boutique, especially for dogs.

THE COTTAGE TABLE COMPANY
550 18th Street

A designers' favorite. Craftsman Tony Cowan custom makes fine classic hardwood tables to order. A rare find. Shipping available. Catalogue.

COTTONWOOD
3461 Sacramento Street

Well–edited Southwest style. Accent on beautiful craftsmanship.

DANDELION
2877 California Street

Ostensibly a gift emporium, this superbly stocked store sells books, tableware, accessories, beautiful things.

Multi–hued "Geo" collection by Julie Sanders for Cyclamen Studio, Berkeley.

DECORUM
1632 Market Street

Impeccably restored authentic Art Deco and Moderne in an expansive store opposite the Zuni Cafe.

DE VERA
334 Gough Street

Objets trouvés, fine art, sculpture. Fresh, original.

F. DORIAN
388 Hayes Street

Handcrafted accessories. Antique textiles and masks.

FILLAMENTO
2185 Fillmore Street

A neighborhood favorite. Style–conscious furniture, tableware, rugs, toys, and gifts. Annieglass, Cyclamen Studio.

FIORIDELLA
1920 Polk Street

Jean Thomson and Barbara Belloli sell the most luscious flowers in a store full of fragrant blooms and new ideas.

FLUSH
245 11th Street

Designer Chuck Winslow and Rosemary Klebahn sell chic sheets, colorful tableware, painted furniture, provocative paintings.

California Catalogue
DESIGN AND STYLE OF THE STATE

THE GARDENER
1836 4th Street
Berkeley

Alta Tingle's sunny store mixes gardening supplies, stone–topped tables, books, tableware, rustic furniture, and beautifully crafted accessories.

GUMPS
250 Post Street

A treasure chest of fine art and Orient–inspired accessories, plus timeless furniture and elegant tableware—since 1861. Recent refurbishing makes the store an essential stop. Be sure to visit the silver and crystal departments.

JAPONESQUE
Crocker Galleria (third level)
50 Post Street

Koichi Hara celebrates the Japanese love of harmony, simplicity, refined beauty, humble materials. The spirit of his design gallery is entirely contemporary.

KRIS KELLY
One Union Square
Fine embellished linens.

LIMN
290 Townsend Street

Contemporary furniture and lighting by over 300 manufacturers. Philippe Starck to le Corbusier and back.

MIKE FURNITURE
Corner of Fillmore and Sacramento streets

With design directed by Michael Moore, the store sells updated classics–with–a–twist. Makes forward design very accessible.

NAOMI'S ANTIQUES TO GO
1817 Polk Street

Art pottery to the rafters! Bauer and Fiesta, of course, plus historic American railroad, airline, luxury liner, and bus depot china.

POLANCO
242 Gough Street

Mexican arts and crafts.

POSTMARK
333 Bryant Street

Owner Lee Gamble buys the best Italian furniture and lighting, with the accent on romantic, classic design. Smooth, chic.

POTTERY BARN
Corner of Chestnut and
Fillmore streets
Also Embarcadero Center

Great style at a low price. Everchanging.

RH
2506 Sacramento Street

Rick Herbert's garden style store. Toparies, too.

SANTA FE
3571 Sacramento Street

Southwestern style for Californians. Fine Navaho rugs, Navaho silver, ranch furniture, photography.

SHABBY CHIC
3075 Sacramento Street

Specializes in chairs and sofas with loose–fitting slipcovers.

SUE FISHER KING
3067 Sacramento Street

Sue King's linens and tableware are the finest and prettiest. A must–stop for accessories and gifts.

The Annieglass Studio "Shell Series" of asymmetrical frosted glass bowls, designed by Ann Morhauser, Santa Cruz.

SLIPS
1543 Grant Avenue

Beautiful, witty slipcovers for chairs, sofas.

TAIL OF THE YAK
2632 Ashby Avenue
Berkeley

Partners Alice Hoffman Erb and Lauren Adams Allard have created an entrancing store that is always a treat. Decorative accessories, Mexican furniture, fabrics, and antique jewelry.

VERO BY VIGNERI
6 Brady Street

Frank and Ann Vigneri's imaginative accessories store.

VIGNETTE
3625 Sacramento Street

Store designed by architect Steve MacCracken. Original accessories, Mish Tworkowski jewelry, contemporary furniture, linens.

LA VILLE DU SOLEIL
444 Post Street

Opera lover Lillian Williams also loves France. Everything for the Francophile, including tableware, furniture, and linens.

WILKES HOME
375 Sutter Street

Wilkes Bashford's vision shines here with tableware, accessories, furniture, and special objets d'art from around the world.

WILLIAMS-SONOMA
150 Post Street

Flagship for the Williams–Sonoma cookware empire. Stores throughout the state, including Rodeo Drive and Pasadena. Delicacies. Catalogue.

WILLIAM STOUT ARCHITECTURAL BOOKS
804 Montgomery Street

Architect Bill Stout's store specializes in obscure twentieth–century publications, along with new and out–of–print design books. Catalogue.

ZIA
6026 College Avenue
Oakland

Artist Colin Smith's wonderful store looks to the Southwest and sells an artful and colorful collection of hands–on furnishings and accessories. Navaho textiles.

ZINC DETAILS
906 Post Street

Architect–designed and hand-crafted furniture, lighting. Provocative, special creation of a triumvirate: Richard Sinkoff, Wendy Nishimura, and Vasilios Kiniris.

LOS ANGELES

AMERICAN RAG CIE. MAISON ET CAFE
148 South La Brea

French taste in tableware, antiques, accessories. Visit cafe and adjacent stores of this empire.

ART OPTIONS
2507 Main Street
Santa Monica

Eclectic collections of contemporary furniture, hand-crafted bowls by Susan Eslick. Beautifully edited.

ASIAPHILE
7975 Melrose Avenue

Noguchi lamps, eighteenth– and nineteenth–century Chinese antiques. Wonderful serendipity here, including woven mats from the Philippines.

THE BRADBURY COLLECTION
Pacific Design Center

Kalef Alaton's furniture, wallpapers, accessories. Contemporary chic. (To the trade.)

BUDDY'S
7208 Melrose Avenue

Takes twentieth–century pottery steps beyond Bauer and Fiestaware. Arts & Crafts setting.

BLUEPRINT
8366 Beverly Boulevard

Large contemporary furniture store. Annieglass collections.

BY DESIGN
Beverly Center, corner of Beverly and La Cienaga

Philippe Starck and Alessi kettles, juicers, colanders, plus design riffs by all today's icons.

CADILLAC JACK
318 N. La Brea Avenue

Named for Larry McMurtry's Cadillac Jack, *this store has a huge supply of cowboy–style gear, including old boots and saddles, covered–wagon lamps, sofas.*

CONRAN'S HABITAT
8500 Beverly Boulevard
Beverly Center

Excellent, well–priced selection of furniture, lighting, accessories.

DETAILS
8625½ Melrose Avenue

Simply the best selection of architectural hardware, plus well–chosen accessories.

DI'ZIN
8302 Melrose Avenue

Concrete–paved shop, featuring Robert Wilson's minimalist chairs and tables.

DOMESTIC FURNITURE
7385 Beverly Boulevard

Sells only Roy McMakin's original furniture designs.

ESPRIT
8491 Santa Monica Boulevard

Designed by Joe D'Urso. Clothing store now expanded with high–consciousness, ecology–minded merchandise.

HEMISPHERE
1426 Montana Avenue
Santa Monica

Furniture, accessories, jewelry. Early California, Southwest, Mexican, and South American influences. Rugs, vintage cowboy boots.

HENNESSEY & INGALLS
1254 Third Street
Santa Monica

The ultimate design and architecture book store. Extraordinary selection. Store designed by Morphosis.

HOLLYHOCK
214 N. Larchmont Boulevard

A new street and shop to discover. Furniture, fabrics for house and garden. A favorite of photographer Tim Street–Porter.

Aperture rocker in plantation teak designed by Kipp Stewart of Big Sur for Summit Furniture. Available at showrooms throughout the world. Stewart also designs furniture and housewares for Smith & Hawken.

California Catalogue
DESIGN AND STYLE OF THE STATE

INDIGO SEAS
123 N. Robertson Boulevard

Lynn von Kersting's wonderfully edited collection shows Colonial Caribbean, Key Largo, French, Early American, and English echoes. Wonderful fabrics, endearing collections. Patou's lovely hats. (Dine outdoors at The Ivy Restaurant next door.)

IRELAND PAYS
2428 Main Street
Santa Monica

Kathryn Ireland and Amanda Pays created le style anglais for Angelenos. Accessories, furniture.

San Francisco ceramist Susan Eslick is known for her one–of–a–kind bowls and plates with geometric patterns.

JADIS
2701 Main Street
Santa Monica

Hollywood set designers often stop here. Sleek, deluxe Art Deco.

KNEEDLER-FAUCHERE
Pacific Design Center.
Also in San Francisco.

Highly respected source of finest fabrics, furniture. (To the trade.)

LARRY TOTAH
654 N. Larchmont
Boulevard

Carries only Totah's romantic contemporary furniture. A favorite with the entertainment crowd.

MIMI LONDON
Pacific Design Center
8687 Melrose Avenue

Mimi's furniture is capacious and bold with a certain refinement. Excellent selection of fabrics. (To the trade.)

MODERN TIMES
338 N. La Brea Avenue

Bill Reed sells California masters: Charles and Ray Eames, Richard Neutra, Paul Frankl.

MODERN LIVING
8125 Melrose Avenue

The kind of store Los Angeles does best. Museum–like setting for Philippe Starck, Borek Sipek, California master furniture re–issues.

NANCY CORZINE
8747 Melrose Avenue

Sand, ivory, and beige rule. Updates on classic Biedermeier, Mies, plus chic, character–building chairs.(To the trade.)

PAMELA BARSKY
100 N. La Cienega
Boulevard

Mottura collections, Annieglass, affordable handcrafted gifts.

PHYLLIS LAPHAM, ANTIQUES
8442 Melrose Place

Refined, special. Especially good resource for French antiques.

RALPH LAUREN/POLO
444 N. Rodeo Drive
Beverly Hills

Interior design department upstairs stocks the full line of furniture, bed linens, accessories. Extremely helpful staff.

RANDOLPH & HEIN
Pacific Design Center

Long–established company originated in San Francisco. Elegant fabrics (some designed by Randolph Arczynski), furniture by California designers, excellent upholstered furniture. (To the trade.)

ROSE TARLOW
Melrose House
8454 Melrose Place

A certain English sensibility, a wonderful sense of scale.

SEEDS
126 S. La Brea Boulevard

Organic garden equipment, books, antiques.

SHABBY CHIC
1013 Montana Avenue
Santa Monica

The original. Loose, easy–to–love slipcovers and big, fat chairs and sofas. Terrific fabrics, pillows.

SONRISA
8214 Melrose Avenue

Peggy and Burke Byrnes handpick folk art and new crafts, Mexican crafts. No clichés here.

STATEMENT ON MONTANA
1302 Montana Avenue
Santa Monica

Kilims, glassware, upholstered furniture.

STEVE OF BEVERLY HILLS
9530 Santa Monica
Boulevard

A style store crammed with tableware (Cyclamen Studio), frames, accessories. All the best resources.

TESORO
319 S. Robertson Boulevard

Largest possible selection of elegant tableware, frames, accessories with accent on handcrafted pieces.

UMBRELLO
8607 Melrose Avenue

Furniture with a salsa beat. Native American pottery, Mexican glassware. A fresh take on Southwest, minus clichés.

UTENSILS
210 N. Larchmont Boulevard

Cookware, Italian pottery, Sasaki, books, linens.

ZERO MINUS PLUS
500 Broadway
Santa Monica

Contemporary gifts, tableware, glassware.

BIG SUR

THE PHOENIX
Highway 1

One of our favorite stores anywhere. Splendid collections of crafts, books, jewelry, sweaters by Kaffe Fassett (who grew up in Big Sur) and toys. Great views. The sixties never left Big Sur—thank goodness.

BURLINGAME

GARDENHOUSE
1129 Howard Avenue

Topiaries, garden ornaments, beautifully presented decorative accessories.

CALISTOGA

BRAMBLES
1117B Lincoln Avenue

Eric Cogswell and Barbera Brookes sell chic, rustic decorative accessories. Always style–setters.

CARMEL

CARMEL BAY COMPANY
Corner of Ocean and Lincoln

Tableware, books, glassware, furniture, prints.

LUCIANO ANTIQUES
San Carlos and Fifth streets

Wander through—to view high–profile antiques from everywhere, every time period.

VIEWPOINT GALLERY
Crossroads Shopping Center

Contemporary American crafts, furniture, quilts.

Robert Wilhite designs highly original tableware for Bissell & Wilhite Co., Beverly Hills.

DEL MAR

DEL MAR COUNTRY DOWNS
1302 Camino Del Mar

Lots of linens, ceramics, garden decor.

HEALDSBURG

PALLADIO
324 Healdsburg Avenue

Owner Tom Scheibal worked with architect Andrew Jaszewski to create a spectacular design store. When in Healdsburg, also discover Winston–Stanley florist, The Raven movie theatre, Ravenous restaurant, and Myra Hoefer's design studio.

JIMTOWN STORE
6706 State Highway 128

J. Carrie Brown and John Werner's great country store in the Alexander Valley. Be sure to visit their Mercantile & Exchange.

INVERNESS

BELLWEATHER
Sir Francis Drake Boulevard

Handcrafted accessories, Chinese ceramic bowls, toys. Visit after hiking at Point Reyes.

LAGUNA BEACH

GARRETT WHITE GALLERY
664 S. Coast Highway

Contemporary American glass and jewelry.

MENDOCINO

GOLDEN GOOSE
Main Street

Embellished linens, antiques, tableware, overlooking the ocean.(When in Mendocino, be sure to make a dinner reservation at Cafe Beaujolais.)

Colorful Putto & Gargoyle pottery by Gerrie Walker and Peter Lu, The Art Ranch, Occidental.

MILL VALLEY

SMITH & HAWKEN
25 Corte Madera

First visit the superb nursery (under Sarah Hammond's direction) and then the store. Everything for gardens. Also in Berkeley, Palo Alto, Santa Rosa. Outstanding catalogues.

SAN RAFAEL

MANDERLEY
1101 E. Francisco Boulevard

Ronnie Welles' antique fabrics and fabric-upholstered furniture emporium will convert you to old fabrics in a second.

SUNRISE INTERIORS
3rd and B Streets

Updated traditional furniture, accessories, antiques.

MONTECITO

PIERRE LAFOND
516 San Ysidro Road

Excellent selection of tableware, antiques, Meridian linens. Afterwards, stop in at Piatti restaurant.

PALM SPRINGS

Palm Springs is a significant center of design, with dozens of design stores and galleries for people who come here from all over the world.

BOHANNON'S
4155 E. Palm Canyon

Largest selection of crystal, tableware (including Cyclamen Studio), and china.

PALM DESERT

DION-ROSS GALLERY
73199 El Paseo at Sage

The best of everything, from pottery to minerals, art glass.

PALO ALTO

HILLARY THATZ
Stanford Shopping Center

A little bit of England, as seen by Cheryl Driver. Beautifully presented.

RALPH LAUREN/POLO
Stanford Shopping Center

A world through Ralph Lauren's eyes. Outstanding selection of furniture, quality housewares.

TURNER MARTIN
540 Emerson Street

David Turner and John Martin's enchanting one-of-a-kind style store/gallery. Definitely worth a detour.

RANCHO MIRAGE

KREISS COLLECTION
69930 Highway 111

Large-scale furniture, lighting, accessories, wrought-iron tables. A certain California sensibility.

SAUSALITO

THE ARTS & CRAFTS SHOP OF THE WEST COAST
1417 Bridgeway

D.J. Puffert finds and sells the finest turn-of-the-century Arts and Crafts furniture, lighting and pottery to connoisseurs like Barbra Streisand. Also custom design.

SAN JUAN CAPISTRANO

G.R. DURENBERGER, ANTIQUARIAN
31531 Camino Capistrano

The legendary Gep Durenberger draws clients from all over the world for fine English and Continental antiques.

SONOMA

THE SONOMA COUNTRY STORE
165 West Napa Street

Ann Thornton's empire now includes a new store at 3575 Sacramento Street, San Francisco. Decorative accessories, linens.

ST. HELENA

BALE MILL COUNTRY DESIGN
3431 N. St. Helena Highway

Classic pine and iron country furniture.

VANDERBILT & CO
1429 Main Street

Stylish tableware, bed linens, books, accessories. A favorite in the wine country.

LAKE TAHOE

TAHOE TREE COMPANY
401 West Lake Boulevard
Tahoe City

Soaring log architecture. Flowers, furniture, gifts, plant nursery.

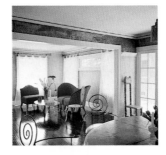

Rolled steel "Spirole" chair and "Wave" sofa by designer Larry Totah. Available through Totah Designs, Los Angeles.

TOWN AND COUNTRY HOTELS

Travelling in California, we like to stay in distinctive hotels with authentic style and an enhanced sense of place. Each of the award–winning hotels listed below offers a memorable only–in–California visit. Situated above the ocean, high on spectacular hills or in beautifully designed gardens, each hotel offers a superb vantage point from which to view California.

AUBERGE DU SOLEIL

180 Rutherford Hill Road
Rutherford
707–963–1211

Hotelier and restaurateur Claude Rouas worked with architect Sandy Walker and designer Michael Taylor to create a world–class wine country hotel. Outstanding cuisine, heart–stopping views of the Napa Valley.

HOTEL BEL–AIR

701 Stone Canyon Road
Los Angeles
213–472–1211

Frequently called the best hotel in the world, the beautiful, timeless Bel–Air radiates a sense of calm and luxe. Carefully groomed subtropical gardens surround spacious suites, some with private terraces. Highly recommended: breakfast in the loggia overlooking the gardens, lunch at the swimming pool, a wedding beside the swan lake.

INN AT THE DEPOT

250 Monterey Avenue
Capitola–By–The–Sea
408–462–3376

With interiors designed by decorator Linda Floyd, this surprising inn was once a train depot. Each luxurious room is individually styled and has a wood–burning fireplace. Private gardens.

RITZ–CARLTON HUNTINGTON HOTEL

1401 South Oak Knoll Avenue,
Pasadena
818–568–3900

The Huntington Hotel has been a landmark in Pasadena since 1907 when it opened as a fashionable resort. The esteemed Ritz–Carlton group renovated with an eye to quiet elegance. Ask for a suite on a top–floor wing overlooking the San Gabriel Valley. Spa, tennis.

RITZ–CARLTON LAGUNA NIGUEL

33533 Ritz–Carlton Drive
Dana Point
714–240–2000

Glorious views over the Pacific Ocean and one of the best surfing beaches in Southern California. Like all Ritz–Carlton hotels, glamour and details are finessed, the welcome is warm and sincere. Two swimming pools.

SAN YSIDRO RANCH

900 San Ysidro Lane
Montecito
805–969–5046

Favored by privacy–seeking Hollywood stars like Kevin Costner and Barbra Streisand, the ranch property was originally a land grant from the King of Spain to Franciscan friars who ran cattle on its

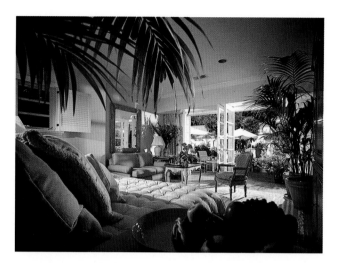

hillside acres. Soothing rooms are set in vibrant gardens. Start the evening at the historic Plough and Angel bar, enjoy dinner in the Stonehouse Restaurant.

SHERMAN HOUSE

2160 Green Street
San Francisco
415–563–3600

An historic Pacific Heights mansion carefully converted into a gracious, stylish small hotel. Hollywood stars and business leaders appreciate its privacy, comfort, and attention to detail. Quiet gardens, fine restaurant. Convenient location.

A sunny garden suite at the Hotel Bel–Air, Los Angeles.

VENTANA INN RESORT

Highway 1
Big Sur
408–667–2331

With handsome weathered–timber buildings designed by Kipp Stewart, Ventana stands in the hills high above Big Sur. Mesmerizing views of the coast and ocean from the restaurant terrace. Rooms are cozy when the summer fog swirls up the valleys. Excellent restaurant.

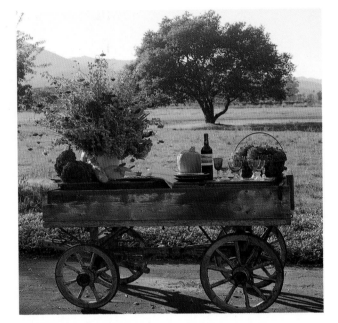